Unforgettable Nevada Women

ONE HUNDRED BIOGRAPHICAL PROFILES OF NEVADA WOMEN IN HISTORY

VOLUME THREE

EDITED BY JAMI CARPENTER

SNWHP

SOUTHERN NEVADA
WOMEN'S HISTORY PROJECT

To standardize the names of the women profiled, the Southern Nevada Women's History Project chose to use each woman's first name, followed by her maiden name and then surname by which she is most well-known. Many of these women were married more than once, and thus have had multiple surnames.

The biographies in *Unforgettable Nevada Women* were written by volunteers dedicated to the project. The Southern Nevada Women's History project is responsible for the accuracy and sourcing of the profiles contained in this volume.

Project Coordinators: Denise Gerdes, Mary Gafford, Susan Houston, and Nancy Sansone

Designer: Sue Campbell

Editor: Jami Carpenter

ISBN: 978-0-578-69934-9

Published by Southern Nevada Women's History Project

Unforgettable Nevada Women

Contents

A Message to Our Readers

The Southern Nevada Women's History Project (SNWHP) is presenting this third volume of books dedicated to recognizing the roles and contributions of Nevada women of women of diverse backgrounds.

Until recently, very little biographical information has been available about the role of women in the development of our Nevada communities, and we hope this book will fill in some gaps. We also hope you will find these histories to be interesting, informative, and at times inspirational.

The SNWHP, a statewide educational and nonprofit delegate agency of the Nevada Women's Fund, created the first book in the series, *Skirts that Swept the Desert Floor*. This volume was distributed free of charge to secondary public and private school libraries and to public libraries throughout the state of Nevada, and was available for purchase.

The SNWHP, affiliated with the National Women's History Project, created the second volume of the series, *Steadfast Sisters of the Silver State*. Again, this volume met the challenge of writing Nevada women into history and the books were distributed free of charge to schools and public libraries. This volume was also available for purchase.

Unforgettable Nevada Women, again fills in the gaps of Nevada history with the accomplishments of notable Nevada women. It was created by the SNWHP and will again be distributed to school and public libraries free of charge, and will be available for purchase. Our organization also participated in the creation of statues of Helen J. Stewart and Sarah Winnemucca. Photos of the statues and information about their creation are included on the next page.

I would like to thank the members of the organization for writing these wonderful biographies, with many members contributing to all three volumes. And a big thank-you goes out to project coordinators Mary Gafford and Susan Houston for their tireless efforts on behalf of this book.

I would also like to acknowledge the generous donation from the late Jim Rogers for providing the seed money to SNWHP to begin this book.

We hope you enjoy this book!

—*Denise Gerdes, Project Coordinator*
Southern Nevada Women's History Project

Helen Jane Wiser Stewart

MARCH 9, 1854 – MARCH 6, 1926

The Southern Nevada Women's History Project made it a part of their mission to honor Helen J. Stewart, affectionately known as the First Lady of Las Vegas. On July 26, 2010 the Historical Commission of the Las Vegas Centennial awarded the 'Friends of the Fort' $99,000 to commission a statue of Helen J. Stewart, which was unveiled in 2011 at the Old Las Vegas Mormon Fort State Historic Park in Las Vegas. Sculpted by Benjamin Victor of Aberdeen, South Dakota, the bronze statue depicts her as a petite woman wearing a fashionable dress and work boots.

Helen J. Stewart came to the Las Vegas Valley in 1882 with her husband, Archibald, and their three children. After her husband's sudden death in 1884, Helen took over running the Las Vegas Rancho and became a major force in the Las Vegas Valley. In 1902 she sold the ranch to a railroad company looking for a depot and watering source, laying the foundation for the City of Las Vegas. She was Clark County's first postmaster, the first woman to serve on a jury, the first woman to serve on a district school board, a founding member of the Mesquite Club and the Nevada Historical Society, and co-founded Christ Episcopal Church in Las Vegas. To honor her memory, Las Vegas was shut down for her funeral in 1926. As a woman who was first in many endeavors, it is fitting that she is remembered as the 'First Lady of Las Vegas.'

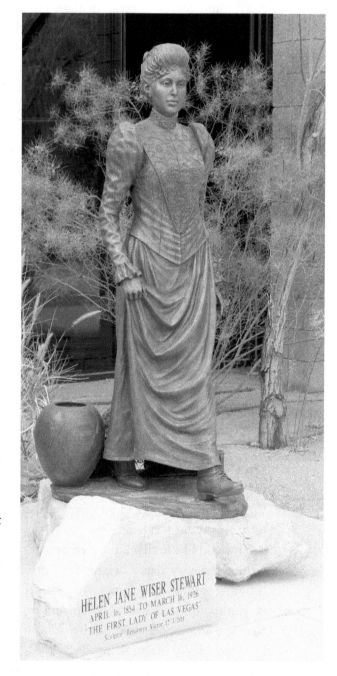

Sarah Winnemucca

1844 – 1891

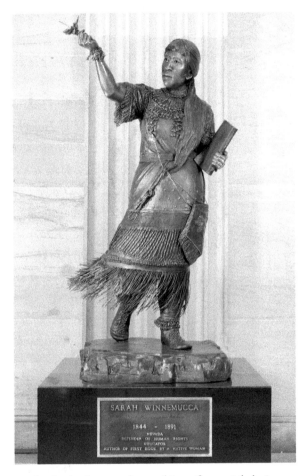

Sarah 'Shell-Flower' Winnemucca was selected by the Nevada Women's History Project to be honored with a statue, sculpted by Benjamin Victor and given by the State of Nevada in 2005 to be displayed in Emancipation Hall in the United States Capitol Visitor Center.

Sarah Winnemucca was a member of the Paiute tribe born in what would later become the state of Nevada. She was the daughter of Chief Winnemucca and granddaughter of Chief Truckee. Her Paiute name was Thocmetony (or Tocmetoni), which means 'shellflower'; it is not known why or when she took the name Sarah. Having a great facility with languages, she served as an interpreter and negotiator between her people and the U.S. Army. When the Bannock Indians revolted and were being pursued by the U.S. Army under General Oliver Howard's command in 1878, Sarah volunteered for a dangerous mission. Locating her father's band being forcibly held by the Bannocks, she secretly led them away to army protection in a three-day ride over 230 miles of rugged terrain with little food or rest.

As a spokesperson for her people, she gave over 300 speeches to win support for them, and in 1880 she met with President Rutherford B. Hayes and Secretary of the Interior Carl Schurz. Her 1883 autobiography, *Life Among the Paiutes: Their Wrongs and Claims*, was the first book written by a Native American woman. She started a school for Native Americans, where she taught children both in their native language and in English. She was married at least twice, first to Lieutenant Edward C. Bartlett and later to Lewis H. Hopkins.

The bronze statue depicts Sarah Winnemucca as she looked around age thirty-five, with hair falling to her waist. She wears a dress adorned with fringe that swirls as if windswept; this and her stance impart a sense of movement. In her right hand she holds a shellflower aloft and with her left arm she holds a book at her side. A plaque affixed to the pedestal reads:

<div align="center">

Sarah Winnemucca

1844 – 1891

Nevada

Defender of Human rights

Educator

Author of first book by a Native woman

</div>

Home Means Nevada

Official Song of the State of Nevada
Words & Music by Bertha Raffetto (1932)

Way out in the land of the setting sun,
Where the wind blows wild and free,
There's a lovely spot, just the only one
That means home sweet home to me.
If you follow the old Kit Carson trail,
Until desert meets the hills,
Oh you certainly will agree with me,
It's the place of a thousand thrills.

Home means Nevada
Home means the hills,
Home means the sage and the pine.
Out by the Truckee, silvery rills,
Out where the sun always shines,
Here is the land which I love the best,
Fairer than all I can see.
Deep in the heart of the golden west
Home means Nevada to me.

Whenever the sun at the close of day,
Colors all the western sky,
Oh my heart returns to the desert grey
And the mountains tow'ring high.
Where the moon beams play in shadowed glen,
With the spotted fawn and doe,
All the live long night until morning light,
Is the loveliest place I know.

Home means Nevada
Home means the hills,
Home means the sage and the pines.
Out by the Truckee's silvery rills,
Out where the sun always shines,
There is the land that I love the best,
Fairer than all I can see.
Right in the heart of the golden west
Home means Nevada to me.

(Bertha Raffetto is profiled in Book 1: *Skirts that Swept the Desert Floor*)

Home Means Nevada

Nevada State Song
By Act of Legislature Feb. 6, 1933

By Bertha Ruffetto

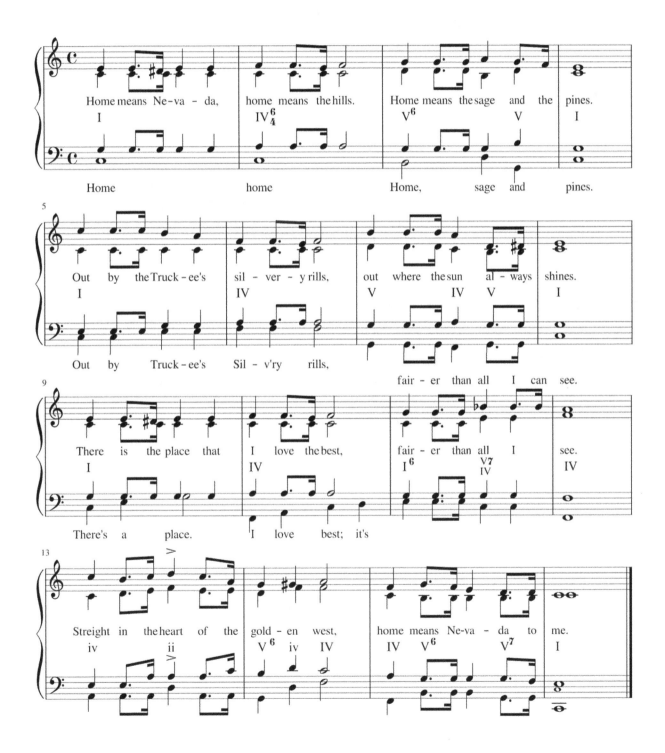

Sari Phillips Aizley

"When do we leave?" was the question on Sari's mind in 1967 when her then-husband called to announce he was considering a job at the young Nevada Southern University campus (now UNLV). He'd been recruited by the Hotel College's first dean, Jerry Vallen, to help start the College of Hotel Administration.

He offered a dreary picture of Las Vegas. "It's a desert that's so hot and dry and every house has a concrete wall around it." She replied that any change would be better than the cold, dank farmhouse in which they were living in that small New York town.

Sari overcame the disagreeable weather and many other hurdles awaiting her. Las Vegas grew academically and culturally because she made it her home.

This new life was a radical departure from her life back east. Born in Newark, New Jersey to David and Ruth Guffenberg, Sari was only two-years-old when her parents moved to Lancaster, Pennsylvania to be near family and other Russian immigrant neighbors. Junior high in that small town had its challenges for Sari as she was one of the only Jews in school.

At seventeen, Sari turned down a scholarship to a New York state teachers college and married Jack Smith. They had two children, Adrienne and Jody.

After divorcing Jack, Sari met and married Boyce Phillips. Sophia and David were born to

JANUARY 10, 1934 – NOVEMBER 1, 2017

that union. Sari, husband Boyce, and three of her four children moved to Las Vegas.

Her first job in Las Vegas was at Channel 5 TV where she was fired by Charles Vanda only days after receiving a complimentary evaluation. He learned she was trying to organize a union at the station. In truth, an associate was the instigator and Sari was a supportive element. The IBEW (union) sued the station on Sari's behalf and prevailed, seeding Vanda's lifelong hatred of her.

Soon after, she was hired by the *Las Vegas Review-Journal* newspaper's general manager, Bill Wright, as the first publications director. Reportedly Mr. Wright said, "I'm supposed to watch out for you!" after word spread of Vanda's firing of her. She worked there from 1968 to 1972, writing promotions and special events for a salary of $125 a week.

Subsequently, Sari moved into the newly created position of real estate editor at the *R-J*. She wrote a column entitled, "Q & A – Ask Jessie Emmett," addressing real estate issues and concerns of locals.

Her concept of 'Newspapers in the Classroom' or 'Living Textbooks' encouraged teachers to introduce the civic, sports, and world news contents to students as it relates to the mathematical and practical applications in life through the information in newspapers. This program is still in use today.

Sari's next job was as publications director at UNLV. In an office adjacent to hers, old boss

Charlie Vanda was developing the Charles Vanda Masters Series for UNLV's Artemus Ham Hall. Ironically, all publications were handled by Sari. Together again, they worked on the Masters Series.

Sari's many creative projects collaborated with other talented Las Vegans. While at Prestige Travel, Sari coordinated with Muriel Stevens [read Stevens' bio in this book] to develop "Travels in Good Taste." Sari scouted, researched, and planned travel to culinary destinations and Muriel hosted the group.

Sari and Mildred Mann produced a guided tour of a porcelain doll factory in Jingdezhen, China, known as the porcelain capital of the world.

The Las Vegas Jazz Society was formed with Myrna Williams [read SNHWP's bio], Monk Montgomery, Sari, and others.

Sari worked with Myrna Williams, Flora Dungan, and others on FOCUS, a drug rehabilitation program.

Sari created another innovative concept to integrate youth with arts and culture when she served with the Nevada Arts Council (NAC). Art in the Great Outdoors! was a student competition with an award of billboard and telephone book exposure throughout the Las Vegas valley.

In the academic year 1983-84 Sari traveled for a year with her third husband, Paul Aizley, on sabbatical from his position as UNLV Professor of Mathematics. They lived in Boulder, Colorado; Innsbruck, Austria, and Israel.

While on the Jewish Family Services board,

Sari was approached to find a home for Learning in Retirement, a program originated at Harvard University. Sari convinced her husband to integrate the program with UNLV's Department of Continuing Education. He produced EXCELL, which is known today as the successful Osher Lifelong Learning Institute (OLLI).

Class! was a publication Sari developed in both English and Spanish for and by high school students. Sari's son, David Phillips, created the concept and Sari oversaw the implementation of it. The newspaper was distributed monthly to an average of 40,000 students during a span of nearly sixteen years.

During this time Sari wrote for and published two newsletters: *The Alliance* and the *Cap and Gown*. *The Alliance* served eight Nevada campuses of higher education. The *Cap and Gown* was a UNLV faculty newsletter. She garnered national awards for her contributions to both publications.

While at UNLV, Sari completed her BA and master's degrees and earned her Legal Aid Certificate.

The American Civil Liberties Union (ACLU) was a project the two Aizleys endorsed for five years. They worked tirelessly on such causes as the acceptance of Spanish language in schools and handicap access in hotel parking areas.

Sari's influence in the academic and civic communities over the past four decades was important for raising the standard in Clark County, Nevada as it moved forward from a population of 125,000 to over two million.

—*Susan Houston*

Shirley Ann Barber

Shirley Ann Barber, lovingly known as Sunshine, was a devoted wife, mother, grandmother and friend. She served as a dedicated educator, an innovative elementary school principal, a passionate community activist, and a Trustee of the Clark County School District School Board.

Shirley was born in Winston Salem, North Carolina, the youngest daughter of William and Carrie (Barber) Gaither. She earned a BA degree from the HBU, Virginia Union University and a master's degree in elementary education from Wright State University.

Shirley married Major Howard Barber, U.S. Air Force (ret.) on April 15, 1958, who was the wind beneath her wings for fifty-nine years. Together, they had four children; Bryant, Karen, Loren, and Bruce.

Shirley served and chaired many diverse committees in Clark County, tirelessly advocating for equity and accessibility for all. She led by example, admired for her commitment, courage, and conviction, realizing significant improvements both in education and the communities she served.

Shirley earned recognition both at the national and state level for her services, including the naming of an elementary school in her honor, the Shirley A. Barber Elementary School.

Shirley made a big impact on the community and many individuals. Many accolades were recorded after her celebration of life services, including:

"I send my condolences, prayers, and love to all of you. I will forever remember the kind and generous spirit of Mrs. Barber. I'll never forget the big box of beautiful flowers/bows she had special made for my wedding arriving on my doorstep; shipped from Nevada to Virginia. Just one example of the giving person she was; an example of love for people, not just her family. I know her legacy will certainly live on through her children and grandchildren. I hope that the family finds comfort in knowing that God promises to always be with us! I pray

NOVEMBER 26, 1934 – JANUARY 26, 2018

14

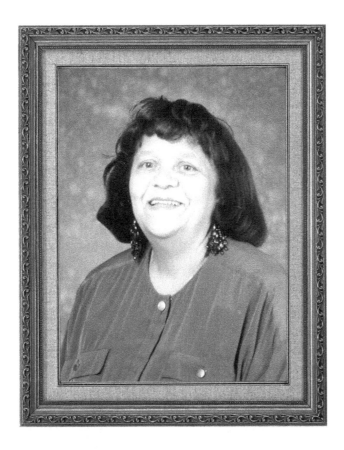

that you rest in the comfort, care and love of Jesus Christ!" *Iris Foster*

"Please know that my prayers are with you and your family during this time of great loss! Mrs. Barber was a 'Living Legend' in the Clark County School District! Furthermore, she was a great mentor to me, in particular supporting me in my first appointment as dean of students at Chaparral High School and still supported me as I climbed the administrative ranks. I will take the torch that she has passed on and continue the fight in doing what's right for children each and every day!" *Lezlie T. Funchess*

"Prayers and condolences to the Barber family. I have known her for thirty-plus years. She hired me at Mable Hoggard in a substitute teacher position and insisted that I continue to teach. 'It's your gift,' she said. She served her community and cherished her family." *Camille Leath*

"You were an amazing advocate for children and an inspiration to me. I will always remember the laughs, tears, and fun of our school board days. You, my friend, and Howard were of great encouragement for me to continue in the fight for families and education." *Karen Gray*

"More important than being an outstanding teacher, principal, and trustee, she was a caring and decent human being. She was one of the first persons to befriend JoAnn and me when we arrived in Las Vegas over twenty years ago." *E. Louis Overstreet, PhD*

At age eighty-three, Shirley Ann Barber passed peacefully at her home in Las Vegas with her loving husband by her side, following a long and brave battle with Alzheimer's. She touched many lives in Southern Nevada and her memory lives on at Shirley A. Barber Elementary School.

—Denise Gerdes

Helen M. Baucum

'Woman of the Century' is an incredibly lofty title for a girl who hailed from small Batesville, Arkansas. But that title came naturally and professionally later in life to Helen McDoniel Baucum who dedicated her life to helping others in the practice of teaching and performing hypnosis for more than forty-five years until retiring in 2011.

Arkansas may have been her birthplace but Las Vegas was lucky to claim her talents for nearly seventy years.

Born to Gladys and Estes McDoniel, Helen left Arkansas after high school to further her education at Los Angeles City College where she was a Beta Sigma Phi.

She moved to Henderson, Nevada where her brother, Estes M. McDoniel, lived and later became mayor of that city. She worked in downtown Las Vegas at the Old Western Club owned by Benny Binion. Helen recalled feeling the first atomic above-ground test blasts while at work. She said buildings would rattle and everyone paid attention!

After a short-lived marriage to an architect associated with UNLV, Helen was single for four years. She then met and married Leslie J. Baucum in 1953, which lasted fifty-one years and produced five children. Mr. Baucum was a conductor/engineer for the Union Pacific railroad.

During one of her five pregnancies, Helen developed an inordinate fear of childbirth. This was a result of a childhood memory hearing her mother scream in pain during the birth of Helen's sibling. She consulted with Dr. Zigmunt Starzynski, a physician who practiced hypnosis technique in Las Vegas in the 1950s, using hypnosis successfully to help women free themselves from the fears of bearing children. Dr. Star, as he was known to his patients, had such an impact on Helen that she began to study hypnosis seriously and he became her mentor.

Rising from patient to pioneer in the field of self-hypnosis, Helen believed this science to be a powerful tool which could aid people in conquering their fears, phobias, and inner sabotage when used correctly.

As she progressed, she developed a series of highly effective and motivating tapes and videos which a patient could use to manage several personality weaknesses in the human psyche, such as smoking cessation, weight control, stress management, positive thinking, memory retention, insomnia, depression, test passing, healing illnesses, and fear of childbirth and other surgeries.

Many of these methods are still in use today.

Around this time, Helen developed a close professional relationship with Layne Keck in the study of neuro-linguistic special training and hypnosis.

NOVEMBER 3, 1920 — MARCH 13, 2013

Baucum and Keck studied extensively with brilliant teachers but never held degrees in the field since none were offered at that time. Such teacher/mentors included Milton Erickson, founder of the American Society of Clinical Hypnosis; Harry Arons, developer of the 'Arons

Depth Scale' or the six stages of hypnosis; David Elman, originator of the Elman Induction technique; Las Vegas dentist Dr. Holt, and Dr. Starzynski.

Helen and Layne held collective study-hypnotic sessions in her office to explore various techniques of hypnosis. These sessions

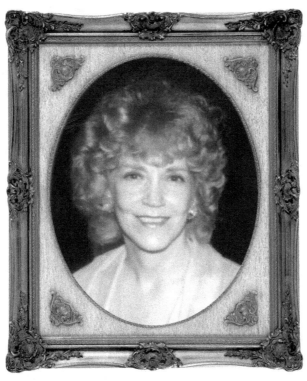

could include up to twenty people at one time. From these sessions, Keck and Baucum developed the 'pin-point method of hypnotherapy' which enabled clients to explore their fears and the root cause of the subconscious block that created their problem.

Rebirthing and neuro-linguistic programming were two areas of study in which Helen accomplished national recognition for her exceptional work as it relates to hypnosis therapy.

A breakthrough case for Baucum in 1996 drew international attention. It concerned a Las Vegas man, Terry Chayra, who was in a comatose state from an accident. His mother knew of Helen's expertise and begged her to intercede on his behalf. Helen produced a thirty-minute continuous loop tape with positive, reinforcing messaging that could be played to the unfortunate victim twenty-four hours a day.

Terry eventually came out of the coma and all proclaimed Helen as the source of his recovery

Layne Keck, currently of the Las Vegas Capstone Institute of Hypnotherapy, and Helen began to travel throughout the country holding seminars and educating people on the advantages of hypnotherapy.

Her knowledge and expertise of the hypnotic technique also brought her fame. She lectured and taught hypnosis at high schools, colleges, and universities. She was a speaker at hundreds of hypnosis seminars.

She appeared on many television and radio programs and worked with celebrities, sports figures, and politicians leading syndicated columnist Dick Maurice to dub her 'Hypnotist to the Stars.'

The International Hypnosis Hall of Fame not only thought enough of Helen's talents to give her the title 'Woman of the Century,' she was also awarded the Silver Alumni Award as well as the Lifetime Achievement Award.

Helen served as the chairperson of education for the National Society of Hypnotherapists and was a member of the Council of Hypnotist Examiners. She authored a book on self-hypnosis entitled, *Self-Hypnosis in Action*.

Helen enjoyed her Big Bear, California home and retreat where she and Layne often hosted group hypnosis sessions as they tried to perfect the science. They claim to have seen literally thousands of grateful patients.

Helen was a life-long Democrat and Catholic who served as a president at the Serene Life Church in Las Vegas. At the time of her passing, she was the mother of five children, twelve grandchildren, and twenty great-grandchildren.

The Serenus Clinical Hypnosis clinic Helen started in Las Vegas is still open under her daughter's direction.

—*Susan Houston*

Judith 'Judy' Bayley

Judith 'Judy' Bayley, namesake of the Judy Bayley Theatre at the University of Nevada, Las Vegas, was affectionately known worldwide as 'The First Lady of Gambling.'

Judy was born in Dallas, Texas to Fred and Ada Belk. She spent most of her youth in the city of her birth, attending St. Mary's Academy prior to attending North Dallas High School. She then attended Southern Methodist University, where she graduated with a double major in music and English. Judy also did some modeling for Neiman Marcus Department Store and worked for her father who had a business in Dallas.

In 1936, she married Warren 'Doc' Bayley, the owner and operator of a chain of California hotels, on June 14, 1936, in Durant, Oklahoma, where Doc was engaged in business. Judy reminisced that it was Flag Day that year.

The Bayleys came to Las Vegas in 1953 to begin expanding their chain into the growing casino business on the Strip. They opened the Hacienda Hotel in 1956 and the casino in 1957. Judy traveled with Doc, working side-by-side with him, learning the various businesses. Doc told Judy to be ready in case she ever had to step in and take charge.

After Doc's death in 1964, Judy became the first woman in Nevada history to be the sole owner and operator of a hotel-casino. From 1964 until her death in 1971, she returned the Hacienda to profitability despite having no formal business training. She also ran operations at other Hacienda hotels located in Fresno, Bakersfield, and Indio, California; the New Frontier Hotel in Las Vegas; and the El Rey Club in Searchlight, Nevada.

She was elected Chairman of the Board of Directors in January 1965 and took the overall management of the Hacienda Hotel Chain. At the time of his death, Doc Bayley had just completed plans to demolish the old building of the New Frontier and construct a new high rise. Determined to carry on the vast programs Doc had started, Judy rolled up her sleeves and worked to complete every project.

AUGUST 21, 1915 — DECEMBER 31, 1971

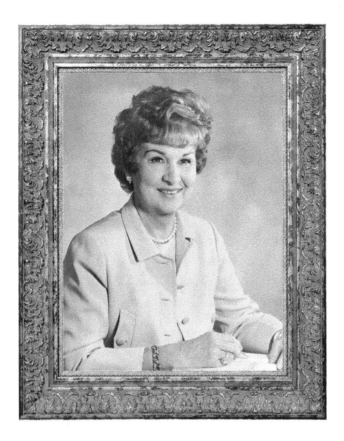

Her early experience with entertaining influenced her business strategy. She recognized the need for publicity to drive business at the Hacienda, so she actively worked to keep herself and her hotel in the media spotlight. Judy had a large Hacienda Hotel sign she designed installed on the Las Vegas Strip. She was also very hands-on in the casino's operation, overseeing the addition of Keno, Poker, and Pan to the gaming operations and working closely with the restaurant and entertainment staff. Her affable demeanor inspired great loyalty among the Hacienda staff.

Bayley was also a great philanthropist, committed to raising money to fight cancer and heart disease and help children in need. Because her husband died from heart disease, she gave her time and talents and provided the Hacienda Hotel's large showroom to host the city's first telethon, the Heart Fund Telethon, on Valentine's Day 1965. She also contributed to subsequent telethons.

She sponsored the very popular Hacienda Trailride, a fundraising event that benefited the Veterans of Foreign Wars, the American Cancer Society, and other charitable organizations. She gave funds to UNLV during an important period of its growth. In 1971, she became active in the fundraising effort to finance a new performing arts center, donating $65,000 in seed money for the project. The Judy Bayley Theatre was completed just after her death and named in honor of her many contributions to Las Vegas and the university.

Judy Bayley's name has been added to the many Nevada women who have contributed so much to the growth and development of Southern Nevada, especially the Las Vegas community.

—*Denise Gerdes*

Marta Becket

On a scorching hot August day in 1967 a weary and talented forty-three-year-old Marta Becket laid eyes for the first time on Death Valley, what would become the center of her world for the next fifty years. From the dust would rise a glorious opera house dedicated to the arts … actually her arts.

Born as Martha Beckett, she thrived as an only child to parents obsessed with showering Marta with lessons in art and dance in New York City's bohemian Greenwich Village.

Martha's first professional gig was at New York City's Radio City Music Hall in the corps de ballet and on the side Martha created her own original scores and dances. She even wrote under a Russian pseudonym. Using her gift for drawing, she illustrated a book for the famous dance master George Balanchine.

Broadway was near her home and she was fortunate to be hired in some major theatrical productions, such as *A Tree Grows in Brooklyn*, *It's a Wonderful Life*, and a 1946 revival of *Show Boat*.

It was at this time that by accident Martha experienced one of her first epiphanies. When she accepted a dance position in the production of *Show Boat*, the program for the musical was misprinted and her name was misspelled as 'Marta Becket.'

"That's me, I realized," she later claimed in her autobiography, *To Dance on the Sands: The Life and Art of Death Valley's Marta Becket*. "That was me all along, and now the truth is uncovered in the playbill." This innocent mistake freed Martha to emerge from the shadows of her namesake grandmother and her own mother who had dubbed her 'Little Martha.'

The marriage of Marta, at age forty-two, to Tom Williams in 1962 presented an opportunity for them to travel together so he became her manager. A theatrical road trip west was booked.

And this is where the sunset, the desert, and an abandoned Mexican Colonial-style building stole her heart for the rest of her life.

One afternoon their damaged truck tire forced them to veer thirty miles out of their way for repairs. The skeletal remains of the once proud, but now decaying, commercial complex had housed the Pacific Coast Borax Company. (Read 20 Mule Team!) There was a twenty-three-room hotel, a restaurant and a rec center, all designed in the mid-1920s by architect Alexander Hamilton McCulloch.

Marta inspected this decrepit assemblage and as she glanced through the dusty window panes of the huge hall, she saw the light play off the faded calico curtains that held court over a built-in stage long ago abandoned. It had been a home to some wonderful occasions, she thought.

Corkhill Hall, as it had been known in its heyday, beckoned Ms. Becket. "As I peered through the tiny hole, I had the distinct feeling that I was looking at the other half of myself. The building seemed to be saying, 'Take me … Do something with me … I offer you life.'"

Marta and Tom inquired with the town manager as to the possibility of a residency there.

To their delight they negotiated a monthly lease of $45 plus repairs. They finished business in

AUGUST 9, 1924 —
JANUARY 30, 2017

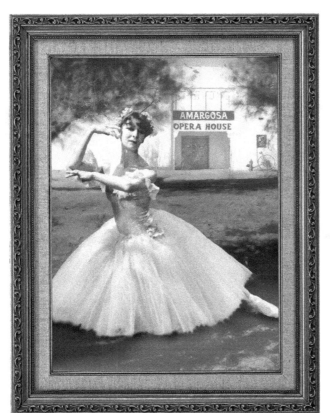

New York and returned to Death Valley Junction, arriving on Marta's forty-third birthday, August 9, 1967.

Marta christened the tired old hall the Amargosa Opera House and immediately commenced to rehabilitate the structure. Amargosa means *bitter* in Spanish, probably a reference to the alkaline waters found throughout the region.

In the spring of 1968, the doors opened and Marta performed. She taught local kids dance there as well.

In another epiphany, Marta envisioned an audience on the surrounding walls to accompany her during her performances. She first painted a Renaissance nobility court. It took years to complete the assemblage of stylized bullfighters, Catholic clergy, gypsies, and other tromp l'oeil figures from her fantasies.

In 1983, after nearly twenty years, Tom and Marta's marriage fizzled and soon Marta discovered the Sancho Panza to her Don Quixote. Tom Willet, the Amargosa Opera House's resident handyman, was dubbed 'Wilget' and the match was made.

Wilget filled most of the duties around the place. He took tickets, he refurbished needy areas, and his jocular nature allowed him to step into some farcical roles on stage opposite Marta. Brandishing wigs, bonnets, and tutus he referred to as 'four-tus' because of his wide girth, Wilget was Marta's soul mate. They 'played' together for the next twenty years until his passing in 2005.

Growing frail after his passing, Marta stopped performing around 2012 at age eighty-eight. Her ballets then became sit-down shows for anyone who would stop by for a performance.

Over the years, Marta became famous in a variety of ways. Many called her eccentric, crazy, wildly talented, and whatever else you would think of a woman who had survived for years just to perform in the formidable climes of Death Valley. Her story was told publicly in her 2006 autobiography, the *New York Times*, *Pahrump Valley Times*, *Las Vegas Review-Journal*, a *National Geographic* documentary, and *Life* and *People* periodicals.

Before her death in 2017, Marta's legacy was recognized by a pretty young dancer, perhaps driven as much as a young 'Martha' had been. As a young girl of six in 1982, Jenna McClintock had enjoyed a Becket performance and never forgot the experience. She said her own ballet career is a result of this connection. She arrived at the Opera House to give her own life the love of ballet influenced by Marta. With Ms. Becket in attendance McClintock performed Marta's original dances at the Amargosa Opera House for about two years before moving back to California.

—*Susan Houston*

Elizabeth Guido Beckwith

I t was a cold, blustery morning when Anello and Francis Guido beheld a glorious ray of sunshine that would bring total joy to their family. On this day, their beautiful baby daughter, Elizabeth, was born in the city of Brooklyn, New York. These immigrants from Naples, Italy and Sicily really had something to write home and brag about amidst the hard times of the depression.

As a daughter of Italian descent and a devout Catholic, Elizabeth grew up at a time when survival came before formal education, which could be quite costly. That was not so in the Guido household. Elizabeth Guido attended and graduated from Blessed Sacrament School in Brooklyn. In the early 1950s, this academically talented young lady received a full scholarship to attend Bishop McDonnell Memorial High School, noted for being quite a selective and very prestigious educational institution.

In 1956 she enrolled at St. John's University in New York where she met Harold J. (Pat)

DECEMBER 11, 1938 – MAY 7, 2019

Beckwith. They married in 1960 and shared fifty-five years of wedded bliss and four wonderful children who brought much love and joy to the Beckwith household.

In 1967, the family received the message to 'Go West,' so they forsook the east coast and traveled to the dry and hot gambling town of Las Vegas, Nevada, where in addition to raising four children, Elizabeth (Liz) ran a household that was a hub for extended family and friends. She provided shelter and incredible Italian food for many. She also worked as a bookkeeper for Landmark Pharmacy.

Then, because Elizabeth was noted for her culinary and bookkeeping talents for many years, she and her husband opened several small businesses. The candy store Sweets of Las Vegas came first. These stores were located throughout the small but growing city of Las Vegas. Next they opened the extremely successful Beckwith Accounting Services business, noted throughout Clark County for its multiplicity of services.

Elizabeth Beckwith and her family were devoted attendees of St. Viator's Catholic Church for over fifty years. As a parishioner, Liz was a founding member of the parish chapter of Catholic Daughters of America, served as president of the Women's Guild, and assisted her husband when he was head of the parish council.

Liz enjoyed cooking and was a voracious reader blessed with an incredible memory. She dispensed wisdom, love, and food in just the right mix. She was a devoted wife, mother, and grandmother, with a generosity of spirit that reached beyond her immediate family.

Liz will be remembered for sharing shelter, services, and great food to family, extended family, and friends in need throughout her years in the Clark County area. She was noted for her generosity and community service, and her many kindnesses extended after the death of her beloved husband in 1975.

Hats off to a sincere and giving lady who truly is an Unforgettable Nevada Woman, deserving of being recognized for her selfless service to others during her time here in the greater Las Vegas area.

—*Mary Gafford*

Barbara Bernabei

Barbara Sue Bernabei, a Las Vegas mental health care advocate and co-founder of Nevada's Easter Seals division, left a lasting legacy for those in Southern Nevada.

Born in St. Louis, Barbara relocated to Las Vegas in 1963 and worked at several historic Las Vegas restaurants and casinos, including Foxy's Deli, the Stardust, Castaways, and the Riviera. She met her husband, Joseph Bernabei, while working as a cocktail waitress at Castaways.

"I was a part owner at the Castaways and I hired her, and we fell in love," Joseph Bernabei said. Barbara Bernabei and her husband had four children, two of whom, John and Sybrina, are still living.

A poster child for 'accidental' activism, Barbara became passionate about mental health when two of her sons were born with mental illnesses, said her daughter, Sybrina Bernabei.

As a fifty-three-year resident of the Las Vegas valley, Bernabei was instrumental in bringing mental health resources to Southern Nevada in the 1970s and 1980s.

She made frequent trips to Carson City and Washington, D.C., lobbying for summer school opportunities and benefits for children with disabilities.

"She was a very strong advocate for the mentally disabled," Joseph Bernabei said. "She was a very good woman."

Her work was revolutionary to Southern Nevada, where mental health resources were few and far between.

"Back in the '70s and '80s, you didn't have resources for kids with special needs," Sybrina said. "She helped empower both moms and their children. She added, "This was before people even knew what autism was."

Barbara Bernabei was co-founder of the Southern Nevada Association for the Handicapped, now known as Easter Seals, with Midge Becker. Easter Seals Nevada was incorporated as a Nevada non-profit corporation in 1976. Today, Easter Seals Nevada maintains its

SEPTEMBER 21, 1941 — JUNE 2, 2015

501c3 status and proudly uses donations to enhance programs and services with no fundraising revenue used to cover corporate or developmental overhead.

Easter Seals Nevada provides exceptional services to help all people with disabilities or special needs and their families become self-sufficient through direct services, education, and community partnerships. Their stated mission is to spread help, hope, and answers for people in Nevada. Easter Seals Nevada is a non-profit that now provides innovative healthcare and human services in pediatric rehabilitation services in Southern and Northern Nevada. They serve families and children who have been diagnosed with developmental delays and other disorders, and adults with physical and intellectual limitations. They provide physical therapy, occupational therapy, and speech therapy for children up to three years of age and their families in their homes through its early intervention programs, and for children of all ages in state-of-the-art therapy clinics located in Las Vegas and Reno. Their goal is to enhance the capabilities and enrich the lives of the clients and patients they serve by providing urgently needed healthcare, social services, and opportunities for social and community engagement to Nevadans with special needs.

Easter Seals Nevada also provides capability enhancement and enrichment services for adults living in Southern Nevada and oversees assistive technology initiatives and independent living home and vehicle modification projects throughout Nevada.

Barbara Bernabei died at age seventy-three. To the very end, Barbara was true to her cause. Her final wishes at her private memorial services included asking for donations be made to Easter Seals in lieu of flowers.

Barbara Bernabei had a fierce sense of humor, loved her family, and made the community a better place. Her dedication to serve those with mental health issues was revolutionary and inspiring for all those in both Northern and Southern Nevada.

—*Denise Gerdes*

Iris Bletsch

Iris Zaiger Bletsch was born in Manistee, Michigan to Iris V. Burtch and John L. Zaiger. In 1958, Iris, John Bletsch, and their son, Gerry, moved to Boulder City and on July 7, 1961 and welcomed the birth of their second son, John Michael Bletsch Jr.

Circumstances caused the family to reluctantly return to Michigan. Their love of Boulder City, and the wish to make it their home, was finally realized in 1968 when they returned to run the Boulder Conoco Station, located on what was then a very short business stretch of Boulder Highway. With the purchase of a single tow truck, Big John's Towing was born. Iris's business skills were instrumental in the success of their new business. Although her husband, John 'Big John' Bletsch, was the face of the business, according to her son, it was Iris who called the shots. "She really made the business decisions on the grand scale," he said.

John and Iris later purchased property on Foothill Drive, and with their hard work and vision, Big John and Sons Inc. was expanded to encompass a complete automotive service and used car sales and grew to include a fleet of five tow trucks.

The Bletsches sold Big John's Towing in 1990, but it remains the city's only towing company. The family still owns the land on which the Foothill Drive business is located.

Iris's business savvy also led her to real estate. In 1980, she and two others opened Desert Sun Realty, which is still in operation.

"The most important thing about Iris, she was a true businessperson through and through,"

SEPTEMBER 10, 1931 — NOVEMBER 10, 2013

Desert Sun Realty broker/owner Bret Runion said. "But deep down inside she really cared about Boulder City and that's why she got involved in politics."

By 1990, Iris had established a political career. She was elected to the Boulder City Council where she served two terms from 1989–1997. She held the title of Boulder City's only female mayor from 1993–1997. At that time the mayor's seat was given to a council member appointed by the other council members.

According to her son, "I think the most important accomplishment to her was being the first female mayor because she was always the type of person who pushed for more of an equality in the workplace for women."

Iris, the oldest of three children, told friend Rose Henderson in a 2010 interview project that her belief in gender equality came from her father.

"My dad raised me like a boy. He and I believed I could do anything a boy could do," she said.

Iris served on numerous local and Clark County boards and committees, including: Boulder City Hospital, Homestead, Regional Transportation Commission (RTC), Regional Flood Control, the Las Vegas Convention and Visitors Authority, plus numerous others. She was awarded the distinction of Nevada Public Official of the Year in 1995. While chairman of the Development Commission, she encouraged the acquisition of the El Dorado Valley by Boulder City.

During her tenure at the RTC, she also visited Washington to appropriate funds for flood control and transportation needs.

Although not popular with all at the time, she knew there was a need for public transportation in Boulder City. Gerry Bletsch said that without local taxi service, his mother saw a need for elderly residents and others without transportation to be able to get to Las Vegas and back.

The proposal was met with strong opposition, which included threats to her safety and a billboard someone erected outside Boulder City with a picture of her driving a bus. "(Some Boulder City residents) had visions of people coming out of Vegas and robbing their house and putting their television on the bus and bringing it back to Vegas," Gerry said. However, "Once she made a decision and thought it was right, she would listen to everyone's point of view but was unwavering," he added.

The council consequently approved bus service and today residents have the option of riding the bus to Henderson and Las Vegas.

Iris also supported the controversial construction of Veteran's Memorial Drive, which she believed was needed to reduce traffic congestion from morning commuters. According to interviewer Rose Henderson, "Iris understood the need to balance nostalgia with some good common sense and pushed for the road to go in."

Gerry told Rose Henderson that his mother's reputation as a tough lady once earned her the nickname 'Godzilla' from former Boulder City Manager George Forbes. However, her resolute approach was essential especially when she supported controversial issues, such as bringing the public bus service to connect Las Vegas and Boulder City.

Despite her controversial ideas, former Mayor Bob Ferraro, who served on the council with Iris, said she was well-respected.

Iris was involved in the early discussions of issues that are important to Boulder City today, including the Boulder City bypass. She pushed hard for the city's acquisition of Eldorado Valley, which it owns and leases to solar power facilities, producing much-needed revenue. "If we didn't get it, others would," she told Henderson.

Iris had numerous organizational affiliations, including: Business and Professional Women, Chamber of Commerce, Sunrise Rotary, and the Women's Political Caucus, where she served as president. Even with these professional commitments, absolutely nothing came before her family and friends. Her unconditional love and support was the rock for everyone she loved.

Iris was also an avid traveler and found time to visit the Pacific Islands, China, and travel throughout Europe, but she mostly loved to spend time on the beach in Mexico.

Former Mayor Iris Bletsch died at the age of eighty-two, but her impact on Boulder City will live on through her many accomplishments.

—*Yvonne Kelly*

Bonnie Bryan

Bonnie Belinda Fairchild Bryan, wife of Nevada's 25th governor and former United States Senator Richard H. Bryan, was born in Lodi, California. She died at the age of seventy-seven in Las Vegas, Nevada following a valiant battle with leukemia.

Bonnie was a fourth generation Californian, born to Bonnie and Bailey Fairchild, a dairyman's daughter and a Grape Festival Princess who graduated from Lodi High School in 1957. Upon graduation, she followed her mother's footsteps and attended the University of Nevada in Reno, where she earned a Bachelor of Arts Degree in psychology, and subsequently worked for two years in the personnel field at Utah Construction and Mining in San Francisco from 1961–1963.

As a student, Bonnie was active on campus, including the Kappa Alpha Theta Sorority. She made many lifelong friendships and met her future husband there. Richard was running for student body president, so to lift his standing he asked Bonnie to the Comstock Stomp. He won the election and also the prize of his life in Bonnie Fairchild.

Bonnie and Dick were married on September 1, 1962, in Lodi. They lived in San Francisco while Dick completed his law degree at Hastings

JUNE 24, 1939 —
AUGUST 30, 2016

Law School, then settled in Las Vegas to start a family and begin their forty-year career in public life. Bonnie devoted most of her time to her family then, attending school activities, games, PTA meetings, and school open houses.

In 1982, Bonnie helped Dick achieve his life-long dream, his election as governor of Nevada. As First Lady, the people of Nevada were introduced to a gracious and engaging hostess who served as Nevada's official Ambassador for Tourism, one of her husband's top policy priorities, and was chairman of the dedication ceremonies of the Great Basin National Park. She was also a member of the State DUI Task Force, State Literacy Board, and functioned as spokeswoman for CALL (Computer Assisted Literacy in Libraries) Program for the Las Vegas-Clark County Library District.

In 1989, the Bryans left Carson City for Washington, D.C. following Dick's election to the U.S. Senate. During her twelve years in Washington, Bonnie enjoyed all that Washington offered, including observing the Senate conduct its regular business, attending state dinners at the White House, joining the International Club and Senate Wives' Club, and touring the many muse-

ums and historical sites in the area. In 2001, Bonnie and Dick returned to Nevada. Home again for good, Bonnie relished the time she spent with her children and their families and her many friends across the state. She attended her grandchildren's sporting and school events, enjoyed weekly lunches with her many friends, traveled the world with Dick, and true to form, scarcely missed a social event in Las Vegas or Reno.

Bonnie was active in civic affairs, serving on the boards of the American Lung Association, Camp Fire, the Sierra Arts Foundation, the Advisory Board of the University of Nevada College of Arts and Science, and the University of Nevada Alumni Association. She has done volunteer work for a number of organizations, including the American Heart Association, Junior Mesquite, United Blood Services, the Junior League of Las Vegas, Carson-Tahoe Hospital Auxiliary, and the Steering Committee of the Assistance League of Las Vegas. She also acted as honorary chairman for numerous events and she was selected to be the first Spotlight Dinner honoree of the Women's Democratic Club of Clark County.

Bonnie Bryan was particularly interested in issues and programs for the Silver State's youth. She supported and worked for the March of Dimes, the Children's Miracle Network Telethon, MADD Red Ribbon Campaign, and Safe Ride—a hotline for teens who have been drinking and need a ride home. She was recognized by the General Federation of Women's Clubs for her support and assistance in gaining state acknowledgment and action regarding child abuse. She was a lifetime member of the Nevada State PTA and spent much time reading to preschool youngsters and primary grade students.

Bonnie was similarly involved with programs and issues affecting older Nevadans. As a result, she spent a great deal of her time visiting nursing homes, nutrition sites, and community centers, meeting with the senior citizens and hearing their concerns. In 1982 she began the 'Brown Bag' program, an education series designed to inform seniors on the safe use of prescription drugs.

Aside from her many accomplishments, Bonnie will be missed for her genuine concern for people.

—Denise M. Gerdes

Mary Carmichael Cashman

Mary Cashman was a community activist throughout her life. She and her husband James were fundamental to the growth and development of Las Vegas and Southern Nevada for over sixty years. The Cashmans were well known and loved throughout Southern Nevada.

Mary Theresa Carmichael was born in 1925 to Gordon Carmichael and Elizabeth Dirks Carmichael in Whitetail, Montana. Mary had three siblings: Patricia, Gordon, and Ken. Mary's father was an engineer on the Union Pacific Railroad.

Mary resided in Las Vegas during her early years and then moved to the Garfield area of Los Angeles in 1931. The family relocated back to Las Vegas just before Mary's tenth year at Las Vegas High School.

She met her future husband, James 'Jim' Cashman, Jr., while sitting on his lap in a 1933 Ford, catching a ride home with her lifelong friends, Donna and Gail Andress. The Cashmans were a significant pioneer family of Southern Nevada. 'Big Jim' Cashman Sr. founded his first business in Searchlight in 1905 and moved what would become a multi-million-dollar Cadillac business to Las Vegas in 1921. James Cashman, Jr., a longtime local business and civic leader was chairman of the family-owned Cashman Enterprises and president of Cashman Equipment Company.

Mary and Jim Cashman were married for sixty years and raised four children: James, Timothy, Rhonda, and Leah. Mary was a patient and supportive mother who instilled values of excellence in her children. Jim Cashman passed away on December 6, 2005.

Mary was a strong woman of body, mind, and spirit, and a pillar of strength for all those around her. She supported Jim's many efforts in Las Vegas: to get land to expand UNLV, when he was co-chairman for many Helldorado Days parades, running

AUGUST 9, 1925 –
JULY 8, 2017

30

the United Fund Drive and the United Way of Clark County.

Mary was a powerhouse on her own and gave of her time and talents to the community. She was a twenty-five-year member of Catholic Welfare at both the local and state level and chaired the state board for two years. Mary also served in many leadership positions for Service League of Las Vegas prior to its formation as the Junior League of Southern Nevada. During her time with the Service and Junior League, Mary worked on a number of community projects including leading Child Welfare Services, the Red Cross, Community Christmas Assistance for Needy Children, the UNLV Library and Library Endowment Fund, and was the chairman for the Variety School for Handicapped Children Project.

The Cashmans' living legacy and name can be found around Southern Nevada, including James Cashman Middle School at 4622 West Desert Inn Road serving over 1500 students; Cashman Field Center, with 483 square feet on 55 acres; and Cashman Equipment, now owned by MaryKaye Cashman, now over eighty-five-years-old, with multiple locations throughout the state and with 700+ employees.

Mary Cashman passed away at the age of 91. She was a loving mother and a wonderful woman, greatly missed by her family, a thankful Las Vegas, and all those she touched during her time on this Earth.

—*Denise Gerdes*

Margaret 'Margie' Conway

Her mark was indelible wherever she took the notion to live … Las Vegas, Nevada was the scene of the last twenty-five years of Margaret Conway's life where she spun her social magic, deftly weaving people in to each other's lives.

Born in the Hawaiian Islands to the islands' first auto dealer, Walter Wilson and his wife Marguerite, she transitioned to the toney Marin County, California for her school years. She was a graduate of Tamalpais High School and the College of Marin in Northern California.

Scholastics must have come easily to Margie as she had time for extra-curricular activities such as student body vice-president, president of the drama society and her sorority, and editor of the college paper.

Her youthful beauty was recognized as she was elected Miss U.S. Coast Guard 1952, an accolade she always held dear, and she claimed to have been asked to dance with the Shah of Iran three times!

SEPTEMBER 18, 1925 – APRIL 26, 2012

Margie soon married and became a San Francisco socialite with ease. She claimed Liberace performed on her Pacific Palisades baby grand piano at one of her many gatherings.

Social memberships were plenty in those years: St. Francis Yacht Club (Oakland), U.S. Coast Guard Auxiliary, California Yacht Club (Marina del Rey), Outrigger Canoe Club (Honolulu), and Riviera Country Club (Pacific Palisades).

Between marriages, Margie weaved social skills with work skills to successfully manage a 200-apartment and 300-boat slip rental complex, the Villa del Mar in Marina del Rey, California for twelve years. She befriended many celebrities and luminaries at that post and had a story to match each encounter!

Another marriage took her to Bakersfield, California for thirteen years where she didn't let her talents rest. Margie in 1967 founded the Kern County chapter of the City of

Hope charity and the National Foundation of Infantile Paralysis of Kern County.

By the time Margie met and married 'the love of her life,' Lt. Col. Jim Conway, they were ready for the bright lights and social scene of Las Vegas. She loved the city, its sophistication and their little love nest 'Hale Makaleka' the moment they pulled in to town and settled.

After twenty wonderful years of marriage, Jim passed and Margie soon filled her time with the social organizations of Las Vegas. She joined the Nellis AFB Retired Officers' Wives Club, Opera Las Vegas, Republican Men's Club, the Red Hat Society, Nevada Arts Advocates, Las Vegas Philharmonic Guild, Las Vegas Towne Club, and Southern Nevada Women's History Project.

Las Vegas came to know Margie as the social glue in many organizations as she could forge the greatest of friendships with others, many of which survive today. Her life touched the hearts of many and she will be greatly missed by the close friends she made throughout her lifetime.

Margie's volunteer work contributed greatly and left a lasting legacy in the Las Vegas community as well as the greater Clark County area.

—*Susan Houston*

Dr. Sheila Conway

Sheila Conway dedicated her entire professional career, which spanned more than five decades, to public service, environmental protection, and public safety.

Sheila was born in New York City. Sheila earned her BA in geography from the University of South Florida and her MA in geography and her doctorate in environmental planning and design from Arizona State University in Tempe, Arizona. Sheila was also an alumnus of the Las Vegas Chamber of Commerce Leadership Las Vegas program.

Sheila served as managing partner of Urban Environmental Research, LLC, which provides evaluation analysis and advice on public safety, homeland security, strategic planning, performance measurement, transportation, socio-economic, and environmental impact assessment for private and public entities.

With her team, she accomplished groundbreaking, cutting-edge work to provide impact assessment, monitoring, and emergency response tools and strategies for the benefit of state and local government agencies. They received numerous awards and recognition from local, national, and international organizations.

Prior to co-founding UER, Sheila served

NOVEMBER 29, 1950 – JAN. 8, 2015

as executive director of the Colorado Center for Environmental Management in Denver, where she oversaw the building of a 501c(3) non-profit public/private partnership to demonstrate and commercialize new environmental techniques.

She previously served as senior project manager for ICF Kaiser Engineers in Edison, N.J., where she was responsible for building the company's first regional office.

Sheila authored several books, articles, and professional papers, and was a widely recognized national and international public speaker.

Sheila was invited to speak at conferences in the UK, Portugal, Austria, Italy, Belgium, Malta, Australia, and across the United States. She served on an International Scientific Advisory Committee for Wessex Institute of Technology in the UK, and was an InfraGard Alliance Board Member. She was also a member of the Institute of Business Forecasters, International Institute of Forecasting, and International Society for Quality of Life Studies and Balanced Scorecard Collaborative.

Sheila actively supported many local organizations, including the Lupus Foundation of America, the Community Philanthropist Circle of the American Red Cross, the American Society for Public Administration, the Nevada

Development Authority, the Las Vegas Chamber of Commerce, Shade Tree, the American Lung Association, the Las Vegas Green-Up, the Marine Corps Law Enforcement Foundation, KNPR, and the UNLV Executive Masters of Science Program in Crisis and Emergency Management. This in addition to all of her immeasurable contributions to the community.

She was highly regarded by her many friends and colleagues, as attested by these comments:

"Sheila was one of the best people I've ever known. She cared deeply for the community, her family and friends. I always appreciated her support and advice, but I will forever treasure her friendship and generosity. She and Paul treated my son with kindness and helped him develop into the young man he is today. We will never forget Ms. Sheila ..." Fernandez Leary, Las Vegas, Nevada.

"My wife and I extend our condolences to Paul and those whose lives Sheila touched. Our work together was exciting. She had outstanding academic and practical skills. I couldn't have asked for a better collaborator on emergency management projects. Happy Trails!" Jim O'Brien, Las Vegas, Nevada.

"For myself, and also on behalf of the staff of the Nevada Agency for Nuclear Projects, I am writing to extend our condolences to Paul and to all the people who knew and loved Sheila. To me, Sheila was a good friend, a trusted and no-nonsense advisor, and a wonderfully smart and hard-working colleague. Sheila was for many years an important member of, and leader of, the State of Nevada's, and Clark County's, team of social scientists assessing the social and economic impacts of Yucca Mountain on Las Vegas and Clark County. Her written work will continue to speak volumes. We will all miss hearing her thoughtful and caring spoken words." Bob Halstead, Carson City, Nevada.

Sheila loved to cook, travel, and spend time with her constant canine companion, Dante. She lived life to the fullest with an upbeat and energetic attitude.

Sheila Conway, PhD, passed away in Phoenix-area hospice care. She was a loyal and loving wife, mother to her son, Clay, who preceded her in death, sister, aunt, mentor, and friend to many. She will be missed by all, and her passing is a significant loss to the community.

—*Denise Gerdes*

Charlene Cruz

Charlene 'Char' and the city of Las Vegas grew up together. Her parents were living at 'Vegas Camp' when she was born. There were 8000 people residing in the valley at that time. Her family built their first home where the Stratosphere now stands, at the beginning of the fabulous Las Vegas Strip. The year she was born, the first resort hotel was built and World War II brought military to the area. From that time on, Char was enthralled with her emerging metropolitan city.

Her family goes back four generations. In 1880, her great-grandparents settled just fifty miles away, and her great-grandmother became the first schoolteacher in Clark County. Her grandparents helped build the first railroad station in 1905, the year Las Vegas became a city. Her parents began trucking and road building operations in 1927 as the Boulder Canyon Project (Hoover Dam) began. They built many of the first roads in Nevada, Utah, Arizona, and California, including Highway 91. Char retained her father's I.C.C. permit, the first issued in the State of Nevada.

With a father in the construction business and a mother dressed in satin and lace, Char was introduced to a world of ballet, piano, road construction, and mining. A stream of blue construction language was as natural to her ear as the language of classical music. She grew up in a childhood of dreams and dirt, practicing her dancing on the flat bed of a diesel truck and tripping her fingers over the keyboard of an old upright piano from the Red Rooster Bar. She drove her dad's heavy equipment through the desert listening to the songs of the wind through the cottonwood trees.

Char was fortunate to have experienced the freedom and harmony of a clean desert environment while riding horseback through the mesquite and creosote. She grew to appreciate the untouched beauty of areas like Red Rock Conservation Area, Valley of Fire, and Mount Charleston. She swam in pools of natural artesian water at the old ranch and at Twin Lakes and concrete pools of the first hotels on the Strip. She attended the opening of Bugsy's Famous Flamingo Hotel in 1946 with her mother and father. She saw Elvis's first appearance in 1956 and grew up listening to old-timers tell of the history and beauty of the west through stories and songs.

Char was a very busy person, with a wide variety experiences. She was a tour guide, spiritual counselor, and a teacher of art, calligraphy, and music. She began teaching

SEPTEMBER 19, 1941 —
MARCH 6, 2014

at the University of Nevada Las Vegas in 1980. As a teacher, her classes ranged from keyboard and calligraphic art to the history of Southern Nevada and the Mojave Desert. She was a no-nonsense teacher, sprinkled with humor and constant encouragement, a style she referred to as the 'Zen of Learning.'

Char created an art form, "which bounces with life with spontaneous freedom of the Oriental brush watercolor and the discipline of traditional calligraphic hands." Her fine art has freshness to it; expressive of the beauty and clarity of the dramatic desert environment she loved so much. She produced her own line of greeting cards as well.

Char's love of the land was apparent. Her Cherokee Indian heritage gave her a deep respect of the earth. She offered professional tour services for the many delegates and visitors to the area. She was a docent with the Friends of Red Rock group, pioneering calligraphy classes in Las Vegas. Proud of her heritage, she would share her special perspective of Southern Nevada, Indian cultures, and legends with storytelling and cowboy style poetry. Her provocative poetry, written in a simple and powerful style, resembled Japanese Haiku and brought additional depth to the work. Her life's work was called *Earth Mark* in reverence to her Indian name. Char published her stories and music.

Char was part Cherokee/Algonquin and in Nevada, Elder for the Kaweah Nation. She was a member of LDS, DAR, and DUP and a licensed minister who performed weddings and other ceremonies. Her achievements included Tour Guide of the Decade, Nevada State Literary Award, American Mothers Association of Nevada, National Music Teachers Association, co-chair of Nevada Women's History Project, American School of Japanese Arts, Women of Achievement finalist in arts, Golden Gleaner Award, Old Spanish Trail Association, National League of Penwomen, American Society Dowsers, Friends of Red Rock, UNLV instructor, and 631 Teamster.

Char brought to her audiences a profound knowledge of regional history and human nature. Acting in all things with an overview of wide experience and keen vision, she was an active participant in the process of living and giving of oneself.

—*Denise Gerdes*

Jean D'Agostino

Jean Porter Somerville McGuire D'Agostino of Las Vegas was a free-spirited, kind, generous, uniquely creative individual with talents for fine arts, sculpture, and textile design. She was a role model and pioneer among women.

Jean's early years were dedicated to raising her family and commercial arts. She founded Matisse Fabrics with Rosanne Slavin, the first female owned and operated textile-converting company located in the heart of the New York City fabric district. She received the prestigious Textile Designer of the Year Award bestowed at the Lincoln Center of the Arts in New York City.

In 1982 Jean moved to Las Vegas and was passionately dedicated to the development of fine arts in the area. She worked with the city government to promote and support the arts.

She was a member of the Desert Sculptors Association, a Las Vegas organization formed in 1986. The group's main intent was to promote sculpture by creating an atmosphere where sculptors could gather, share thoughts, and develop a common fellowship with sculpting as the central focus. With Jean and Bill Joanitis providing the leadership, the group established the first outdoor sculpture garden in Southern Nevada. The sculpture garden was named the Reflection Center and received the Nevada Governors Award for its contribution to the local community. The first Annual Sculpture show was held in the Reflections Center in September of 1995, with the exhibit earning the Desert Sculptors Group the Beyond the Neon Certificate of Appreciation from the City of Las Vegas. This organization has been in operation for thirty-two years, which makes it older than other nonprofits in the state.

Jean helped develop The Arts Factory located on Charleston Boulevard, which houses the galleries of painters and graphic designers, photographers, and architects, in addition to a bistro and retail shop.

She also participated in the development of the First Friday event of every month in Downtown Las Vegas. The First Friday Foundation works with community-minded organizations across the Las Vegas valley, including schools, youth groups, senior centers, ethnic and faith-based organizations, and other nonprofits. They

NOVEMBER 13, 1923 —
FEBRUARY 24, 2015

celebrate diversity and engage people around one core central theme—creativity! The mission of the organization is to seek, discover, inspire, and explore creativity in all its forms, and to ignite the creative spirit that exists within. Their stated public purpose is to provide long-lasting, community-wide cooperative effort between the private sector, public sector, and government to create, facilitate, and manage artistic endeavors in all mediums, to the betterment and enrichment of society—in particular, to low income and disenfranchised communities.

People come from wide and far to see fine art, hear local bands, and eat from some of Las Vegas' best food trucks. Today, the Arts Factory is the lynchpin for First Friday events, with as many as 10,000 people stepping inside the vibrant collective to see gallery exhibits on the first Friday evening of every month. Next door, Art Square has even more galleries, eclectic shops, experimental theater space, and an arty bar.

Jean was noted as one of the 100 Most Influential Women in Las Vegas. She served as an inspiration and mentor to women and artists. In 2005 an extensive project—100 Years of Influence, the Role of Women in Shaping the First Hundred Years of Las Vegas—was exhibited at the Las Vegas Art Museum (March 15–May 22, 2006), components at the Sprint Corporate Atrium (May 23–September) and at various libraries in the area (through Jan. 12, 2007). This exhibit consisted of three video kiosks, twenty-three women's organization graphic histories, The Wall of Women (256 women), the Women of Diversity Triad Tower (a six-foot architectural ceramics art sculpture) and a juried art exhibition, entitled Essential Dimensions. Women of Diversity is dedicated to the achievement of equality and respect for women and ensuring that women live on as role models for everyone all over the world.

Jean D'Agostino was a loving mother, grandmother, and great-grandmother. The countless people whose paths she crossed will fondly remember her. They will always celebrate her wonderful life and adventurous spirit. Her contributions to the Las Vegas arts community will leave a lasting legacy in Las Vegas.

—Denise Gerdes

Mary Dann

Mary was reared on a ranch in Crescent Valley, Nevada, along with six siblings. Like her ancestors, she gathered herbs and pine nuts, fished and hunted, tended a garden, and herded cattle.

In the 1930s, Mary and her sister Carrie purchased and managed the 500-acre ranch acquired by their father, Dewey Dann, through homesteading and purchases from the railroad. They also grazed their cattle and horses on surrounding federal acreage for which others had paid grazing fees and they had not. This practice eventually led to a confrontation with the federal government. The encounter was directly related to events that date back to the 1960s when the federal government was planning the transcontinental railroad. Western Shoshone bands had been attacking travelers on the Humboldt and Overland Trail and the government wanted to be assured of peace along the route.

On October 1st, 1863, the US made the peace Treaty of Ruby Valley with the Western Shoshone, which was to allow US citizens safe passage through their territory and permit mining for gold on their land. It defined their territory as what is now a large portion of Nevada and four other states, as well as the underlying mineral rights, and said the Shoshone "would never have to give up their land." Unfortunately, this was not to be the case. Under the agreement the federal government would pay the Shoshone for their loss of food supply because of the infringement of their land. (In 1985 the Supreme Court ruled that the Treaty gave 'use,' not ownership to the Shoshone.)

JANUARY 2, 1923 —
APRIL 22, 2005

For more than three decades Mary and Carrie were in the forefront of efforts to reclaim the large tract of land that comprised the original Western Shoshone property. The sisters conducted civil protest by ranching and refusing to pay grazing fees to the BLM on land that was formerly Shoshone land.

In 1973 the fight became close to home and personal for the Dann family. One day, Mary was out herding cattle on horseback when she was stopped by a federal agent who said the animals were trespassing.

"I told him he was wrong," she told The *Times* in 1985. "The land was ours because the Western Shoshone have been here since time began." The sisters were sued for trespassing. The Western Shoshone Defense Project, which was organized a few years earlier to work on the land dispute, joined the Danns' cause.

A standoff occurred in 1992, when heavily armed agents from the BLM moved in to round up 250 of the Danns' horses. Mary and her Dann siblings and tribal supporters fought as best they could during a six-day crisis that saw Clifford Dann douse himself with gasoline and threaten to light it if the BLM persisted. The beginning of the end for any justice came in 2002, when the BLM seized 277 head of cattle from the Danns' herd. In 2003 the BLM, which claimed jurisdiction over the same range, charged that the Danns owed $3 million in fees and penalties.

Over the years, the US acquired much of the Western Shoshone land, largely by congressional legislation. Most of the land is now publicly held

by federal agencies such as the Bureau of Land Management (BLM) in the Department of Interior and the Department of Energy (DOE).

Mary died in an-all-terrain vehicle accident while fixing fence on her Crescent Valley, Nevada ranch. She was eighty-two-years-old, a mother and grandmother, and an active rancher who still kept and herded cattle and horses. She was considered a highly knowledgeable traditionalist who had lived on the land all her life. A woman of deep commitment to the justice of her case for the sovereignty of Western Shoshone land, she died, as her niece Patricia Paul stated, "as she would have wanted—with her boots on and hay in her pocket!"

According to Mary's cousin Mary Gibson, the Shoshone language was spoken daily in Mary's home, mostly when stories were told as a means of teaching a lesson. She added, "Mary would give sound advice. She was kind and gentle. Everyone leaned on her even though she didn't say very much."

About the passing of her beloved sister, Carrie Dann, as always, provided the strongest, most appropriate words:

"You must remember she [Mary] came from the earth and she is returning back to the arms of her mother, the earth. She has completed the cycle. This Earth Mother will cradle her forever.

The wind will carry her body in all four directions. Those of us remaining here in the physical world ... must be strong—stronger now for those who have passed ahead of us and those who are yet to come. Mary believed in living her life for the protection of her family, the life-the sacred [the land, air, water, and sun] and for the future generations."

"We must remember that Mary stood proud, strong, dignified [and] respectful against all types of racial discrimination, [and the] desecration of her spiritual ways by the [Bureau of Land Management and] Department of Interior ... She stood up against the mining industry, the nuclear industry, the energy industry."

"Mary never took 'no' for an answer but she stood her ground for what she believed in and for the Truth. Not because she wanted to, but because she had to. I will continue to do this, even with my sister gone. I believe in these things also."

Carrie told *Associated Press* reporters that Mary's death would not mean the death of their long crusade. "This was Mary's life work," she said. "As far as we are concerned we will live up to our spiritual beliefs and nothing will change that. Mary believed that and lived by it and so do I."

—*Denise Gerdes*

Helen Maxine Joy Daseler

Helen was born in Denver to Hollis and Lenore Joy. She attended University High School in Los Angeles, and was a graduate of George Washington University, but earned her degree from University of California Santa Barbara as a physical education major.

After graduation, she married Jack E. Daseler, who was a pilot in the Lighter-Than-Air Program with the U.S. Navy, flying blimps along the Pacific Coast during World War II. After the war ended, they relocated to Europe, where Jack worked with the military dependents school system as a teaching principal. All three of her sons, Neil, Jack, and Frank, were born overseas; Neil in Landstuhl, Germany, Jack in Izmir, Turkey and Frank in Ankara, Turkey.

Helen's life in Europe fostered her love of travel and the family took every weekend opportunity to explore various countries. Jack and Helen continued their travels throughout their lives together seeing countries around the globe. Of the top one hundred places to visit listed by *National Geographic*, they had been to ninety-seven of them!

In 1961, after ten years in Europe, Helen and Jack decided to move back to the United States and start a private school. After much thought and research, they finally ended up in Las Vegas. At the time the population numbered 60,000, without a private school to be found anywhere in the entire state of Nevada. The school was the first non-sectarian, non-denominational private school in Nevada.

The school started with twenty-seven students in a rented facility and functioned as a one-room schoolhouse for the first year. The next year construction of a permanent facility began on five acres of land located at Jones Boulevard and Desert Inn Road. Desert Inn Road was then a dirt road and the area was so undeveloped that there was literally nothing within miles of the school.

In 2001 the school started the first phase of its completely new campus master plan on five acres of land directly behind the original school. The new school was built off from Red Rock Street with the original facility finally demolished in June of 2009. Today the campus comprises 135,000 square feet on seventeen acres with an enrollment of 800 students and a faculty and staff of 150. The school remains a family enterprise with all three of Helen's sons involved, each with his own area of expertise. Son Neil is the director and Jack and Frank are assistant directors. The school today is educating numerous second-generation children whose parents attended the school.

As cofounder of the school Helen helped take

JULY 9, 1929 —
OCTOBER 6, 2012

Las Vegas Day School from its humble beginning of twenty-nine students in a rented church building to what it is today.

According to her son Neil, "In the early days she wrote the paychecks, paid the bills, hired teachers, and even drove an occasional school bus. There will never be a question of her total involvement and dedication to the success of the school."

Helen's life at school, however, was always focused on her kindergarten children. "Those adorable fiveyearolds were her pride and joy," said Neil. "None of us have ever spent any time with Mom without the conversation turning to something wonderful that one of her kids did that day. Her favorite quote was, "Everything you ever learned, you learned in kindergarten." He added, "Life in Helen's kindergarten is something that no one will ever be able to top. Who else could sit calmly reading with a child while a group of boys noisily built a play structure with life-sized wood blocks and actual boards that would rival a construction project?"

Helen's other true love was following the Running Rebels. "She was a devoted fan beginning with the games in the Convention Center and moving on to the Thomas and Mack. She took great pride in her support of the UNLV Foundation and that she and her husband were some of the original supporters of the school championship games." In her later years she never missed a game on television and loved talking basketball with her grandsons, her son said.

Helen taught kindergarten at Las Vegas Day School for thirty-nine years, retiring at age seventy, and was a part of the education of numerous community leaders in Las Vegas, as well as many of their children. In adding up all her years of teaching, she personally touched the lives of over 900 children.

Helen was also a proud member of First Presbyterian Church, PEO Sisterhood, Alpha Delta Kappa, and was a past president of the Pi Beta Phi Alumni Association.

As a wife, mother, grandmother, great-grandmother, and dearly loved kindergarten teacher, Helen Maxine Joy Daseler lived a full and complete life filled with love, adventure, and satisfaction. She passed away peacefully, finally succumbing to Alzheimer's disease at eighty-three-years-old.

—*Yvonne Kelly*

Niki Devine

Niki Aschwald Gale Devine Zindler Devine—Las Vegas socialite—exemplifies life in Las Vegas during the earlier years. She was larger than life and had more fun in her lifetime than most people have in a number of lifetimes. She was married four times and was a world traveler, an avid golfer, and a model during her career.

She was born Niki Silver in Montreal to Russian immigrants Hyman and Mania Silver. Niki immigrated to New York City with her family at age seven, after the United States eased restrictions on Eastern European Jews migrating into the country.

Her father was a jewelry store owner in New York. Hyman later was dubbed 'the jeweler to the stars' at his Roney Place Hotel store in Miami Beach. As a result, Niki grew up in the lap of the Big Apple's and South Beach's high society.

Shortly after graduating from high school, Devine married Howard Aschwald; together they had a daughter.

JUNE 17, 1927 — SEPTEMBER 2014

After that short marriage, Devine married Florida and Texas bookie Louis Gale, and they had three sons. They moved from Houston to Las Vegas in the mid-1970s where he became an executive for the original MGM Grand (now Bally's); his job was to bring in high rollers from Miami and Houston on gambling junkets.

Devine's third marriage was to Irving 'Niggy' Devine, a longtime strong-armed associate and courier for mob boss Meyer Lansky. When she met Devine, he was the owner of New York Meats and Provisions, which had the lucrative contract to provide quality meat to downtown and Strip hotel restaurants.

After her husband's death, Devine, a world traveler, was in Houston in 2000 when she met and soon after married veteran television newsman Marvin Zindler, whose 1973 reports on the Chicken Ranch brothel in Fayette County led to it being shut down by authorities. Zindler's coverage also inspired the Broadway play and movie musical, *The Best Little Whorehouse in Texas*.

Zindler and Devine and their bichon frise, Magic, shared Zindler's longtime home in Houston until his death in 2007. Soon after, his widow retook the last name Devine and moved back to Las Vegas.

Standing only about 5-foot-5, Niki began a modeling career in the late 1940s, where she displayed the latest high fashion clothing at runway shows and posed for bathing-suit photos. She was signed by the Harry Conover Model Agency in New York but gave up the profession in the 1950s to start and raise a family.

As a scratch golfer, Devine also was a longtime member of the Las Vegas Country Club. In 1961, she was ladies club champion at a Houston country club. A longtime amateur golfer, she won women's tournaments in Las Vegas, Texas, and California.

"Niki for many years was a fixture on the Las Vegas social scene," said daughter-in-law Janie Greenspun Gale, daughter of late *Las Vegas Sun* publishers Hank and Barbara Greenspun. "She prided herself on marrying colorful men. Niki was beautiful, charming, intelligent, and funny. She certainly loved to have fun, but she also was a no-nonsense type of person who took no guff from anyone."

Devine was a member of Congregation Ner Tamid and Temple Beth Sholom in Las Vegas. She had a second home in Indian Wells, California, where she was a member of the Desert Horizons Country Club.

The cause of death, her family said, was complications from Alzheimer's disease, which she had battled since 2009.

—*Denise Gerdes*

Doree Dickerson

*D*oree Dickerson is a model of selflessness and commitment to the improvement to all who crossed her path and the community where she resided. She received many awards and acclamations recognizing these qualities.

Doree was born in Winnemucca to Paul and Freda Maloney, the younger of two children, with an older sister, Pauline (Kidwell).

She graduated from the University of Nevada, Reno in 1949 with a degree in elementary education. She met the love of her life October 3, 1948, in San Francisco when the University of Nevada, Reno football team played the University of San Francisco. It was love at first sight and they were inseparable since then.

Doree and George Dickerson were married June 12, 1949 in Reno and moved to Las Vegas that same year. George took a position as Deputy District Attorney of Clark County and Doree became a kindergarten teacher at John S. Park Elementary School.

JULY 16, 1927 – MARCH 6, 2019

Doree recognized all that she had been given in life and spent her nine decades of life looking to give back. She was deeply involved in the Junior League of Las Vegas, an organization she joined in 1953, and spent four decades collecting toys, clothing, and food for families in need around the holidays. Described as a 'dynamo' by those who knew her best, Doree would dress up as Santa Claus every year to deliver the bounty of toys she had gathered to over 400 children a year.

Doree won numerous awards for her work helping people, including the KVBC 3 Spirit Award and the Junior League's Volunteer of the Year Award, which recognizes women committed to promoting voluntarism, developing the potential of women, and improving the community through the effective action and leadership of trained volunteers.

She was recognized as the Nevada Mother of the Year in 1986; no honor made her prouder. To receive the Mother of the Year award, one must be the mother of one or more children. She should embody those traits highly regarded

in mothers and display the ability to strengthen family relationships. She should exemplify in her life and conduct the precepts of the Golden Rule and the power of a mother's inner strength to deal with the successes and challenges in life. She should also exhibit an interest in her community by participation in programs and services that enrich mothers, children and/or families.

Doree went on to compete in the National Mother of the Year and was First Runner-Up, the first and only time a Nevada mother finished that high. Doree spent her life, whether it was tutoring children with special needs, working as a Girl Scout Leader, or being the mother advisor to Rainbow Girls, focused on educating, inspiring, and improving the lives of children.

Known as everyone's favorite grandma by her grandchildren's friends, Doree was the consummate nurturer, caretaker, and children's advocate.

Her crowning achievement in life was the loving family she built with George Dickerson, her husband of seventy years, who passed away nineteen days before her. Their life was an epic love story until their final days, their marriage one of ceaseless adoration, constant respect and undying partnership. What one of them achieved, the other achieved.

Doree Dickerson, an eternally spirited wife, mother, grandmother, and great-grandmother, a woman who could brighten any room she walked into and win over anyone with her welcoming personality, passed away at the age of ninety-one.
—*Denise Gerdes*

Minnie Dobbins

Minnie Dobbins was an artist. She once wrote about her art, "It was my farm background, and the undisciplined humor of my unruly family that are reflected in my work. I paint gratefully, overjoyed that I may share what I feel."

Minnie L. Dobbins was born Minnie Belle Larson in Blue Earth, Minnesota to Pearl and Oscar Larson. Her brothers were Mickey, Morris, Jim, Joseph, and Jerry. She met and married Joseph Dobbins and had three children: Joe, Sue and Timothy.

During her life, Minnie loved raising her children, playing the piano, and giving piano lessons to the neighborhood children. She served as PTA president and as a Boy Scout den mother and Girl Scout leader while raising her family. She had many interests in life, including gardening, camping, hiking, sewing, cooking, reading nonfiction, journaling, traveling, and playing bridge and Scrabble. And of course her passion, painting for endless hours in her studio.

JUNE 11, 1933 —
JUNE 22, 2018

Her other passions were teaching art at the Clark County School District and the Community College of Southern Nevada. She also worked as an art critic for the *Las Vegas Sun*, where she had her own column.

Minnie received her Bachelor of Fine Arts degree from the University of Nevada, Las Vegas in 1975. It was there that her professors realized her natural talents. Minnie flourished as a student. She exhibited her work at a show at the Harris Knudson Memorial Exhibition at the UNLV Museum of Natural History in November 1987 and at the UNLV Marjorie Barrick Museum of Art in September 2017. In February, 1991, Minnie exhibited in an art gallery exhibition "Under the Influence"; the next exhibition at UNLV's Jessie Metcalf Gallery featured the work of eleven women artists, with several of the artists who were teaching or had taught in the University of Nevada System, or were graduates or current graduate students of the university. Real or fictional heroines inspired their works. This was

the second exhibition for this group of women artists who were collectively known as 'eleven.' They were an association of women who jointly exhibited in recognition of Women's Studies Month and the Women's Studies Conference held on the UNLV campus. Minnie participated in many other art shows at UNLV, too numerous to mention.

Aside from the many shows at UNLV, Minnie was an award-winning mixed media specialist who had exhibits throughout Nevada in solo and group shows since 1982. She was nationally represented in numerous collections commissioned by General Motors, Detroit; Colorado Bank Shares and South Denver National Bank, Denver; Las Poloma Resort Hotel, Tucson; the International Athletic Club, Kansas City; Doubletree Hotel, San Francisco; Del Lago

Conference Center, Montgomery, Texas; and in Las Vegas at the Rio Hotel, Quirk & Tratos Law Firm, Golden Nugget Hotel & Casino, Stardust Hotel & Casino, Summerlin TPC Golf Course, and by art collector Steve Wynn. In 1994, her work was featured in a one-person show at the Nevada Museum of Art in Reno.

Minnie Dobbins passed away at the age of eighty-five. She was an exceptional woman of many artistic talents, and was well loved by those in her circle. She was a beloved daughter, sister, wife, mother, aunt, Gan-Gan, and friend.

Her art is a testimony to her artistic abilities, and can be viewed in many places in Nevada and around the country. Although she was an extraordinary person, she simply stated, "I came, I saw, I went."

—*Denise Gerdes*

Verlie Doing

*V*erlie Doing was certainly the backbone and founder of Searchlight, Nevada. Although she would never have admitted it, she was the smiling matron of the town, with her family and friends surrounding her with love and admiration. According to Verlie, Searchlight was a great town, with the best fishing on the Colorado River, wonderful trails and mountains, and a gold mine to boot!

She was born in Amarillo, Texas to Harvey and Mattie Gentry. She grew up in Amarillo, moving to Gallup, New Mexico in 1944 to work at the El Rancho Hotel. She met Warren Doing there, who ran the casino until 1947.

When the casino in the hotel closed, Verlie and Warren moved to Phoenix to work in a casino. They were married there on December 31, 1948. Their son, Riley, was born there. When the casino in Phoenix closed, the family moved to Beatty, where they bought and ran a casino for six years. They then moved to Las Vegas where Warren went to work for Bill Boyd at the Golden Nugget Casino.

FEBRUARY 29, 1924 — JANUARY 19, 2016

During this time, Warren and Verlie drove out to Searchlight where they owned a mining claim. They bought Sandy's Club in Searchlight and moved there, living in a trailer. They bought property on the highway going through Searchlight and had an architect draw up plans for a casino, which was opened on Labor Day 1979.

The Searchlight Nugget Casino prospered because of the highway visitors, and became famous for its ten-cent coffee. The family lived on the top floor of the casino, and the casino was the hub of the town. They employed sixty–seventy employees and were very active in the town. The Golden Nugget could find a job for locals whenever it was necessary. Her husband had about 240 horses and about ten acres with corrals, so he also employed people to work with the horses.

Warren and Verlie were very civic minded. They donated the land and building for the area senior citizens. The Las Vegas-Clark County Library District opened a small library within the center as well. Many peo-

ple moved to Searchlight from California to retire and these people were active in the community activity center and used the library.

Verlie was appointed to the original Parks and Recreation Commission and the Searchlight Community Center Planning and Development Committee, served on the first Searchlight Volunteer Ambulance Crew, was a founding member of the Searchlight Museum Guild, and served on the board of the Searchlight Community Church where she played the organ. These many civic activities garnered many accolades and awards, including U.S. Senate and U.S. Congressional recognition and numerous state and county proclamations. During the Searchlight Centennial Celebration, Verlie was named the 'Searchlight Citizen of the Century.' Verlie was included in the U.S. Congressional Record by her friend of many years, U.S. Senator Harry Reid.

In 1969, the legislature passed a bill requiring every town to have a town board, so Verlie served as the chairperson, continuing in that position for forty-three years. During this time, Verlie hired local attorney Lief Reid to get clear title for the people with claims in the area. She also negotiated for a sewer, electricity, and a water tank for the town.

When Warren died in 1984, Verlie hung a portrait of her cowboy husband in the lobby of the casino and went back to work, saving the business and paying off the mortgage early. She ran the casino with her son and grandson, Reggie, until it was sold to JETT Gaming in 2015.

Verlie passed away at the age of ninety-one.

—*Denise Gerdes*

Linnea Miller Domz

When the twins were born at home in Chicago, Illinois, the father admired his handsome son, then held his new little daughter and said, "She will grow into a beautiful Linnea" (the unofficial national flower of his native Sweden, also known as Twin flower).

Her given name was Sigrid Linnea Christine Johnson and her twin brother's name was Sigrud Johnson. Parents Ephram and Caroline Johnson had six children: Harold, Florence, twins Sigrud and Linnea, Violet, and Willard. Father dreamed of having a dairy farm and as a toddler Linnea and the family moved to their new farm in Mason, Wisconsin. Although her parents immediately learned English after coming to the United States, and were proud to be Americans, Linnea was able to speak Swedish at home as well.

Linnea once shared a photo with us of her siblings and friends in front of their school transportation—a horse-drawn covered wagon with a stove inside to keep them warm in the frosty winter!

After high school, Linnea went to nurses' training and earned an RN degree from Ashland General Hospital. With a true pioneer spirit, she answered an ad for a nurse in California. Within nine days, she moved across the country and started her new job at California Lutheran Hospital. It was there that she met a patient—Abe Miller.

Abe and Linnea were reacquainted after his second hospital stay. They were married and moved to Las Vegas. They had three children: Paul, Carolyn, and Marilyn. In downtown Las Vegas, they owned and operated the Sal Sagev (Las Vegas backwards) Hotel on Fremont St. In 1931 the casino on the 1st floor reopened when gambling was legalized again in Nevada. Later in 1955 it was renamed the Golden Gate Casino. Their home was on several acres on Pinto Lane off Rancho Drive and Charleston. Linnea always loved flowers and gardening and was fortunate to have naturally wet soil to work with.

Linnea saw a notice that there was going to be a flower show in Las Vegas. She thought, "I should enter that flower show." She took some wild flowers from her yard and put them in a pretty little teacup and won an Honorable Mention ribbon. That is how it all began and she went on to win many sweepstakes awards.

While visiting a friend in Arizona, she spotted and read *The National Gardener* cover to cover. After discussing the benefits of being a member of National Garden Clubs, she realized Nevada was missing out. She worked tirelessly and the Nevada Garden Clubs

MAY 5, 1913 –
JULY 18, 2018

were federated with National in 1963. She was the first president of Nevada Garden Clubs for the term 1963–1965.

While visiting in Arizona, she bravely attended a National Garden Club sanctioned flower show school course IV and passed. She went on to become a flower show judge, which involved several schools, tests, and refresher symposiums and was an active judge until she went Emeritus in 2012 at ninety-nine-years-old.

Linnea had a passion for sharing her knowledge and encouraging others. She became an instructor for National Garden Clubs and served almost twenty years. She instructed in Japan, Guatemala, Peru, and twenty states in the USA. Linnea's flower arrangements have been featured in the National Garden Clubs official Vision of Beauty yearly calendar book many times, including on the cover three times. In 1982, Linnea was given the National Best Designer award. She also served on the National Board for National Garden Clubs for over twenty-seven years.

In 1970, after many meetings with the local politicians and City Council, Linnea and her husband Abe were able to build the Nevada Garden Club Center in the northwest part of Lorenzi Park and donate it to the City of Las Vegas. The building is still in use for garden club meetings, flower shows, state conventions, workshops, symposiums, schools, and plant sales.

Linnea had been a part of the Rose Garden Club since 1950. They built a Touch and Smell Garden for the blind. In June of 2018, at what was to be her last NV Garden Club Annual Spring Meeting, Linnea, along with the local city councilman, rededicated the Touch and Smell Garden.

Linnea's children told of their mother's stories about growing up and family in Wisconsin, and about Linnea and her sisters Violet and Florence, with their beautiful voices, singing on the radio. Linnea was very active in her church and choir all her life.

After the death of her husband Abe Miller in 1982, she married Dr. Casey Domz, a respected family friend and physician. Linnea continued her participation in her local garden clubs—Rose Garden Club, Grower's Study Guild, and Las Vegas Flower Arrangers' Guild. Her guidance, love of all God's creations, and heart inspired all who knew her.

Linnea Miller Domz will always be remembered by the Las Vegas Gardening Community, the national gardeners and arrangers whose lives she touched and her loyal friends and family for her intelligence, grace, generosity, and loving spirit.

Thank you, Linnea, from the bottoms of our hearts!

—Judy Stebbins

Thalia Marie Sperry Dondero

Thalia Marie Sperry Dondero was born in Greeley, Colorado. Her family moved to Laramie, Wyoming and then to Bakersfield, California, though her father, a taxidermist and a teacher, did not travel with the family to Bakersfield. Her mother, now single, worked in a local dry cleaner as the first woman boiler operator and eventually also played the violin for various groups.

Thalia attended Bakersfield High School and a local community college. She was an artist and made jewelry, creating a ring that took first place at the California State Fair. She moved to Las Vegas in 1942 to take a job at Basic Magnesium and was living in a rooming house on 7th street when she met her husband, Harvey Dondero, who had just returned from serving in the Army. He was a teacher at Las Vegas High School from 1932 until 1940 when he left for the war. They moved to the state capitol, Carson City, from 1946–1948 while her husband worked for the US Office of Education and then returned to Las Vegas in 1948.

Upon returning, the couple bought a little house on 17th street off of Charleston Boulevard.

JANUARY 23, 1920 – SEPTEMBER 4, 2016

Thalia first got involved with public education at the Mayfair Elementary School. She became active in the Parent-Teacher Association, and became friends with Maude Frazier, superintendent of schools. Maude mentored her as they drove back and forth to meetings. It was this encouragement that later prompted Thalia to seek office.

Thalia did not limit her activity to the schools. She was active in the Service League and was the director of the Frontier Girl Scouts. She participated with the Girl Scouts from 1960–1970, first as a scout leader and then as president of the Girl Scouts. They revamped the Girl Scout camp and had to hire a camp nurse, director, and counselor. They discovered they needed housing for the caretaker to live in. They approached the core of engineers asked them to build a house; they bought the lumber and the house was built and is still standing up in Lee Canyon. It was the first camp for those with learning disabilities and other minority groups.

In 1972, Thalia made her first run for public office, the Nevada State Assembly, but was defeated. She did not allow this defeat to stop her and ran for the Clark

County Commission two years later. She was elected the first woman commissioner in 1974 and served on the Clark County Commission for twenty years. Thalia's two top priorities at that time were the Las Vegas Airport and the Waste Water Treatment Center. Both were very important issues.

Thalia served on the Las Vegas Water Authority Advisory Committee. She believed that water is a critical issue for everyone in Nevada and for the future of Nevada. She thought the quality of water should be studied to improve and maintain a clean water resource in Las Vegas.

During her time on the commission, she served as chair three times. Thalia made the news when she refused to act as secretary to the male members of the commission. She was defeated in the election of 1994. Her service on the Clark County Commission helped open doors for other women to serve without facing the same kind of discrimination she originally faced.

She was appointed to the Nevada State Parks Commission. Many of the parks in the state today were planned during her time on the com-

mission, including the Valley of Fire, Red Rock Conservation Area, and the Spring Mountain State Park.

Her public service continued in 1996 when she was elected to the Nevada System of Higher Education Board of Regents. As a regent, she worked to improve higher education in the state. She served on the Community College of Southern Nevada Organizational Committee and the Chancellor and Presidential Search Committees.

Thalia also served on the Ice Age Park Development Committee and visited local elementary schools educating the children about fossils. She believed it is important to preserve these fossils and educate people in the area perhaps with a museum in the Ice Age Park. Thalia also served on the Nevada State Museum Committee and the Gilcrease Nature Sanctuary.

Thalia made important contributions to the Las Vegas community over the last fifty years. Her dedication to public service was to improve the overall quality of life in Southern Nevada.

—*Denise Gerdes*

Jeanne Crawford Duarte

Jeanne Crawford Duarte was born in Cripple Creek, Colorado, the daughter of John Crawford, a long line muleskinner, and Mina Lucha Crawford. Her parents moved to Nevada in March 1912, when she was thirteen-months-old, first to National, living in a tent house and then settling in Winnemucca in 1915.

Jeanne showed her independence at an early age. One time her father gave her money to purchase a sewing machine, a highly prized item since most clothes were hand-sewn at the time. When the delivery persons showed up at the house and unloaded a piano, her father said that was the largest sewing machine he had ever seen. He sent her back, this time with explicit instructions to get a machine that sewed fabric. She became a good pianist and played that piano all her life. The piano long outlasted the sewing machine.

When Jeanne was in her freshman year of high school, she was hospitalized with a ruptured appendix. After her recuperation, she realized she had lost half a year's credits. Since most students at the time quit after the eighth grade, she quit, too, and went to work for the local Eagle Drug Store, which paid her $1.00 a day as a soda jerk. She also worked to help her mother at home. She eventually took a second job at Reinhart's Department Store, working in the office during the week and at Eagle Drug Store on the weekends. It was at Reinhart's Department Store that she learned bookkeeping, a skill that would support her for the rest of her life. Years after her sons grew up and started their own lives, she went back to school at night and received her high school diploma in 1955.

Jeanne married John R. Duarte and they had two sons, Roger and John. They divorced after the younger child was born. Jeanne often worked two jobs to support her family.

She successfully campaigned for the Humboldt County Treasurer position and began serving in 1943. She never lost an election, even when she ran as an independent against men from the two main political parties. She lobbied to have her clerk paid by public funding as all prior clerks were paid with the treasurer's personal funds. She also successfully worked for equal pay for her own position, as she was paid $6000 annually compared to the male county officer's salary of $10,000. It took two legislative sessions with the help of Senator A.V. Tallman to get it passed. The position's responsibilities included holding a comparable position with the City of Winnemucca and fulfilling those responsibilities.

Grant L. Robinson appointed her as the Assistant Superintendent of State Banks for the state of Nevada in 1962. She was the first woman to be hired in the division's auditing department. Robinson publicly justified his appointment stating that her experience and knowledge met the job's requirements. She moved to Carson City for this position and resided there until she retired in 1971,

FEBRUARY 6, 1911 —
OCTOBER, 1996

when she returned to Winnemucca. She traveled to all seventeen counties three times a year in the course of her responsibilities.

Her work extended to other facets of her professional life. She was elected president of the Nevada Fiscal Officers' Association in 1949. They were dedicated to the exchange of ideas and the study of legislation for the improvement of all county records. In addition, she was elected in 1962 as vice-chairman of the Public Employees Retirement Board.

Jeanne became a businesswoman when she took over the Orchid Flower Shop in Winnemucca. She owned the shop and had an onsite manager as she was still employed as the county treasurer. They offered potted plants, cut flowers, funeral pieces, and corsages. In addition, at one time, she co-owned a hobby store that was open only on weekends.

She was a charter member of the Winnemucca Toastmistress Club and spoke on issues ranging from chinaware, art appreciation, and hobbies to "Why Should Every Citizen Be Interested in Civil Defense?" and "The Origin of Flags."

Jeanne believed in contributing to her community and was fiercely in support of women's rights. She was a Worthy Matron for chapter 6, Silver State Order of the Eastern Star. She was a charter member of the Winnemucca chapter of Business and Professional Women's Association and was elected to Nevada State President of the Nevada Federation of Business and Professional Women's Clubs in 1955. She continued to be an active member throughout her life and served as a role model for younger women.

She was always willing to have fun, especially if it was for a good cause. She became an amateur actress in 1952 when she was one of a three-person lead in the comedy "Suds in Your Eye," a play by the Community Players with proceeds going to the high school PTA.

Jeanne's attention to detail made her an excellent craftswoman and she was often awarded blue ribbons in the county fair. Her skills and talents included quilting, knitting, crochet, sewing, lace making, crewel, embroidery, felting, leather art, and more. Local women would try to discover what she was working on each year so they could make things in other categories in order to give them a chance of winning. She passed on her knowledge and skills to anyone who was willing to learn. She was the 4-H district director of Pershing, Humboldt, and Lander counties for the 'Make It With Wool,' a felting contest for young women.

Jeanne died in Reno, Nevada. She had lived to see her sons become successful in their fields, see her grandsons grow and develop into young men, and see that her work in women's issues benefit her granddaughter, who carried the torch for feminism as she rose in the ranks of Business and Professional Women's Clubs and other women's organizations.

—*Denise R. Duarte*

Flora Dungan

Flora Dungan was an influential woman in Las Vegas who brought a successful lawsuit forcing Nevada to reapportion its legislature and the governing board of its university system, giving Southern Nevada equal representation in state government. As a social worker, accountant, university regent and state legislator, Flora Dungan excelled in all of her positions.

Flora Turchinsky was born in Minnesota to immigrant parents from Russia. She graduated from Polytechnic High School in Los Angeles in 1933 and from Los Angeles Junior College in 1936. In 1938 she received a bachelor's degree in psychology from the University of California, Berkeley.

Upon obtaining her degree, she worked in legal research and worked to improve child welfare. With World War II, Flora found it impossible to continue to work in those fields, so she took an accounting job until the end of the war.

She moved to Las Vegas in 1948, where she worked as a public accountant. After moving there, Flora and her husband, L. Donald Dungan, divorced. Although Flora remarried three times, she retained the Dungan last name. Flora continued to work as a public accountant and soon became active in Clark County, joining many local organizations.

Flora became a member of the Las Vegas League of Women Voters, the American Association of University Women, Zonta, a women's service club, and the Nevada Society of Public Accountants and various other professional clubs. She also became active in the Clark County Democratic Party, serving on both the county and state central committees. Flora's involvement with the Democratic Party laid the groundwork for her tenure in the Nevada Legislature.

Flora Dungan was elected to the Nevada State Assembly in 1962 as a Democrat. She served during the 1963 regular session and a special session in 1964. At that time, Flora and Dr. Clare Woodbury of Las Vegas filed a lawsuit against the state over its formula for apportionment of legislators, arguing that Clark County sent the same number of representatives to the legislature as the small rural counties.

After the regular legislative session was over in 1965, the case, Dungan vs. Sawyer, went to the Federal District Court and reapportionment was granted. As a result, Clark County gained four seats in the state assembly and seven seats in the state senate.

Flora was reelected to the state assembly in

1917 –

OCTOBER 25, 1973

1967. In that year she sued the state once again, this time for an expansion of the Board of Regents. She was successful and Clark County gained the majority of seats on the Board of Regents.

Flora was the first woman to serve on the Legislative Judiciary Committee, where she was a leader in fighting for prison reform and rehabilitation. As chairman of the Assembly Institutions Committee, she led the way in investigating complaints of inmate abuse at Nevada State Prison. However, she was barred from visiting the prison because she was a woman. She also worked to expand juvenile assistance programs in the courts and to lessen the penalties for possession of marijuana.

Flora ran for the State Senate in 1968 but was defeated in her bid. In 1969 she helped found Focus, a juvenile assistance facility, which achieved national renown.

In 1972 Flora was elected to the University Board of Regents. Shortly after she was diagnosed with cancer. She underwent radiation treatment while continuing to serve as regent.

The Humanities Building at the University of Nevada, Las Vegas campus bears her name, a reminder of Flora's dedication to the area.

The Flora Dungan Humanities Building is the tallest building on campus, containing auditoriums, classrooms, and lecture halls on the first two floors. On the upper five floors, the building houses the offices of the president, provost, and other administrative offices and departments.

The Special Collections & Archives at UNLV have a collection of Flora Dungan photographs, containing photographs of Nevada politician and activist Flora Dungan from 1950 to 1973. Materials include portraits of Dungan, photographs of Dungan at public events, and a photograph of Dungan with the Nevada Board of Regents. Materials also include three photographs of U.S. President John F. Kennedy, U.S. Senator Howard Cannon, and Nevada Senator Alan Bible.

Flora Dungan left a lasting legacy in Southern Nevada and is remembered fondly as a longtime Nevada political activist, legislator, and regent.

—*Denise Gerdes*

Jessie May Emmett

The descriptor 'first' is found frequently in the chronicles of Jessie May Emmett. She owned and managed several businesses, set world records in aviation, and excelled in many political appointments, all while serving her community and innovating programs to help working women.

Born Jessie May Wallace in Fresno, California, she developed her strong work ethic early in life. "I started working when I was thirteen-years-old. I'd get up at three in the morning and shag milk. My dad had a dairy, and my sister and I used to deliver milk. We used to make fun that we were abused. But that was good for us. People in our generation were used to working," Jessie related in an interview with *Home Scene*.

The family moved to Redondo Beach where Jessie attended Redondo Union High School. Her parents started Sandy's Malt Shop near the Pacific Coast Highway and Jessie spent time working behind the counter where she met the love of her life, Robert Emmett. They were married in 1943 and started the Bay City Taxi Company. Jessie worked as their dispatcher and also ran the Malt Shop after her father retired.

Jessie's lifelong passion for community service also started early. She was an active member of the philanthropic group, Diana's, which sponsored the Baptist Orphans Home. Jessie competed on behalf of the orphanage on the *Queen for a Day* television show in

1953, winning fishing poles for the boys as the runner-up.

In 1954 an old army buddy contacted Robert with a job opportunity working at the Nevada Test Site. They made the jump to Las Vegas and Jessie tried to be the typical stay-at-home mom, but her entrepreneurial spirit wouldn't allow it. Her first job in Las Vegas was at the Last Frontier hotel gift shop where she met many of the up-and-coming businessmen of the city.

In 1959 Jessie joined Underwood Realty and got her Nevada realtor's license. She sold real estate out of the trunk of an old white Cadillac so she could quickly run home and fix dinner, but on many evenings she would get a call and have to leave her three young daughters, Patricia, Peggy, and Penny at home with Robert.

Jessie got her broker's license and started her own real estate business in 1962, naming it Jessie Emmett Realty. "What makes Jessie Emmett so interesting is she may be as much a counselor as a salesperson. There is reason to make money, but there is also reason to make others happy. She wants young people to own a home, and she wants the community to support the residents with culture, proper infrastructure, and anything else that is essential to being a happy camper," wrote Mike Henle in an article for *Home Scene*.

In 1972 she was awarded the title of Realtor of the Year and became the first woman to serve

MAY 23, 1923 –
DECEMBER 20, 2005

as president of the Greater Las Vegas Association of Realtors. Jessie was also the first woman to serve on the Real Estate Commission. In 1976 Jessie became the first woman president of the Nevada Association of Realtors and was acknowledged for being an innovator and active force in the Las Vegas community. At the time Jessie reflected, "Through cooperation with the business community and concern for the consumer we can help more first home buyers realize their share of the American dream."

In 1977 the Goodwill Industries Outstanding Women of 77 event honored Jessie with the top award in the business category. By the early 80s, there were three Jessie Emmett Realty offices. She decided to get into the travel agency business and opened two offices called Jessie Emmett Travel Time in 1981. Jessie then started a travel agency school which grew to two locations. She was managing over 200 employees in seven different offices.

When Robert passed in 1983, Jessie decided to cut back and sold or closed her businesses. Jessie's love of travel and her adventurous side came out when she joined Marie McMillan on what they called the Flying Grandma's Odyssey. With McMillan as pilot, they set off in 1984 on a multiple country, island-hopping journey to break aviation records aboard a single-engine Beechcraft Bonanza. The first world record they broke together was for speed between Las Vegas and Fresno, Jessie's birthplace.

After meeting First Lady Nancy Reagan, Jessie was determined to help working women in Las Vegas by starting a child-care after school program. She called on her many friends and fund raised enough to start what grew into the current day Safe Key program.

Jessie, now a PriMerit Bank Public Relations Officer, received the National Jewish Humanitarian Award in 1989. Jessie's many ground-breaking accomplishments as a woman in real estate, as chairwoman of the Governor's Advisory Council for the State Job Training Partnership Act, as co-chairwoman of the committee that raises and administers the program funds for her afterschool program, and her contribution to numerous charity drives were cited.

In 1991 Jessie was approached to enter the Las Vegas Mayoral race. She decided against it but said, "If I would have been mayor, nobody would have owned me."

Jessie was inducted into the Realtor Hall of Fame 1991. In 1998 Jessie was selected to serve on the newly created College of Business Advisory Board at UNLV. In 2001 Jessie served as the vice chairwoman of the Governor's Workforce Investment Board and was integral in the development of the WorkSource Southern Nevada One-Stop facility.

Many honors came her way, including a Jessie Emmett Day proclamation from Governor Mike O'Callaghan. Jessie lived a long, successful life full of firsts.

—*Michele Tombari*

Andrea Engleman

Andrea 'Ande' Engleman, a former newswoman and longtime fixture in Nevada media, was a strong advocate for open government, open records laws, and freedom of the press in the state. She left a legacy in Nevada and will not be forgotten.

Born in Los Angeles to S. Keith and Alice Linden, Ande Engleman described herself in a press association biography as a fourth-generation Californian. Because her father worked in politics, she was raised in both California and Washington, D.C., graduating from Bethesda-Chevy Chase High School in 1958. She earned her bachelor's degree in business administration from the University of Maryland and took her first journalism job in the nation's capital at WTOP, now WUSA.

Returning to the West, she settled in Carson City. She worked in journalism for Reuters, KOLO News, and a political newsletter. From 1984–87 she served under Governor (and later U.S. Senator) Richard Bryan as executive director of the state Occupational Information Coordinating Committee before returning to head the press association in 1987. In 1998, she became public information officer for then-Secretary of State Dean Heller. She later headed her own management consulting and communications firm and consulted for Republican candidates, including Nevada Rep. Mark Amodei.

In 1983, she became manager of the Nevada Press Association office, beginning her immersion in public access issues. She departed the association for a time but came back and expanded the job into an executive director's post.

It was her work for the Nevada Press Association from the mid-1980s to late 1990s where Ande made lasting contributions to the state's media landscape, lobbying the Legislature for improved open meeting and public records laws and greater access to public information. She served as secretary-manager of the group in 1983–84, when the position was part time, and later served as full-time executive director for more than a decade.

She learned the ins and outs of press law intimately, sometimes coaching lawyers on the issues and jumping into frays that did not initially seem like open government disputes but which were later shown to engage public access. Assertive and sometimes abrasive, she seldom conceded anything if the public's access was involved.

She went over legislation with a fine-toothed comb, often spotting problems lawmakers had to fix. In an article for the RN&R in 2005, she wrote of one measure, "There's also a more basic sentence structure

MAY 3, 1940 –
JUNE 12, 2019

problem with the new law—the phrase 'knowing such report to be false' appears, but because of the tortured 57-word sentence in which it is located, it refers to the police instead of a complainant."

In 2013, she was named by Carson City's mayor to head the city's Ethics Ordinance Review Committee to review how the city's ethics ordinances matched up with state ethics law.

"Ande had a unique ability to take complex subjects and make them understandable to the general public," said her colleague Sam Shad. "That was quite a gift."

"She was just amazing," said Don Ham, a retired *Review-Journal* editor and editor of the *Nevada Appeal* in Carson City from 1984–95. "She was extremely aggressive and she knew everybody in the Legislature. She was a very strong lobbyist for open government and freedom of the press, just extremely strong."

Ande Engleman was still working in communications when she took ill. Her work in Nevada media dates to the 1980s, mostly covering politics and the Legislature, including stints for Reuters and TV network affiliates in Reno. She did political analysis for the Nevada NewsMakers show on the Reno station KRNV and also worked for the ABC affiliate in Reno, KOLO, opening a Carson City bureau in 1999. She started in broadcasting at the former WTOP (now WUSA) in Washington, D.C.

In learning she was dying in April, Engleman told a friend in an email, "Have a few months after I start chemo. Hope someone will look out for open government." She warned against 2019 legislation drafted by the state Open Meeting Law Task Force.

In her last weeks, she underwent chemotherapy, but only, she said, to buy herself a little time to put her affairs in order. "Thank goodness it's not dementia! I want a quality of life and that's my choice. Can't keep food down so am getting weaker and weaker. Chemo is just [to] ensure I have a month to get things wrapped up."

"I think she loved Carson City, and she loved Nevada, and she loved its people," said her daughter, Pam Egner, of Arlington, Virginia. "She was very passionate about her community."

Another daughter, Laura Lohmeyer, of Stafford, Virginia, said her mother remarked that her happiest years were spent in Carson City.

Ande died of cancer at her home in Carson City. She was seventy-nine-years-old.

—*Denise Gerdes*

Vicki Satterfield Ewy

Vicki Satterfield Ewy was a distinct individual who was passionate and devoted to her goals. A well-known performer in Las Vegas for many years, from Broadway performances to lounge singing, she displayed her talent at many casinos and venues in Southern Nevada.

Vicki was the beloved daughter of Wilbur and Geraldine Satterfield. She was born in Fairmont, West Virginia.

Vicki and her family moved to Las Vegas from West Virginia in 1961 and graduated from Rancho High in 1967. Soon after she went to work at the Test Site as an office secretary. A year later, she took a position as executive secretary to the president at the Frontier Hotel. After eighteen years, the company was sold and Vicki moved on to accept a position as Human Relations Director at Palm Mortuary. She retired May 7, 1996, when she married Dave.

Vicki kept very busy before and after retirement with her many talents. She was always involved in singing and acting, starting in grade school. As an adult, she was in fifty-six performances of *My Fair Lady*, forty-two performances of *God Spell*, and forty-three performances of *A Streetcar Named Desire*, all at the Meadows Playhouse. Vicki also performed in *South Pacific* at the Stardust Hotel and Casino. Most of these shows were in the 80s and early 90s. She spent many years as a lounge singer at the Frontier Hotel and other Las Vegas Strip Hotels. She belonged to a local singing group called The Voices that performed for many charities.

A special hobby she enjoyed was raising and showing Rottweilers. Vicki was an avid reader, and donned an extensive library of approximately 800 books, which she planned to donate to a local library. In her youth, she spent hour after hour on a friend's horse riding the sagebrush trails outside of Las Vegas. Later in life she owned two Tennessee Walkers, her prized possessions, named Blue and Mocha.

Vicki introduced her entire family to

AUGUST 19, 1949 –
AUGUST 22, 2014

Vicki was a distinct individual who was passionate and devoted to her goals.

SafeNest. Tracing roots back to 1977, SafeNest was incorporated as Temporary Assistance for Women (TAW) when the agency opened the first shelter house for abused women and children in Southern Nevada and launched the 24-hour crisis hotline. Over the next twenty years, with the help of individual donations, legislation, and state-wide partnerships, Temporary Assistance for Women was able to add more shelters, open donation and counseling centers, provide critical legal assistance, and expand programming. In 1996 Temporary Assistance for Women adopted the name SafeNest and opened additional offices in Laughlin, Mesquite, and Boulder City. Today SafeNest is continuing to innovate and grow and has a staff of 91 full- and part-time staff dedicated to creating social change and preventing domestic violence in Clark County. Because of her efforts, her family made substantial contributions to this great and worthy organization. Her family continues to support this charity that was so very important to Vicki.

Vicki passed away in Las Vegas, Nevada at the age of sixty-five.

It is mentioned that powerful women are distinct individuals in terms of their life experiences and leadership styles. In addition, they show a nurturing side by being involved and standing for social change. Vicki was definitely a successful actress and leader. The sum total of her experiences displayed a well-rounded and nurturing individual.

—*Vivian Fully*

Janice 'Cinnamon' Steen Fahey

Janice 'Cinnamon' Steen Fahey was a Las Vegas singer, dancer, and choreographer who became a star in the 1970s through natural-born talent and sheer determination. Admirers say she could sing the blues, play just about any musical instrument, and was one of the finest dancers in town. A real showgirl.

Janice was born in Port Arthur, Texas. Exhibiting an outgoing personality from early on, Cinnamon hit the stage at age six! She was the lead baton twirler and drum majorette in high school and college. Cinnamon loved being in the public eye, and performed to her audience whenever and wherever possible.

Then the lights of Las Vegas called to her, and in 1969 she followed her dream and moved to the city in which she successfully launched her award-winning career. In a day and age when musical talent is randomly plucked from obscurity, or largely determined by reality television or America's Got Talent, Janice Cinnamon Steen Fahey was old school.

She was a girl who earned her stardom the old-fashioned way, through sheer determination and natural-born talent, at a time when the big call-up came by rotary telephone, when the screens were black-and-white, not to mention the photographs.

Initially performing in the "Al Bello Show," she then went on to join the Ron Lewis cast of "Bare Touch of Vegas" and "Sahara Girls."

A world tour with Isaac Hayes, the man who wrote the musical score for Shaft, an early 1970s favorite movie, was also on her agenda. Twice during the early '70s Cinnamon was named 'Las Vegas Ensemble Girl of the Year,' with Bob Hope making the awards presentations. She also made appearances on the Johnny Carson late night show and with Bob Hope, Liza Minelli, and Sammy Davis, Jr.

In addition to singing and dancing, Cinnamon choreographed her own show, "Five Shameless Hussies," at the Maxim and Hacienda Casinos. And for her friend, Liza Minelli, she choreographed a Christmas special.

MARCH 6, 1946 —
JULY 15, 2013

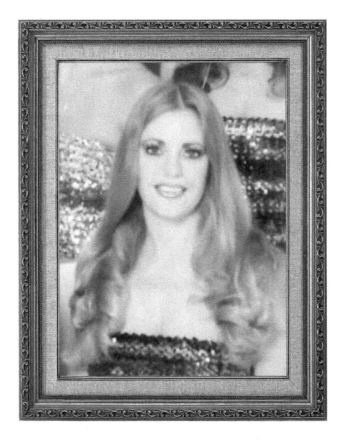

During the Vietnam War before the fall of Saigon, Cinnamon performed for United States troops alongside Sammy Davis, Jr. This earned her a special Certificate of Esteem from the United States Secretary of Defense.

Drums, the piano, the guitar, and the saxophone were among the many musical instruments this talented and accomplished woman could play, and she sang and played in her all-girl band.

Zack Fahey, Cinnamon's only child, had great admiration for his mother. "She was not your ordinary mom," said Zack, an actor who lives in Santa Monica, California and who is following in his mom's footsteps. "You know how some people just can't focus? Well, my mom wasn't one of them. When she put her mind to something, she did it. From the age of six she knew she wanted to be a dancer, so she went from a small town in Texas to the absolute heights of Vegas."

In 1989 Tom Kresky, a business owner who had moved from Wisconsin to Las Vegas, met Cinnamon, fell in love with her, and became her trusted and loving partner for the remainder of her life. "She was just one of those people who was really talented," he said. "But I'll give you a tip; she was one of the greatest singers I've ever heard. She could sing as good as Etta James, one of the most famous blues singers of all time."

In 2007, Cinnamon began a courageous six-year battle with cancer. Always a fighter, she battled the dreaded disease with dignity.

At the age of sixty-seven, her remarkable life came to an end too soon. Loving friends and family will dearly miss her. She was survived by her son, Zack; brother, Jim Steen; sister, Barbara Mouton; and her loving partner, Tom Kresky.

Janice 'Cinnamon' Steen Fahey's talent, courage, lively spirit, and bright star will live on as an exemplary Las Vegas singer, dancer, showgirl, and all-around entertainer.

—*Nancy Fiorello*

Virginia 'Teddy' Fenton

*V*irginia 'Teddy' Fenton was born in Williston, North Dakota to a young, unmarried woman who gave her baby up to coal miner John Hill and his wife, Virginia, for whom Teddy was named. The Hills were bootleggers who ran an operation in Williston's Bootleg Alley. Teddy spent her childhood breaking up the coal Mr. Hill brought home to burn, and selling the liquor he brewed. Teddy learned to throw a piece of rubber tire in the wood stove when the revenuers came so the stench of burning rubber camouflaged the odor of brewing hooch. She remembered a childhood of coal dust, bed bugs, and being passed from family to family when John Hill was sent to jail and Virginia abandoned her. When she was fifteen, Teddy was sent to live with May Sikes, a coach cleaner on the Great Northern Railway, who put Teddy to work cleaning passenger cars. Teddy yearned for an education but was seven-years-old before she held her first book. Though her formal education ended in eighth grade, Teddy's devotion to learning continued for the rest of her life.

It was while living with May Sikes that

DEC. 2, 1916 –
MARCH 30, 2005

Teddy met her future husband, Steve Fenton, May's nephew. Fenton had gone to Nevada to work on Hoover Dam and in 1935 came home to visit. The longer Steve stayed, the more attention he paid Teddy, and when he returned to Nevada the two corresponded for a year. In 1936 Teddy took the train west to Boulder City to live with Steve's parents until she and Steve married on March 2, 1937.

Teddy's fondest memory of arriving in Boulder City was the carpet of wildflowers that greeted her. "It was love at first sight," Teddy said, recalling Boulder City's wide streets and neat houses, its parks and prosperous shops. "You couldn't have dynamited me out!"

Steve and Teddy raised five children: Patricia, Donna, David, Steven, and Richard. The family ran boarding houses while Steve worked at various jobs after the dam was finished. Teddy joined the Rebekahs and Eastern Star and established Boulder City's first youth center, known as Polka Dot Haven. On November 17, 1953 Steve died from an accidental gunshot, leaving Teddy alone with five children.

Two years later, Teddy married Rupert

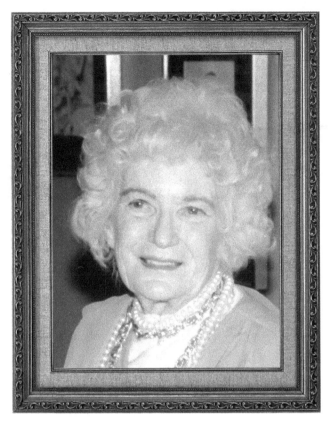

Bayley, an engineer for the Los Angeles Department of Water and Power, and moved her family to Los Angeles. Rupert introduced Teddy to his friends, who were highly educated. One of these friends introduced Teddy to classic literature and provided her with books. Rupert and Teddy divorced after eight years and Teddy returned to Boulder City to manage her boarding houses, and wrote for the *Boulder City News* to supplement her income. Of marriage and herself Teddy said, "I don't bring out kindness in men when they're married to me. Steve Fenton and Rupert Bayley didn't respect women. They didn't give me any respect whatever."

It was through her work with the *Boulder City News* that Teddy met the man who finally gave her the respect she deserved and with whom she developed the relationship she referred to as "my last springtime." This was Bill Harbour, the newspaper's editor. Together, they researched the history of Hoover Dam and Boulder City, collected historical artifacts and documents, and wrote hundreds of stories about them. Through this work, Teddy became friends with Walker Young, the dam's construction engineer; Steve Bechtel

of the Bechtel Corporation; and Sessions 'Buck' Wheeler, a trustee of the Max C. Fleishmann Foundation, from whom Teddy received a grant to build a new public library in Boulder City. Bill and Teddy were founding members of the Boulder City Museum and Historical Association, while Teddy funded events and organizations such as Boulder City's Art in the Park; St. Jude's Ranch for Children; and Boulder City's Fourth of July Damboree celebration. Teddy also underwrote publication of several books on Hoover Dam and Boulder City history. Teddy wielded political influence as well, and area candidates routinely sought her endorsement. The last gift Teddy made to Boulder City was building the Reflections Center sculpture park, known today as Teddy Fenton Memorial Park.

Teddy died in the TLC Care Center in Henderson, Nevada. As difficult as her life was Teddy always remained positive. "I don't ever feel sorry for being an orphan," she said. "I don't want to be raised by somebody that pushed all their ideas on me. I would be different than I am."

—*Denise Gerdes and Dennis McBride*

Vivian Freeman

Vivian Freeman was a champion of women's rights and a fighter for child and family issues, from education to healthcare to environment.

Vivian Lois Ruff was born in Ashton, Idaho, daughter of Raymond A. and Julia G. Ruff. She was raised on a farm in Springfield, Idaho, and graduated from high school in Aberdeen, Idaho.

She began training as a nurse at St. Marks Hospital in Salt Lake City in 1945 and completed her education in the U.S. Army Cadet Nurse Corps in the spring of 1948, all before she turned twenty-one. She earned her bachelor of science in Nursing from University of Utah and worked as a registered nurse in several states.

She was a fifty-three-year resident of Reno, having moved there in 1960 with her husband, Richard O. Freeman, whom she married in 1951. The popular Dick Freeman was both her lifelong partner and campaign manager. He died on the eve of Election Day 2002.

A Democrat, she served in the Nevada State Assembly representing northwest Reno from 1986 to 2002. As a registered nurse, she was elected to the Washoe Medical Center (now called Renown) Board of Trustees, serving from 1982 to 1986. She was co-founder of the hospital's pregnancy center.

In the legislature, she championed women's rights, mining reclamation, and family resource centers in public schools. She served on the Glenn Duncan Elementary School Family Focus Center. During her tenure, she chaired both the Health and Human Services Committee and the Natural Resources, Agriculture & Mining Committee.

She was instrumental in placing Question 7 on the general election ballot. On Nov. 6, 1990, Nevada voters overwhelmingly approved placing a woman's right to choose in Nevada law. (Nevada Revised Statutes 442.250)

Longtime activist and Freeman associate Mylan Hawkins noted Freeman's push for recycling. "Vivian was always a champion and fighter for all the causes from kids and women to education, healthcare, and the environment. Vivian is the recycle lady and stood with us on the frontlines of the Equal

AUGUST 18, 1927 — DECEMBER 5, 2013

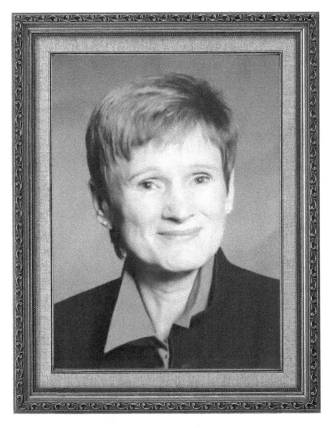

Rights Amendment and Question 7. She was modest. She worked alone. She moved mountains and hardly anyone ever even really paid notice. In her quiet way she changed our state. Despite ourselves and because of her we moved from the Mississippi of the West to becoming a better place," Hawkins said.

Vivian was involved in many community organizations, and was honored in several. The long list includes: Washoe Parks Foundation; Chair, Anne Martin Women's Political Caucus; Virginia Demmler Memorial Honoree; Democratic Party of Washoe County, 2003; American Association of University Women; Western Industrial Nevada, Reno-Sparks NAACP; Northern Nevada Black Cultural Awareness Society; Nevada Women's Fund; advisory board, Food Bank of Northern Nevada; past board member, Child Care Resource Council; President, PTA, elementary and middle schools; Reno Women's

Network, and the Glenn Duncan Elementary School Family Focus Center, 1992.

Vivian was awarded by many organizations. The American Association of Retired Persons named her woman of the year in 1990. Environmental Leadership honored her with its Environmentalist of the Year Pine Cone Award in 1989. The Truckee Meadows Human Services Consortium named her 'Politician of the Year' in 1991. She was named Woman of Distinction for Environment by the Soroptimists in 1991, and the Nevada Wildlife Federation honored her as Legislative Conservationist of the Year in 1993.

Vivian successfully underwent kidney transplant surgery in 2011, and passed away at her home in Reno two years later due to complications from a stroke. She was eighty-six-years-old.

Vivian Freeman received bipartisan support throughout her career in Nevada and will be remembered as a longtime political activist in the State of Nevada.

—*Denise Gerdes*

71

Jessie Benton Frémont

essie Ann Benton was born in Cherry Grove, Virginia, to US Senator Thomas Hart Benton and Elizabeth McDowell Benton. Jessie was her father's obvious favorite of the couple's six children. From the start, Sen. Benton—one of the country's most powerful Antebellum senators—recognized Jessie's intellect and curiosity, and personally oversaw her education and cultivation at their Washington home.

Jessie learned to read at four, and by the time she was a teen she already spoke five languages, read Latin and Greek, and was well versed in history, geography, literature, and science. Her father took her to debates on the floor of Congress and she pored over Thomas Jefferson's library of 6,000 books. At fifteen, Jessie was as trained and astute a politician as any young man her age.

In February 1840, Benton introduced Jessie to a twenty-seven-year-old explorer named John C. Frémont, who had just surveyed the country between the Mississippi and Missouri rivers, and who was in Washington to report his findings to President Martin Van Buren.

The couple eloped and was married on October 19, 1841. Over the next six decades, they would become the power couple of the Wild West—witnesses and participants in the defining moments of 19th century American expansionism, from the Gold Rush to the birth of the Republican Party to the Civil War.

John's first expedition after their marriage was to Oregon. Jessie assumed the role of John's assistant, secretary, and adviser, just as she had done for her father. On that expedition, John raised an American flag in the Rockies, pronouncing it the gateway to the West, and when he returned from that successful expedition Jessie co-wrote his report to the War Department. She transformed his notes into a wonderful adventure story. Their teamwork brought drama to the landscape John had charted and breathed life into the characters—Kit Carson, Indians, mountain men, fur traders and scouts. On the written page, the unshaven, rough-hewn explorers became heroes, and for the first time in US history an explorer's report had a gripping narrative.

Congress printed the report, and newspapers throughout America excerpted it. Literary critics compared it to Robinson Crusoe and Frémont became instantly famous, his and Jessie's names synonymous with the lure of the exciting West. Word spread that Jessie was John's 'amanuensis' and the literary genius behind his work.

Next, John traversed the Mojave Desert in May 1844 to the oasis of spring-fed meadows the

MAY 31, 1824 – 1902

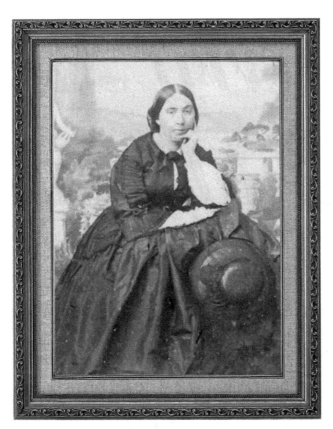

Spanish called Las Vegas. He was the first official explorer of Nevada, and the first white American to see such wonders as Lake Tahoe and the Great Basin. But while John literally put Las Vegas on the map, it was Jessie—waiting for him in Washington—who turned that expedition into an international bestselling book, making his map available to thousands of westward emigrants, and delineating prime locations where settlements could be built and crops raised.

Frémont and Jessie were the poster couple for American expansion, proving that the continent could be traveled and populated from sea to sea. They were superstars, and invitations and interview requests besieged the attractive young couple.

In 1850 John became one of California's first US senators.

By 1855, Jessie and John had been married for thirteen years, and they had made millions of dollars in California gold mines. They had four children and she was pregnant, and that spring John was being recruited by the new progressive Republican Party to be its first presidential candidate and to challenge slavery. That fall, they moved to New York City to pursue the presidency. The campaign marked the first time in American history that women were drawn into the political process. The 'Frémont and Jessie' campaign, as it became known, inspired thousands of women to take to the streets, and their zeal for Jessie was palpable. Seen as a full-fledged partner in her husband's pursuits, she was a heroine to women who had been disenfranchised since the nation's inception. Jessie straddled the boundaries of Victorian society—outspoken but polite, irreverent but tactful, opinionated but respectful—a woman so far ahead of her time that other women flocked to her.

"She could not trek across the wilderness with Indian scouts and Kit Carson, run for President, or command a Civil War department," wrote one scholar, but she "created opportunities for herself by acting as her husband's strategist and, later, as the chronicler of their history."

In 1890, after fifty years of marriage, at the age of seventy-seven, John died. Their children worried she would die from grief. Twelve years later, in 1902, seventy-eight-year-old Jessie died at their Los Angeles home.

—*Sally Denton*

73

Terry Lee Gialketsis

Terry Gialketsis was a community activist and philanthropist in Las Vegas and Southern Nevada. She had a strong passion to help people in need, always responding with her heart and timeless efforts with assistance.

Terry Lee Jeffers was born in Reno, Nevada, a fourth generation Nevadan. She moved to Las Vegas and graduated from Las Vegas High School in 1957. While in high school, Terry participated in Las Vegas High School's Rhythmettes from 1954–1957—a dance squad of such precision that it appeared on *The Ed Sullivan Show* in 1955 and was featured in films and on stages nationwide for two decades, serving as Las Vegas' fresh-faced, toe-tapping goodwill ambassadors.

Terry spent much of her adult life singing the praises of the legendary dance troupe and helped keep alive the group's memory for more than half a century. Together with former team member Nancy Craft, they erected a tribute display of Rhythmette memorabilia at the 2011 Las Vegas High School reunion.

At nineteen-years-old, Terry won the 1958 Miss Nevada USA beauty pageant, and in the 1960s she was a showgirl at the Sahara and the Desert Inn. She married William 'Babe' Gialketsis, owner of Bonanza Beverage Company, in 1972.

For many years Terry, together with good friend Dina Remeta, operated the first interior design studio business in Las Vegas. They called it 'One of a Kind.' According to Dina, the business evolved into more than just design and "became known for philanthropic dedication to the community."

In remembering Terry, Dina wrote "As a former Miss Nevada, she was an extraordinary person whose character and personality strengthened the bond within her family, among her friends, and throughout the community. Terry was incredibly charismatic and kind. Her tireless fundraising was in tandem with being a wonderful mother and creative partner. I shall always remember this wonderful woman as … 'One of a Kind'."

Her mother, Ruthe Deskin, was an award-winning columnist who crusaded against child abuse and neglect and was a proponent of many causes, including education and the arts. It is no surprise then that Terry never lost her passion for Nevada history.

As a proud native of Nevada, Terry celebrated the excitement and history of her state but seemed always to derive the greatest joy and satisfaction in helping those in need in her longtime hometown of Las Vegas. "As to her work with nonprofits, my mom gave not only monetary donations but also volunteered many hours for charitable groups. She had a

AUGUST 13, 1939 –
2013

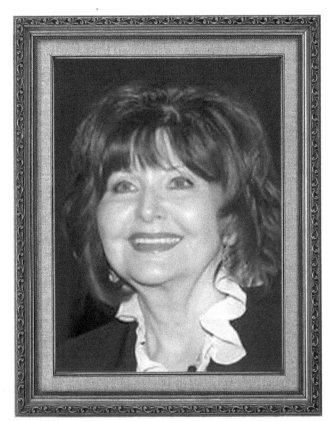

passion to help people in need, and what she did, she did from the heart," said her son, Ron Woodbury of Riverside, Calif. Her statewide philanthropic beneficiaries included Three Square Food Bank, the Candlelighters Childhood Cancer Foundation of Nevada, and the Juvenile Diabetes Foundation Nevada Chapter. Terry supported many Nevada charities that, among other things, fed the impoverished and comforted seriously ill children.

As an adult, Terry highlighted both the struggles of 19th century pioneer women such as American Indian activist Sarah Winnemucca, and the journalistic and charitable accomplishments of her late mother, Ruthe Deskin, the longtime *Las Vegas Sun* Assistant to the Publisher and distinguished Nevadan.

"As a fourth-generation Nevadan, the state's history was rooted in my mother's life," said Ron Woodbury. "She took great pride in preserving it. For example, she was inspired by how Nevada pioneer Sarah Winnemucca fought for civil rights for Paiute women. So much so, Terry and her sister Nancy Cummings made donations in their mother's memory to the Washoe County Library System to commission a bust of the Indian author that now is displayed in Northern Nevada."

Upon making the donations in 2004, the sisters said Winnemucca, like their mother, symbolized the best in Nevada womanhood, striving to attain and preserve education, equality, and peace.

Time after time, Terry focused on what she could do to help future generations.

"My sister took a hands-on approach to enhance education about Las Vegas and the state," said Cummings, the retired longtime director of the Washoe County Library System. "That included participating in the oral history project for the Huntridge neighborhood and by often speaking to students at the Ruthe Deskin Elementary School."

To honor her late mother, Terry and her sister established the Ruthe Deskin Memorial Scholarship Endowment Fund at UNLV's Hank Greenspun School of Journalism and Media Studies.

At the time, Terry said the fund was intended to continue her mother's legacy as a hall-of-fame newspaperwoman and memorialize Deskin's commitment to young reporters and to their education. Within weeks, her scholarship fundraising goal was met.

Terry Gialketsis died from natural causes; she was seventy-four-years-old.

—*Yvonne Kelly*

Elda Ann Gilcrease

Elda Ann Gilcrease was a woman who conquered two different worlds. One that started with her birth in Reno, Nevada to a privileged and well-known family. She was a city girl. She graduated from the University of Nevada, Reno and studied at the New England Conservatory of music. She was a brilliant pianist who played for the Boston Pops Orchestra in 1915. The other world, where in 1920 she became the owner of a large ranch in Las Vegas.

Elda Ann (Ora) Gilcrease came from a prominent Reno family of Scottish descent and with early colonial roots. Her mother, Elda (William) Simpson Orr, was descended from Roger William, a Quaker. Elda Ann's father, John Orr, was from a Scottish ship building family that settled in Northern Ireland. He arrived in New York, and went to San Francisco during the Gold Rush of 1849. John Orr was a mine owner and in the 1800s one of the builders of the Orr Ditch, which diverted water from the Truckee River into farming land.

Elda Ann's parents died in separate accidents that left Elda Ann a substantial sum of inheritance.

While in Reno, Elda Ann graduated from the University of Nevada and became a founder of Delta Tri Sorority. She was

OCTOBER 6, 1891 — MARCH 1968

on the basketball team, an ice skater, hiker, and a sharp shooter with a .22 rifle.

She met Leonard Gilcrease who graduated with a degree in mechanical engineering from the University of Nevada. They married and had two sons: John Theodore (Ted) on June 29, 1916, and William Orr (Bill) on June 21, 1919.

Leonard persuaded Elda Ann to use part of her inheritance for a car dealership. It was a failure. With encouragement from their good friend professor James G. Scrugham (future governor of the state of Nevada) they moved south to the Las Vegas area and invested $10,000 for a house and ranch that was offered by Bill Morgan. She was not happy, but followed her husband's wishes. They moved Elda Ann's grand Steinway piano and many books near Lower Tule Springs. Shortly after, there was a fire where everything was lost. Leonard and Elda and sons moved into a 13'x16' storage shed. It was not insulated for the first year. They used lots of blankets and lived in the storeroom for many years.

In the early years, Leonard and Elda made improvements on the farm/ranch.

"It was just a desert flat with sagebrush, creosote, and a few scattered mesquite trees to start with. They had to take out the brush, level the ground, and plant it with alfalfa or wheat or whatever they

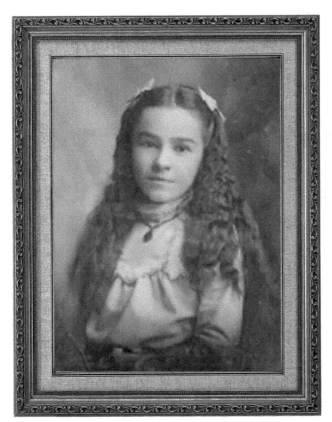

going to plant," said Ted Gilcrease.

Elda Ann and Leonard started to grow fancy grapes, but failed. They turned to growing alfalfa and went on to raising thousands of chickens and grow grain, milo, wheat, and barley to feed the chickens and later thousands of turkeys. At 4 a.m. Elda Ann would start the lighting plant to lengthen the days in the winter for 3,000 chickens. Eggs produced in November-December equal twice as much as in April. Children would collect and candle the eggs at night.

Elda Ann would deliver eggs two or three times a week. Ted and Bill recognized their mother as a 5'4" rugged woman who could handle 100 of pounds of grain.

Elda Ann was a woman of great courage, chasing off a couple of would-be thieves at the ranch with her sharp shooting 22 rifle. Often, she sat overnight guarding the chickens from coyotes and bobcats. One night, Elda Ann's dog, Kelvik, a Norwegian Elkhound, was attacked by a red wolf. Elda was sleeping in the laying house and ran outside; her dog was losing the battle. With blatant disregard Elda beat off the wolf with a crowbar, and after a long struggle, finally killed it, saving her dog.

She educated her two sons with the Calvert Home Course. It is a credit to her and the boys that both scored high on tests when the Gilcrease brothers later took advanced courses at the university.

Leonard Gilcrease came and went, chasing a series of money-making schemes that all ended in failure. At one point he wanted to move the family to his home in Lemoore, California. Elda said "no." "One day my mother told my father, 'If you leave again don't come back.' He must have taken her seriously," said Bill Gilcrease. Leonard left during the Great Depression and they divorced. He died in the 1950s.

Elda and her two sons, young teenagers, kept the ranch going. The Gilcrease Ranch was one of the few local ranches that was able to survive economically without outside assistance. After close to a hundred years later it still exists in the form of the Gilcrease Orchid and Gilcrease Nature Sanctuary.

When Elda died at seventy-eight-years-old, she had conquered both worlds. Ted and Bill donated land near the orchard to the Clark County School District to build a school named after this remarkable woman.

—*Helen Hamilton Wood Mortenson*

Dr. Toni Aileen Hart

Although she was astronomically talented, Toni would say she was the sum of all her parts: Linda, Garry, and Larry being her beloved three children.

The talent that emanated from her to her three children was seemingly natural although each would say it was more than enough hard work.

Toni mastered seventeen instruments by the time she was sixteen.

Married at a tender age of seventeen, Toni and her husband, Reverend Ralph Hart, took to spreading the gospel. They performed countrywide in gospel tents—living out of cars, buses, and whatever would get them to the next venue.

In Detroit they put down roots of a sort and there Reverend Ralph founded a church where he performed his weekly gospel tent services. Toni schooled the children in their musical abilities. They had a weekly television show, twenty-one radio broadcasts per week and a thirty-two-room house.

After a brief stint in California, Nashville called and his name was Johnny Cash. House of Cash production studios hired the talented group to write exclusively for the company. During that time, the family performed at hundreds of state and county fairs and amusement parks, and the family (or

parts of it!) opened for Hank Snow, Kitty Wells, Charlie Rich, Tommy Cash, and others.

She earned a doctorate of theology while living this busy life in Nashville and this vocation defined her life, as she would officiate at more than 50,000 weddings.

Toni kept the family busy with musical treats; they wrote jingles for both American and United Airlines and she found positions for them in television shows, such as Hee Haw, Square Pegs, and Dukes of Hazzard.

Four Grammy award nominations followed the group's success as Toni co-produced the family's musical albums in the 1970s. In 1978, Larry won a coveted Grammy for his original gospel song, "What a Friend," from his Grammy nominated album *Goin' Up in Smoke*.

Eventually the Hart family recorded more than two dozen gospel albums.

Toni marched onto the Las Vegas stage with her children in 1979 after leaving her husband of thirty years. Their first Las Vegas gig was at the old MGM and the Doumani family hired them for one of their first appearances at the Tropicana Hotel. The Hart trio performed at many Las Vegas venues.

Engelbert Humperdinck, a close family friend, produced and collaborated on many compositions with the family.

Around 1980 Toni found a hulk of a house

OCTOBER 13, 1926 —
MARCH 21, 2014

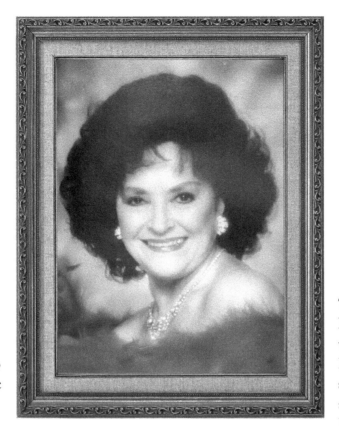

near Charleston and Las Vegas Boulevard, which she realized could be the answer to the family's peripatetic nature. The family worked 'sweat equity' on the project and combined two homes to make a nearly 31,000 square foot home, complete with an indoor swimming pool, eight bedrooms, and a 6500 square foot ballroom.

They would call this monument to Hart love, sweat, and tears, the Hartland Mansion.

Each Hart worked within his own talents: Larry hot-glued more than 20,000 beads, gilt objects, and ribbon on the walls and brother Garry used his construction skills to form a fantastic showplace where they hosted hundreds of weddings, close-circuit events, gospel meets, political affairs, and private parties for the rich and famous. Many of these events were charitable donations from the Hart family as it was Toni's nature to give back. She was always taking in some poor individual or three to give them a roof for which, in exchange, she orchestrated much work out of them as Hartland always needed a fresh coat of paint applied or a leaky faucet fixed.

Upon topping out the construction and interior decorating phases of Hartland in 1984, Toni and the Harts agreed to co-chair a gala,

'A Symphony of the Heart,' honoring their friend Ginger Rogers, the legendary singer, dancer, and actor. Benefiting the Las Vegas Symphony Orchestra, 'A Symphony of the Heart' was a financial and social success. The proceeds awarded scholarships to the underprivileged and handicapped.

Mayor Bill Briare proclaimed May 19, 1984, 'Symphony of the Heart Day.'

Many productions were filmed at Hartland, most recently *Cee Lo Green's Muppet Christmas Special*.

Toni's awards are many as she was recognized for serving many needy individuals, attending to the children, and raising money for education scholarships. In Tennessee she was named the Ambassador of Goodwill and made a Tennessee Colonel. She earned the National Women's Executive Club's 'Lamplighter's Award.' She was knighted Dame of Grace, a position of which she was very proud.

Toni was fiercely proud of her Republican affiliation and she ran for, but did not win, the Las Vegas City Council seat, Ward 1.

There was still much to be done at Hartland Mansion but Toni's god would not let her wait.

—*Susan Houston*

Mary Healy

\mathcal{M}ary was born in New Orleans, Louisiana, but called Las Vegas her home for many years as she performed at various Las Vegas casinos with her husband, Peter Lind Hayes.

Mary was the youngest of four children born to John Joseph Healy and Viola Armbruster. In 1935, at age seventeen, she became Miss New Orleans. Two years later, a 20th Century Fox talent scout heard her sing at New Orleans' Roosevelt Hotel and put her on a train to Hollywood. She made her first screen appearance in *Josette* (1938). After a bit part in the 1938 feature, *Thanks for Everything*, she earned her first major film role in the 1939 musical comedy *Second Fiddle*, which starred Sonje Henie, Tyrone Power, and Rudy Vallee. When she was twenty-two, Mary appeared in the film comedy *Star Dust* (1940) starring Linda Darnell, John Payne, Roland Young, Charlotte Greenwood, George Montgomery, and William Gargan. She also sang the title song composed by Alfred Newman.

Sent on a national tour in 1940, Mary met

**APRIL 14, 1918 —
FEBRUARY 3, 2015**

and married Peter Lind Hayes, a movie actor and Broadway nightclub and television comedian. In 1941, she co-starred with her husband and his mother, Grace Hayes, in the musical comedy film *Zis Boom Bah*. After this, Mary joined her husband's cabaret act. She worked almost exclusively with him thereafter. Mary and Peter were parents to two adopted children: a daughter, actress Cathy Lind Hayes, and a son, Peter Michael Hayes.

Mary went on to appear in four Broadway productions between 1942 and 1958. She made her Broadway stage debut (at age twenty-four) in the musical revue/comedy *Count Me In*, with sixty-one performances opposite Charles Butterworth and Jean Arthur. In 1945, Mary appeared in sixty-nine performances in the original play *Common Ground*. In 1946, she starred in seventy-five performances as Mrs. Aouda in Orson Welles' production for Broadway, an original Cole Porter composed extravaganza musical production of *Around the World*, a role she reprised for Orson Welles' the *Mercury Summer Theatre on the Air* radio adaptation of the musical play.

Mary and her husband appeared together in the early '50s on two variety shows, *The Peter Lind Hayes Show* on NBC and *Star of the Family* on CBS. Mary and Mr. Hayes were the first to sing the Chevrolet commercial jingle, "See the U.S.A. in your Chevrolet." After 1952, Dinah Shore sang the song and it became her signature on the long-running *Dinah Shore Show*. In 1958, the couple starred in the Broadway farce, *Who Was That Lady I Saw You With?* which ran for twenty-six weeks.

For several years in the early '60s they starred on a WOR radio show broadcast on weekday mornings from their home in New Rochelle. Many metropolitan-area listeners identified with their witty observations and unrehearsed chatter about children, meals, commuting, friends, and life's little exasperations—the things ordinary people talked about over the breakfast table. In addition to their TV and film work the couple were popular in Las Vegas and headlined at the Sands Hotel for fourteen successful nightclub circuit engagements. In 1960, they also starred in a sitcom *Peter Loves Mary*. They were frequent

guest panelists on the CBS game show *What's My Line?* and vacation hosts on Arthur Godfrey's television programs. Healy and Hayes were also among the substitute hosts of *The Tonight Show* in 1962 between Jack Paar's departure and Johnny Carson's arrival. In this same time span, Ms. Healy and Mr. Hayes also found time to write a memoir, *Twenty-Five Minutes From Broadway* (1961). Its title was inspired by George M. Cohan's musical about New Rochelle, *Forty-Five Minutes From Broadway*.

In 2004, Healy self-published a second book, *Moments to Remember with Peter and Mary—Our Life in Show Business from Vaudeville to Video*, in 2004.

In 2006, Mary and Peter Lind Hayes were inducted into the Nevada Entertainer/Artist Hall of Fame established by the University of Las Vegas's College of Fine Arts.

Mary Healy died of natural causes in the California city of Calabasas, ten weeks before her 97th birthday.

—Yvonne Kelly

Sylvia Barcus Healy

To meet Sylvia Barcus Healy was to learn about all the ugly problems in Nevada's nursing home facilities for the infirm and elderly—whether you wanted to hear about them or not. Her mantra was one she read somewhere: "Let's put the seniors in jail and the criminals in a nursing home. This way the seniors would have access to clean clothes, nutritious food, showers, hobbies and walks; they would receive unlimited free prescriptions, dental and medical treatment, wheel chairs, and have constant monitoring; in other words, lots of attention."

Sylvia and Richard Barcus, married thirty-seven years, retired to Las Vegas in 1988 from Chula Vista, California where Richard had been a high school math teacher and coach. Sylvia, an avid gardener, won numerous awards for her gardening expertise.

When Richard became very ill in 2005, he entered a Las Vegas nursing facility; shortly after being admitted, Sylvia began noticing bruises and wounds on Richard's body and indications of neglect. She was told that her husband must have fallen out of bed. As it continued, Sylvia began to be suspicious and visited constantly, but things got worse for Richard as he continued to 'fall' and have more injuries. He died May 9, 2005.

Sylvia began talking to everyone she knew about Richard's case. She found more and more people who had similar stories: people who were grieving, wondering what had happened to their loved one, and didn't know what to do about it. Sylvia realized the so-called nursing homes were perpetrating enormous injustices on the mostly elderly charges in their care. When she tried to reach management and owners of facilities, she found that most of them were run by conglomerates, out-of-state companies with no apparent oversight except for revenue. It was then that she decided to establish 'Citizens for Patient Dignity,' a group of like-minded people to assess and address nursing home problems and try to do something about them. John Healy (who became her second husband) came to meetings. Like Sylvia, he had experienced almost identical circumstances with his wife in a local nursing home.

Sylvia's early career in advertising sales for newspapers and magazines helped her with her lobbying. Not only was she physically attractive, but she was charming, persuasive, and intelligent.

She spoke to legislators in Oregon and

NOVEMBER 7, 1940 – AUGUST 28, 2013

California to see what would be the best way to approach Nevada lawmakers. She was tireless and seemed invincible. She wrote proposals and sent them to churches in Las Vegas for suggestions. She pleaded with clergymen to encourage their congregation to join together for support of her project. She frequently appeared and appealed to the Nevada Silver Haired Legislators, State and Local Ombudsman Programs, Offices on Aging, Protection and Advocacy, Medicaid.

Sylvia continued to be a tireless advocate; she found nurses who had worked in poorly run facilities to speak at workshops in Las Vegas and in 2007 she established a Committee for Political Action (PAC). Its purpose was 'Information and Education on Health Care Matters.' Ultimately, Channel 13 recognized her with an award for her dedication.

Sylvia worked with the Research Division Legislative Counsel Bureau, which deals with the drafting of legislation to present to the Nevada legislature. Nevada Work Session Document of June 15, 2010, #23, was entitled: "Draft legislation to make the following changes concerning facilities for long-term-care (submitted by Sylvia Healy on Behalf of Citizens for Patient Dignity)."

Sylvia's Nursing Home Reform draft consisted of 6 parts. Briefly, they were as follows:

A. Require the adoption of regulations mandating specific nurse staffing levels in skilled nursing facilities.

B. A patient or the legal guardian of the patient must be provided a document that allows the patient or the legal guardian of the patient to authorize the facility to perform an autopsy in the event that the resident dies.

C. Increase the frequency of facility inspections to three or four times per year.

D. Require that each facility provides monthly trainings and debriefing meetings.

E. Require that the accounting books of facilities be open to public inspection upon the request of any person or governmental entity, including state agencies, family members, and residents.

F. Mandate facilities to contract with an outside company to install cameras in the facility and keep the recordings so that they may be referred to if incidents of patient harm occur.

And there was more, always more. Many horror stories continue but Sylvia had given everything she could. In 2013 she was diagnosed with incurable cancer. Though she fought it with the same vengeance as she fought for Nursing Home Reform, she died in a hospice where she had been placed by neighbors who had been taking care of her. She had no children or relatives.

Hopefully, the Nevada Legislature will someday give serious attention to her work. There is no opting out of the end of life—and that includes legislators.

—*Barbara Riiff Davis*

Hazel Pauline Shepherd Hefner

Hazel Hefner, as she was fondly known, according to the limited number of pioneer families residing in Clark County in the early 1900s, was born in Ohio. Her parents were Nancy Bently Shepherd and Edmund Shepherd. Soon the Shepherds relocated to Toronto in Canada.

It was there that Hazel grew up amidst her fraternal grandparents' region. Their Protestant family did not make a name for themselves in the church. But her grandfather, Edmund Shepherd, Sr., became an exceptionally popular Protestant revivalist who was recognized as a Bethany College scholar. He was sought in the Toronto and nearby regions to perform funerals, baptisms, and weddings. Unfortunately, Hazel's father, Edmund Shepherd, Jr., did not follow in his father's footsteps.

Hazel was born into a very strict household where children were seen but not necessarily heard. In her efforts to please, from childhood on Hazel showed signs of wishing to break those very constraining ropes of bondage expected from a young lady at that time.

After graduating from high school in Toronto, Hazel attended the University of Toronto for a short time, about two years. It was then that her parents decided she should become a housewife. They set up an arranged marriage between Hazel and William Wagner. This marriage was not in any way the desire of this young, liberated woman but she had been brought up to honor and respect the wishes of her parents.

Unfortunately for Hazel, the marriage was anything but happy. After several years, now pregnant with child, she told her parents she was going to seek a divorce—something a woman simply did not do!

The Shepherds bade Hazel good-bye and let her know that by divorcing her husband she was not welcome in their home any longer. Yet this strong-willed woman did not let that deter her. She went first to Hawaii but ended up in Nevada in 1910, where divorce was accepted in six weeks.

This liberated, intelligent woman next sought a job that would allow her financial stability and independence. However, the positions acceptable for a woman were extremely limited. After a while she found culinary work at a large ranch, the Weiser Ranch in Moapa, Nevada. She was hired as a cook to prepare and serve food to the ranch help.

OCTOBER 1881 – APRIL 1941

While at the Weiser Ranch she met and married one of the ranch hands, Gilbert Hefner, in Las Vegas, where they sought out their destiny. At that time in their lives Prohibition was rampant. Hazel and Gilbert moved to a ranch at Tule Springs. Hazel had become quite an experienced cook and Gilbert, being of German descent, knew some recipes for beer and possibly 'moonshine.' Although the Hefners had a productive garden, like those in the area in the desert landscape, their bootlegging business began to flourish.

Meanwhile, Hazel's mother tried to make amends to her daughter, secretly meeting in Salt Lake City. Always before parting, Hazel's mother, whose husband was a wealthy publisher by now, slipped money into Hazel's hands. Though this was the Great Depression, Hazel saved the money so the family could purchase their own forty-acre ranch on West Charleston. There were other ranchers in the area at that time: Browns, Filbys, Blandings, Ellises, Lindsays, and Vellums. All of these families survived by selling milk, eggs, produce and other similar items. Meanwhile, Hazel and Gilbert had moved their thriving bootlegging business to their newly acquired West Charleston Ranch. This property covered land from Rancho Road to where the Southern Nevada Memorial Hospital was located. There was an irrigation pond frequented by family, neighbors, and even some bootleggers!

Hazel felt even more liberated as time went on. Before the Home for Unwed Mothers opened

Hazel decided to open a bookstore on Frémont Street. From that she founded a ladies book club ... and motivated ladies to purchase their own book.

on Jones Road, Hazel took in young girls facing this predicament. Also, before World War II, when the United States government began rounding up Japanese Americans and placing them in internment camps in California, Hazel and Gilbert allowed Japanese Americans to camp out on Hefner Ranch while working for them. This dual economic burden Hazel handled by selling milk and eggs in town. Again, she used her ranch cooking experience.

Intellectual that Hazel was, she loved reading and had an extensive library within her home. Finally, she decided to open a bookstore on Frémont Street. From that she founded a ladies book club. At meetings the ladies would share books, discuss their personal interpretations, and be motivated to purchase their own book from the store. Hazel also enjoyed writing her own stories and reading them to the group.

Hazel's death in 1941 was under very unique circumstances. She had been invited to join the Shepherd family in Toronto, Canada. Her mother insisted that she come to the family home to reconcile, so Hazel did. The night Hazel died the family dog acted spooked and continuously barked throughout the entire night. At about 6:00 a.m., Hazel was found deceased in the bedroom in the family home she grew up in from complications of diabetes and a heart condition. Her heartbroken husband sold the ranch, moved in with the family, and passed away in 1956.

—*Mary Gafford*

Charlotte Hill

After graduating from the University of Cincinnati, Charlotte married James Hill and together they traveled west where Charlotte Hill discovered her strength. From the minute she landed in Las Vegas in 1952, she became a tiny titan of will and selflessness.

She was focused on furthering the lives of others. It would be difficult to name another individual who participated in as many organizations that existed to boast human morale and self-worth.

Charlotte's first effort might have been accidental as she supported the Brownies when her two children were little tykes.

She then founded the Frontier Girl Scouts of Las Vegas, later heading up that group as executive director, volunteer trainer, and nominating committee member.

Daughter Candy Hill Schneider said, "My mother wanted to give young girls quality time after school to help them build character and independence."

Not satisfied with helping the children in her own community, Charlotte reached out in the late 60s to *Las Vegas Sun* editor Hank Greenspun and his wife, Barbara, to help underwrite a local inner-city children's summer camp. Her camping interests grew from her work as a board member and secretary of the Coronado section of the American Camping Association.

With the *Las Vegas Sun* and the Office of Economic Opportunity, of which she was a board member, a planning committee chair and a Youth Advisory board member, Charlotte meshed forces and created the *Las Vegas Sun* Summer Camp Fund, which funded perhaps thousands of Las Vegas area youngsters happy summer days at the camp. The fund paid for transportation and camp fees, among other expenses.

In 2015, when Charlotte stepped down as chairwoman, the Sun Camp Fund merged with the Boys and Girls Club of Southern Nevada. It was noted that Charlotte insisted no money directed to the project go to administrative costs.

Another area of interest for Charlotte was volunteering. She served for three years on the board of directors of the Volunteer Bureau of Clark County, which placed over 1000 volunteers in 1972.

Her work on the Clark County Volunteer Bureau led to the establishment of the Service League of Las Vegas, now the Junior League of Las Vegas. In the Junior League Charlotte served on their Advisory Board.

Charlotte also founded the Voluntary Action Center, now called HELP of Southern Nevada.

In 1974, Charlotte served as a budget committee member of the United Way. She served as the first woman campaign chair for that group and organized the most successful campaign fundraiser to date.

Through the Las Vegas Mayor's office,

OCTOBER 15, 1925 —
APRIL 26, 2018

Charlotte served on the Manpower Council as well its Youth Board and Youth Executive Board.

Also an advocate of higher education, Charlotte served on the Nevada State Board of Education in 2009, was past chair of the Community College of Southern Nevada Foundation, and was a member of the UNLV Foundation.

Charlotte founded and was a charter member of the Home of the Good Shepherd Auxiliary. She served as vice president of that organization and organized the very popular Red, White, and Blue Ball to raise funds for the home.

Perhaps the most enduring, satisfying, and important legacy of Charlotte's activism is the legacy she left with KLVX Channel 10, Las Vegas' local Public Broadcasting Service (PBS) television station. Helping to create Friends of Channel 10 in 1971, Charlotte served as its director through 1998, nearly thirty years.

During many of these years she organized volunteers for fundraising drives for PBS Channel 10 and served on several public broadcasting organizations including the PBS Voluntary Advisory committee and the Corporation for Public Broadcasting Public Participation Task Force.

She originated, 'The Auctioneers,' a popular, nationally recognized fundraiser for the station.

Charlotte has been honored for her activism in numerous ways. On February 13, 1975, Charlotte was honored with the Distinguished Citizen of the Year Award from the National Conference of Christians and Jews.

She also received the Distinguished Nevadan Award from UNLV, the Las Vegas Chamber of Commerce's Women of Achievement Acknowledgment, the United Way's Alexis de Tocqueville Award and the Golden Rule Award.

In 1991, the Clark County School District honored Charlotte with an elementary school in her name.

Her husband became a successful casino executive with Caesars Palace and served as president of the Fremont Hotel.

To this full life of public service, Charlotte enjoyed a rich private life. Charlotte and James had two girls, Candice Hill Schneider and Linda Hill Wade. There are two grandchildren and five great grandchildren to date.

Until his death in 2000, Charlotte and James were married for nearly fifty years.

—*Susan Houston*

Rita McClain Isom

Rita McClain Isom was born in Covington, Kentucky. She moved to Cincinnati, Ohio when she was six. In 1937 the family experienced a flood that completely wiped them out. They relocated to Batavia, Ohio, where she attended school from the fifth grade until graduating from high school. She returned to Cincinnati where she was employed as a medical secretary at a private psychiatric hospital.

During her time in Cincinnati, she met and married Roland McClain. They raised two sons, Scott and Greg. Roland entered the military service and was stationed in Rhode Island, Texas, California, and Germany. They moved to Las Vegas in 1962 where Col. McClain was stationed at Nellis Air Force Base until his retirement in 1965. He then went into private practice as a medical doctor. Roland passed away in 1986.

Rita remained in Las Vegas where she met and married Warren Isom. They were together for many happy years. They enjoyed entertaining in their home and spending time with their friends in the 'Rousers'—a group they helped organize. The Rousers began as a small church group and quickly expanded. It was a time to socialize, network, connect with old friends, and make new

March 9, 1926 — December 29, 2017

ones. The Rousers created their own 'theme song' and was frequently heard at their gatherings.

Rita was involved in a variety of local organizations and served as a volunteer in many community groups. She was active in the Officers' Wives Club and held the office of treasurer. While living in Riverside, California, she worked for the Peace Officers Training Program and attended classes at Riverside City College.

While living in Las Vegas she was county president of the Medical Auxiliary and president of the NV State Medical Auxiliary. She served on the National Board of Long Range Planning and Reference Committee for medical issues.

She taught CPR for five years both for the Red Cross and the American Heart Association. She also chaired the First Aid Committee for the Red Cross and held many blood drives. She set up a volunteer chaplain program for Valley Hospital while working there as Director of Volunteers.

Rita modeled vintage clothing for ten years for the Nevada Museum. The money raised was dedicated to fund a building for the museum.

She stayed active her entire life; an avid reader, she enjoyed many 'lively' conversations with

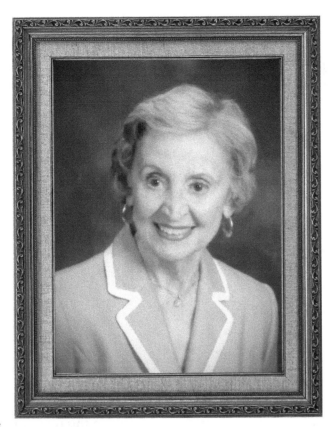

friends. She volunteered as long as she was able and then gave her financial support to many non-profit organizations.

Rita was ordained as an Elder in the Presbyterian Church and held many positions on the church Board. She was also on the Board of the Pastor Counseling Committee. Rita was very committed to her church.

Rita was a fifty-year member of the Mesquite Club, a non-profit organization that brings women together for education and cultural purposes for the benefit of its members and the Las Vegas Community.

The Mesquite Club was founded in 1911 and their first act of public service was the planting of 2,000 trees throughout the Las Vegas Valley in an effort to provide some shade and beauty to our landscape. From then the membership grew and they have completed over a century of service. The Mesquite Club members established the first community library in Las Vegas and created the Rose Gardens at Lorenzi Park. Rita continued to give her support to maintain the beauty of the gardens.

She held many office positions in the Mesquite Club and made lifetime friends. She helped create the Club cookbook, including some of her famous dishes. She participated in numerous fundraisers, giving her time and financial support. She also supported the General Federation of Women's Clubs (the GFWC), an international organization whose members are dedicated to community improvement by enhancing the lives of others through volunteer service. The Mesquite Club is an affiliate of the GFWC.

She was a member of the New West Theatre Board. She held season tickets and loved attending the concerts at the Las Vegas Philharmonic and was a life-time supporter of the Arts. She began supporting the Philharmonic when they were at UNLV and then at the New Smith Center.

She enjoyed the lifestyle living in Las Vegas, especially her home in Los Prados, where she and Warren spent many hours on the golf course and entertaining family and friends.

She died at the age of ninety-one. She often commented that she was blessed to have 'two great loves' in her life along with her two dedicated sons. She is with both Roland and Warren at the Southern Nevada Veterans Memorial Cemetery in Boulder City, Nevada.

—Ilene Baker

Jean Bowles Jenkins

There are so many interesting facts of Jean Jenkins' one hundred years of life it's hard to know where to start.

But first we'll go back to her beginnings in Stratton, Ohio, a town named for her mother's family. Her father was in government civil engineering with a large office in Cleveland. Her mother was a direct descendant of one of the original signers of the Declaration of Independence, Josiah Bartlett.

Jean went to Cleveland High School in 1930 where she played piano and French horn. Her high school band won a national competition and she performed a short solo on the French horn with world-renowned composer, conductor, and bandleader John Phillips Sousa. Sousa died in 1932, only months after that performance.

Jean won a scholarship to the prestigious Julliard School for her musical talents but her father refused to give her permission to attend.

So, at the ripe old age of twenty-one in 1936, Jean traveled west from Ohio to Los Angeles.

Jean was hired to do a small bookkeeping job for $40 a week. Then Max Glick, father of one-time Stardust Hotel-Casino owner Allen Glick, noticed Jean's abilities and hired her to manage the Los Angeles apartment empire he had built.

During this time, Jean was busy building her own professional and personal relationship with Tommy Bowles, Max's real estate partner. By 1946, this successful home mortgage juggernaut team was running Builders Mortgage Corporation.

As secretary-treasurer of Builders Mortgage in Los Angeles, a position rarely held by a woman in those times, Jean noticed the lack of creative financing provided by the government and she claimed to have convinced Federal Housing Administration (FHA) to create the thirty-year home loan program, a staple in the real estate world now.

Another original concept Jean conceived of in home construction design was to open up the kitchen to the rest of the home so the housewife wasn't isolated from the family. Unfortunately, it was such a controversial idea that the newly created FHA refused to loan their firm money to build a trial model of this plan.

But Jean and Tommy forged ahead with this new home design idea in Buena Park, California, cautiously building a subdivision of eighteen

JUNE 9, 1915 – DECEMBER 15, 2015

homes with their own finances. This 'open home' concept was such an immediate success that the initial eighteen homes were sold in the first weekend of sales with back-up orders.

From that time onward, the couple built 100, then 200, homes at a time with FHA loans. Jean once said of her accomplishment, "Now almost every house is built like that."

She claimed to have had a hand in naming the community of Garden Grove, California where she bought acreage for $4,000 an acre for their home construction business.

She was ultimately a partner in twenty-eight corporations in California and the Del Webb Corporation offered Jean a partnership in the first Sun City Del Webb development in Tucson, Arizona.

Jean first came to Las Vegas in the forties for health reasons but permanently moved here in the sixties.

By 1968, she was single again so she opened her own real estate company at the corner of Charleston and Las Vegas Boulevard. Ray Jenkins worked in her office and they became enamored with each other and soon married.

Jean was the first to move in to a new home on the south side of Desert Inn Road on the brand new Stardust golf course. The homes were built by Irwin Molasky and Sheldon Adelson during the same time they were building Sunrise Hospital on Maryland Parkway. She had no telephone line for months and by hooking up

to Sunrise Hospital's phone line she was linked to the world.

Jean was the first woman to join the commercial division of the Greater Las Vegas Association of Realtors (GLVAR) in 1968. She served as chairman of the division for a time. She was the GLVAR 'Realtor of the Month' six times for the most homes sold in each month.

In 1979, she convinced Las Vegas homebuilder Hal Ober to be the first broker/builder to list his new homes for sale with GLVAR, thereby paying a sales commission to realtors as they brought buyers to his home site. This was a very important step forward for the association, and Jean claimed it started the building boom of the 1980s.

Jean was the first realtor to 'sit' an open house tract on the south side of Sunset Road before a single structure was there, and the first to 'sit' an open house on barren land south of St. Rose Pkwy (now 215).

"There just weren't any homes out there!" she said. "I sat in a trailer with no facilities waiting for the new home buyers!"

She also earned her pilot's license and flew for a short period.

Jean always said she felt a tremendous responsibility to live her life as a patriot and high achiever. "All I did was think about the welfare of this town and making houses better, like a pioneer."

And that she did for all of us.

—*Susan Houston*

Fern Jennings

One lady who 'warmed the cockles of the heart' of each and every person she knew was Fern Jennings. She is credited with being the creator of the Happy Hoofers, a group of mature women from Clark County who tap-danced professionally, first at VFW Post 1753 and then at the American Legion Post 8. Fern once said these women loved to perform for service men and veterans as well as at retirement homes, nursing homes, hotels, casinos, and social outings. The women were even asked to perform at McCarran Airport for tourists.

Fern donated countless hours in her community and in Clark County to make this area of Nevada a better place. But her real love was with the Happy Hoofers. She and the other women, including Jen Geroir, Janet DeRoth, CeeAee DoVanne, Judi Weissinger, and Janet Melandez, could dress up in seasonal and colorful garb for the show themes of the event. Happy Hoofers became a household word in Clark County that brought smiles to the faces of all the event attendees. They performed

NOVEMBER 4, 1930 — MARCH 9, 2018

free of charge and any donation received was given to the American Legion Post 8.

Fern Jennings was born to Sam and Edith Rosen in Duluth, Minnesota. After graduating from high school she attended the city's community college. As there were only five girls in the school, she and the other four girls were selected by the teaching staff to be the school cheerleaders. They performed at all the football games. They also partook of the activities in the Pasadena, California Rose Bowl Parades and halftime activities.

From junior college days, Fern worked for the Duluth Probate Court System in Minnesota for twenty years. Next she went to New York City where the Paul Weiss and Associates Law Firm employed her for ten years. During these years she met and married the love of her life, Ed Jennings, the president of the Sunshine Biscuit Company and a World War II veteran.

Fern relocated to Las Vegas following the death of her husband. She was already a Nevada

vacation homeowner, escaping the cold New York winters, and knew many people in the community. She immediately became involved in volunteer activities with the local veterans and other groups, trying to make a difference in Las Vegas. Much of her time was spent at the Veterans of Foreign Wars Post 1758 and at the American Legion Post 8. Fern often stated that by donating so much of her time to these respective groups she felt she was keeping alive the patriotic feelings her husband had expressed regarding the part he played during World War II in protecting his beloved United States of America against all enemies.

Because of her feelings, Fern took on a related mission quite near and dear to her heart, a mission that would keep alive the patriotic feelings of so many service men who served in the war. She found a shoebox filled with letters that her deceased husband Ed had written to his mother during his time in the service in the 1940s. Within these letters he painstakingly detailed all his military adventures, beginning with his military training. He had written with visual detail about such historic events as the invasion of and reclamation of France and Germany. He described the horrific sights viewed the by military as they methodically freed those held in concentration camps and of virtual prisoners held within the boundaries of Nazi occupied Germany. Fern published these letters in the book titled, *Your Loving Son, Ed*. The entire proceeds from the book went to benefit veterans.

Thus this vivacious and energetic lady gave tirelessly of herself in many ways. During the 150 Year Sesquicentennial of Nevada in 2015, she appeared and spoke to many organizations about her days as a Happy Hoofer and about her book. In fact, she was one of the persons displaying literary talents at the Mesquite Club, one of Las Vegas's oldest women's civic organizations.

With a smile on her face after her battle with pancreatic cancer, Fern Jennings passed away. She will be deeply missed by scores, if not hundreds, of loving, caring and genuine family, friends, fellow entertainers, and applauding audience members. May she rest in peace for contributing so much to her community.

—*Mary Gafford*

Miriam 'Mimi' Katz

You've heard the phrase 'whirling dervish?' Miriam 'Mimi' Katz was a working dervish if there ever was one. She was a continual flurry of activity her entire life. Her quest to learn and participate never wavered.

Mimi was born in Brighton, a suburb of Boston, to William and Frances (nee Green) Goldberg. As a young student at Alexander Hamilton School, Mimi was twice promoted to a higher grade who excelled in sports to such a degree she was appointed captain of the field hockey team.

She graduated from the Girl's Latin School, a college preparatory high school in Boston. Her attractive physical abilities again were apparent as her A.H.S. yearbook described her as, "The feminine figure divine—the one we all want but haven't got ... loves sports!"

Mimi's vocational career path started in the direction of secretarial school at first. She worked at Raytheon Manufacturing to pay for her own education. Perhaps the love of sports intervened at that time because she graduated from the Massachusetts School of Physiotherapy and found a job at the National Institute of Poliomyelitis in Washington, D.C. during the World War II years. She subsequently moved back to Boston and worked for a general practitioner in private practice.

She met the love of her life George Katz and in 1957 at thirty-one years of age, she and George started their life adventures together by honeymooning in Las Vegas.

Mimi soon found a job in the Clark School District but this vocation was cut short because three little girls soon entered their lives. Now grown, they are Toby Katz Bergen, Nancy Katz, and Amy Katz Parker.

After her child-raising hiatus, Mimi re-joined the Las Vegas work force with a fury. She found a rewarding career in convention sales at three casinos: the Las Vegas Hilton, Sahara, and the Sands.

Another community public relations job proved very rewarding at the Jewish Federation of Las Vegas for ten years. At this post she helped create and organize a Holocaust survivors' speaker program to enlighten a new generation of students in Clark County.

Upon her retirement from her paid careers, Mimi launched into her philanthropic associations. The American Civil Liberties Union, the League of Women Voters, the Las Vegas Chapter of Brandeis University, and Volunteers in

APRIL 25, 1926 –
APRIL 11, 2015

94

Medicine of Southern Nevada all received special attention and support from Mimi.

The American Civil Liberties Union (ACLU) Southern Nevada chapter was initiated by Mimi's group of notable citizens, such as Judge Michael Cherry, Sari (in this book) and Paul Aizley. An attractive calendar was created during the early 1990s, which was one of the more successful ACLU fundraisers by Mimi's group that continued for years.

One time, Mimi was caught by scammers and bilked out of some of her savings. She retaliated by being proactive about the problem. She organized meetings between senior citizens and the FBI and the local police crime-fighting units to help educate seniors and others who wanted to be more aware of possible ill-will situations.

Mimi volunteered weekly at the Cleveland Clinic, the Larry Ruvo Center for Brain Health. She loved the promise held for her fellow seniors within the walls of this new Las Vegas educational and research institution. And she encouraged the interaction.

Her ability to organize furthered the causes of the national and local Democratic parties. Most notable, she worked on President Bill Clinton's campaign and worked tirelessly at the grass roots level to support her beloved party. She hosted political hopefuls' campaign fundraisers at all levels.

UNLV's life-long learning institute, Osher Lifelong Learning Institute or OLLI, was a beloved part of her later years. She took two or three classes each semester. The classroom connection was important to her.

Mimi had been a member of a Russian dance group while she lived in Boston and this activity and love for dance carried with her forever. She enjoyed driving her friends to the local dance programs.

The couple joined the Temple Beth Sholom (TBS) soon after they moved to Las Vegas. They concentrated their efforts in that arena to fundraise for Jewish war veterans and the TBS Women's League.

Mimi left a lasting imprint on the city of Las Vegas and is remembered fondly by many.

—*Susan Houston*

Edythe Sperling Katz-Yarchever

One of the most highly regarded ladies of Jewish descent who made voluminous contributions to Clark County is Edythe Sperling Katz-Yarchever. She was born to Gertrude and Hyman Sperling in Boston, Massachusetts where she spent a happy but uneventful youth. Upon graduation from high school, Edythe next attended the Charles School in Cambridge where she developed an interest in politics.

During the early years of World War II she joined the Massachusetts National Guard and drove an ambulance. She was then employed by the United States Army Medical Corps, serving as the executive secretary at Edgewood Arsenal in the state of Maryland. Her next assignment was secretary of the Neurological Division at Cushing General Hospital.

In 1946, after a short time back in Boston, Edythe was employed in Culver City, California at MGM Picture Studios and then at the Harold Hecht Agency a year later.

In 1948 Edythe met and married Lloyd Katz. The two of them moved to Las Vegas in 1951,

JULY 6, 1920 —
AUGUST 15, 2016

where Lloyd was hired to manage three of the four movie houses existing in there.

The first thing Lloyd Katz did during those troubled times before federally mandated national integration was to practice desegregation both in hiring of employees and seating of all races. This act was peacefully carried out at a time when racial unrest prevailed in numerous other states.

Meanwhile Edythe opened the first Jewish gift shop and served as Sisterhood President at Temple Beth Shalom. Edythe established the Temple Preschool and the newsworthy *Jewish Reporter*.

In these times Edythe approached the Clark County School District (CCSD) regarding the creation of a District Curriculum Guide in Holocaust Education. She and a concentration camp survivor friend of the Holocaust went to public schools, to libraries, and other learning institutions to offer factual accounts of events leading up to and transpiring during the horrific World War II era in Europe.

Edythe founded the Sperling Knomberg-

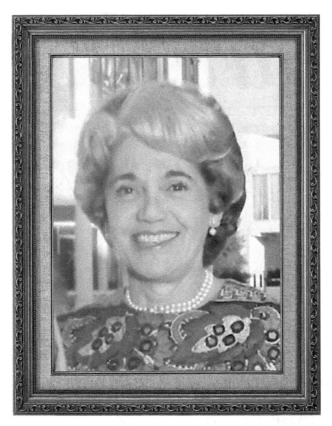

Mack Las Vegas Holocaust Research Center. She was also appointed by Nevada Governor Miller to the Governor's Advisory Council on Education Related to the Holocaust.

Lloyd and Edythe were blessed with two sons: Barry and Jeff. Her family did not stop her tireless presentation of factually informative programs about the Holocaust throughout Nevada. A founding member of the Jewish Family Services Agency, Edythe also became a member of the Anne Frank Institute of Philadelphia, Pennsylvania, and served on the Board of Directors. She was instrumental in bringing the Anne Frank in the World Exhibit to the Marjorie Barrick Museum of Natural History at the University of Nevada Las Vegas (UNLV). Both students and the general public flocked there to learn more about this historical tribute to the World War II events shared throughout the world.

Edythe was appointed by Governor Grant Sawyer to the Operation Independence Committee for Clark County. She also headed the United Way Fund for many years and successfully raised much money for this cause.

Junior Art League, Children's Auxiliary, and the Las Vegas Art League were inspirations of both Edythe and her husband Lloyd. They supported Channel 10 generously, too. Although Lloyd passed away in 1986, the Katz financial contributions continued to Clark County. In the early 1990s, the Edythe and Lloyd Katz Elementary School was built and dedicated.

In 1995, retired Judge Gilbert Yarchever and Edythe were married. They continued generous donations to the University of Nevada Las Vegas College of Fine Arts, the Boyd School of Law, the College of Liberal Arts, and the UNLV Library. Their philanthropic contributions continued to Judge Yarchever's passing in 2010 and up until Edythe's passing.

Innumerable projects in Nevada are credited to Edythe's generosity. What a remarkable life this woman and her family led! Certainly Nevada and especially Clark County owe a debt of gratitude to Edythe Katz-Yarchever and her family for the myriad marks they made ... still here to this day.

—*Mary Gafford*

Mary Kay Keiser

Mary Kay Heim Keiser was noted for her outstanding community service provided to mentally and physically challenged individuals.

As the oldest of five children born to Clarence and Ruth Heim in Mishawaka, Indiana, Mary Kay was expected to set a good example for her siblings. For that reason, as well as the fact that she was an exceptionally intelligent child, she learned how to play the piano, how to crochet, and how to encourage her younger brothers and sisters to listen to and obey their parents.

Once in school, Mary Kay was a model student in every way. She was a member of the Girl Scouts and was in the National Honor Society in high school. In 1954 she graduated from Mishawaka High School. After graduation this wonderful young woman began working at the General Adjustment Bureau. After a short time she met the love of her life, John Keiser. Not long after, the couple was married on March 16, 1956. The couple soon started a family and within six years, from 1957–1962, four children were born into the family: John, James, Jana, and Julie.

The Keiser family moved to Arizona, but would move to 'the promised land,' Las Vegas,

JUNE 24, 1936 –
SEPTEMBER 26, 2016

Nevada, in 1963. They settled on Longridge Avenue for over ten years, then relocated to the Painted Desert development for twenty-six years. Mary Kay and John made many friends and felt part of both residential neighborhoods. They acclimated beautifully in every way and got to love the desert climate, the flora and fauna, as well as their neighbors. They joined the First Presbyterian Church, eventually known as Grace Presbyterian, and contributed many hours of their time at the church.

The Keisers loved to spend their vacations traveling to many different countries. As their four children with respective families aged, Mary Kay and John planned a yearly family outing beginning around 1995. These annual jaunts remain among the highlights of genuine family fun and great memories.

In Las Vegas, Mary Kay worked at the Desert Regional Center (DDC) as the director of community services. She served as a crisis counselor in Southern Nevada dealing with trauma intervention. All the employees, including Barbara Bolling and Marge Pepper—who remember her as a compassionate person, showing special interest and

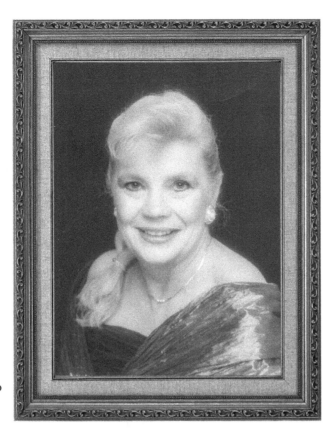

caring to everyone who crossed her path—respected her.

Next came her entrance into private practice. She served as a marriage and family counselor and referred to herself as a psychotherapist. Mary Kay was viewed as an outstanding crisis counselor in Southern Nevada. She gave her all in a professional way to those who suffered trauma, horrific experiences, or extraordinary loss.

Mary Kay earned three degrees: a bachelor of arts and a master's degree from the University of Nevada Las Vegas (UNLV), and later a bachelor of science degree specializing in special education from UNLV. She graduated summa cum laude, all while being a loving mother and pursuing her career in the psychology and counseling fields.

She was active in the community and was a member of many local organizations. She volunteered as a grief counselor and led a cancer support group at Grace Presbyterian Church for over twenty years. As a charter member, Mary Kay helped organize P.E.O. Chapter Y in 1973 and was an active member ever since. She was a member of the Presbyterian Women's Group, the Red Hat Society, the Phi Kappa Phi and Kappa Delta Pi, as an Elder at First Presbyterian and the National Education Fraternity. She was an active volunteer for many non-profit organizations, including the American Cancer Society after being diagnosed with cancer at the age of thirty-two. She also set up a grief counseling group for those who had lost a loved one and a cancer survivor group at the Grace Presbyterian Church. These groups are still active and meet regularly, a lasting legacy for Southern Nevada.

According to her daughters, Mary Kay received high praise in a 1977 letter from Charlotte Crawford, Regional Director for Human Services in Nevada, stating the outstanding service she had provided to the community was respected and appreciated, and really made a difference for everyone she came into contact with. Mary Kay also received a letter from the pastor of the First Presbyterian Church, thanking her for her many services and contributions and his appreciation of her.

Mary Kay Keiser's husband of sixty years, John, died a year after Mary Kay. Both left behind a beautiful legacy.

—*Mary Gafford*

Dorothy Laurel Kemp

As Dorothy flirted with the young pianist in the Los Angeles band on Valentine's Day 1959, she couldn't have guessed that this chance meeting would lead to a musically adventuresome life in Las Vegas that would span more than fifty years. On that day she met young Don Kemp, who had recently emigrated from England and performed at that Valentine dance only as a last minute favor for a friend.

Born Dorothy Laurel Kramer in Washington, she earned the nickname 'Dorrie' as a young girl.

After moving with her parents to the Los Angeles area and before meeting Don, Dorrie explored her musical vocal talents by attending the Hollywood Professional School and the Los Angeles Music Conservatory. She performed on the Los Angeles radio many times.

For eighteen months between 1959 and 1960, Don began commuting to Las Vegas to perform; the casinos needed musical talent and there were lots of opportunities for bookings in the showrooms. With her nice vocal range, Dorrie soon began to accompany Don on his trips and was welcomed onto the Las Vegas musical scene as well. She performed in the lounges at many strip hotels, most notably the Dunes and the Sahara.

Their love grew stronger and through their common faith of Judaism, they joined the Temple Beth Shalom in Las Vegas. They were married in the temple on August 7, 1960.

In 1963, Dorrie and her husband opened their first Las Vegas business, Southern Nevada Music, originally located at Charleston and Eastern Avenues. For the first four years they worked in the piano showroom during the day and performed in casinos and hotels at night. The smoky Las Vegas casino atmosphere then became too oppressive for Dorrie so she turned her talents to teaching vocals to young performers. Many evenings Don would bring home an aspiring vocalist during his break and Dorrie would teach the pupil during that time. More than one eyebrow was raised at this little arrangement.

The Kemps were especially proud of a record baby grand pianos sold to Caesar's Palace when it opened in 1966, creating a record for the most pianos sold in one day. And by the same year, the Kemps owned the largest piano dealership in Nevada since many of the major hotels were clients.

Dorrie developed a successful sheet music business and at one time had nearly 300 students learning to play the piano under the tutelage of the teachers Dorrie hired.

After they sold Southern Nevada Music, they opened Music World, a second successful piano showroom located on Sahara near Eastern Avenue.

APRIL 4, 1940 —
AUGUST 9, 2016

One day another idea came to them—to develop a business of restoring old pianos. They began to purchase mostly upright and grand pianos from the east coast and had them shipped to a facility in North Las Vegas to be restored, with the 'guts' of the piano coming from Korea.

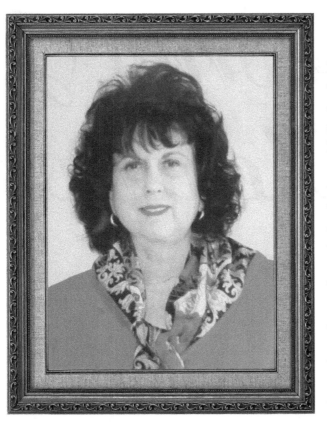

They produced nickelodeons, which are player pianos with sheet music on rolls, and player pianos that carried an average retail value of $16,000 each. Thus started another aspect of a successful piano business that lasted eighteen years in Las Vegas. In fact, the demand for their player pianos was so great that Dorrie and Don purchased replicas of 1920s pianos to keep up with the demand. Dorrie would design the stained glass inserts while they were being built and then ship the finished product to customers worldwide. One Japanese salesman managed to sell five or six a month.

One of their famous 'Muzelle' player pianos was featured on the cover of a Hammacher Schlemmer Christmas catalog, creating such a demand for the product that Dorrie was interviewed on all major national morning TV shows.

The Kemps enjoyed music so much that at one time they owned shares in the Steinway Piano Company. In 1969 their stockbroker notified them that twenty-five Steinway shares had come on the market. The Kemps said they were interested in purchasing those shares and any more that might be offered. Soon they held 4,000 shares and Henry Steinway personally called the Kemps one day and exclaimed, "We just have had a big surprise. We were going through our records and you are the largest shareholders outside of the Steinway family!" Later the Kemps were able to convert the sizable accumulation of stock to CBS stock when Steinway was acquired by CBS.

The Kemps also were active in the Las Vegas real estate world. With the Steinway/CBS stock proceeds they bought the aforementioned land on Sahara and developed a building, which housed Music World. They also owned properties located at Tropicana and Mountain Vista Street, Harmon and Eastern, and in other areas of Las Vegas.

Dorrie would host fundraisers to raise funds for the underprivileged in South America through the Rotary International. Once she raised enough money to help remodel the kitchen facilities at a children's foster home in Chile. Another charitable undertaking was to help fund an organization that supported a helpline for troubled children. People still talk of her imaginative fundraisers with themes such a Hoedown or a Hawaiian luau and they talk of her legendary backyard parties.

She was involved in many local charity organizations including Temple Beth Shalom where she sang in the choir, the Las Vegas Performing Arts Center, and the Las Vegas Rotary Club, where she was an honorary member.

Don and Dorrie was one unit in love, life, and business. Her portion of that life was as significant as Don's was. This he lovingly admits.

—*Susan Houston*

Lorna J. Kesterson

The legacy of Lorna Kesterson will be forever remembered in her service to others. She paved an incredible path in this life for all to follow.

Lorna Kesterson was born in St. George, Utah to Donal Jones Jolley and Nora Crawford Jolley. At that time the family resided in Zion National Park where she attended elementary school in a four-room school in Springdale, Utah; then attended high school in Hurricane, Utah, riding a bus twenty-five miles each way to reach school.

The family moved to Boulder City in 1943 when her father was transferred to the park service there, where he was the chief ranger of the National Park Association. She attended and graduated from Boulder City High School, where she was a pitcher for the baseball and softball teams, played tennis, and enjoyed living in town where she could ride her bike to the Boulder Beach at Lake Mead and many other local spots. Since gas was rationed at the time, being able to get around was very important.

Lorna's time spent swimming at Lake Mead proved life changing. In 1947, Lorna was awarded a certificate of merit from the Red Cross and President Harry S. Truman for saving the life of a California boy xcout who was drowning in Lake Mead.

Lorna attended Utah State University and graduated in 1948 with a degree in journalism, after which she returned to Boulder City, where she worked in several government offices. She then served a mission for the Church of Jesus Christ of Latter-day Saints, mainly in New York and Philadelphia.

Lorna worked for the *Henderson Home News* for over thirty years when she and her husband, Robert Earl Kesterson, moved to Henderson in 1953. She started as a reporter and worked up to become managing editor of the *Henderson Home News*. At the same time she sold articles to other newspapers including the *Las Vegas Sun* and *Deseret News*.

In Henderson, where her four sons were born and raised, she and her husband worked with the youth in PTA and Boy Scouts. Her unconditional

DECEMBER 30, 1925 –
JANUARY 16, 2012

She led a life of service to others and will always be remembered for her loving and giving character toward family, church, and community.

love for her 'boys' and her family was evident by her selflessness that not only extended to her immediate family, but to all of those she came into contact with. All four boys graduated from Basic High School.

When a vacancy occurred on the Henderson City Council in 1975, Lorna was named as a replacement. She ran for re-election in 1977–1981. In 1985 she was elected mayor of Henderson and re-elected for an additional term in 1989. In every election she was elected by more than 50 percent of the vote in the primary election. She never ran during the general election.

Lorna and was named the city of Henderson's Woman of the Year in 1975. She was named as 'Woman of Distinction' by Nevada Alpha Delta Kappa for 1992–1994, as Nevada Public Official of the Year in 1991, honored by the Southern Nevada Home Builders and the Chamber of Commerce, and was named Henderson Woman of Distinction in 1985.

She was also honored as a member of the National Junior Honor Society of the secondary schools by Burkholder Junior High, based on scholarship, leadership, service, character, and citizenship.

Lorna was an active member of many boards, which include, the Las Vegas Convention and Visitors Authority, Daughter of the Utah Pioneers, Honorary Member of the 31ers, the Henderson Development Association, and the Nevada League of Cities Board of Directors, to name a few.

The Lorna J. Kesterson Elementary School was dedicated in February 2000. A recreational center was also named on her behalf, both of which are located in Henderson.

Lorna served diligently in many capacities within the Church of Jesus Christ of Latter-day Saints all her life, which allowed her the opportunity to share her love for music by playing the organ for over thirty years.

Lorna Jolley Kesterson passed away in Henderson at eighty-six-years-old. She led a life of service to others and will always be remembered for her loving and giving character toward family, church, and community.

—*Denise Gerdes*

103

Ai-Ja Kim

Possibly one of the best examples of the great American dream is the story of the Kim Sisters. Beginning in the early 1950s, this trio was a South Korean-American entertainment juggernaut that spawned a special musical style called K-pop .

Known as the Kim Sisters, Sue Kim (Sook-Ja), sister (Ai-Ja), and cousin Mia (Min-ja) formed a musical variety act that thrilled audiences for more than four decades throughout the world, particularly in Las Vegas at the Thunderbird Hotel in the main showroom. They also performed regularly for fifteen years at the Stardust, five years at the Las Vegas Hilton, and fifteen years at the Holiday Casino. Their audiences rivaled the likes of Dean Martin, Sammy Davis Jr., and others. Hugh Hefner invited them to perform at the grand opening of the Playboy Club.

Ai-Ja was born one of seven children in Seoul, South Korea to a vocally-gifted mother, Lee Nan-Yong, who some say was the most admired singer in Korean history. Her father, a renowned orchestra leader, Kim Hae-Song, was abducted and killed by the military, which left the charmed, wealthy family destitute. During the Korean War, as many as twenty-two family members and others lived together at one time in a brick storage unit without an indoor bathroom. The girls said their six siblings often went days without a thing to eat.

Her mother provided for her family by entertaining and charming U.S. military troops with American songs she learned phonetically from records purchased in the black market. They rewarded her with whiskey and beer, which she then traded for food.

DECEMBER 1940 — APRIL 18, 1987

Fortunately, Ai-Ja's mother found her young daughters exhibited her musical abilities. So in 1953, she trained the girls, starting at their tender ages of thirteen, twelve, and eleven, to sing songs American style, such as Tony Bennett's, "I Left my Heart in San Francisco," though they knew nothing about the meaning of the words because they spoke little English. She also taught them dance steps and choreography. And their mother also trained them early in musical instrumentation as well. The girls each mastered thirteen different pieces.

Wildly popular with large audiences of U.S. troops, the young girls' zestful, energetic performances were a regular production in South Korea's American G I camps. The combination of talent and entertainment value caught the eye of talent scouts and Las Vegas producer, Tom Ball, imported the girls to Las Vegas in 1959.

Their first stage show was the *China Doll Revue* at the Thunderbird Hotel on the Strip. It was made clear to them that they had only four weeks to create sell-out showrooms, which they did, and they continued to perform there and at other Las Vegas venues for the next three-plus decades. They worked two shows a night, six days a week for years.

In 1959, the same year they landed on U. S. soil, they appeared on American television on *The Ed Sullivan Show*. Again, they still had no English understanding of the lyrics to their American song catalog but they were so charismatic and gifted musically they convinced and charmed all.

The Kim Sisters appeared on *The Ed Sullivan*

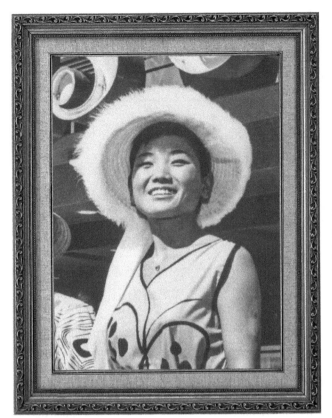

Show a record twenty-two times, more than any other person or act.

In 1962, their mother joined them in the U.S. and appeared with them on the *Ed Sullivan Show* for a musical reunion in which the girls sang harmony behind their famous mother. Their mother toured with them for eight months after that.

Also in 1962, the group recorded "Charlie Brown," a song originally recorded by The Coasters, which rose to #7 on the Billboard singles chart.

Much was made of the attractive trio and publicity was abundant for them. *The Hollywood Palace*, a variety show an ABC television, regularly featured them as well as the cover of many publications, such as the *Chicago Daily Tribune*, *Los Angeles Times* and the *New York Post*. *Newsweek* and a ten-page spread in *Life* magazine featured the musical group's talents.

As the Kim Sisters performed and earned good money, they sent piles of it back to their Korean relatives, which helped the family prosper. In the 1960s, Ai-Ja's three brothers were sent to be with their sisters in Las Vegas. Also talented, they formed the Kim Brothers, though it did not prove to be as successful as the Kim Sisters.

The monetary success of the trio also provided an immigration path to American citizenship for forty more family members. They had truly reached and touched the great American dream!

The Korean Kims were the first commercially successful crossover Asian-American musical artists. The enthusiastic K-pop style was mimicked by a number of sister-based artists, including the Kimchi Kats, the Pearl Sisters, the Chong Sisters, and the Yi Sisters.

The Kim Sisters was the first Asian group to produce a recording in the U.S. They recorded a country and western ballad in Nashville, which did not produce the thrills of earlier live stage successes. It was thought the visual impact of the Kims was significantly integral to their success regardless of their command of the English language. The group released other records in the United States and Korea.

Mia Lee and Sue Kim had a falling out over their husbands' involvement in the Kim Sisters group, which led to Mia Lee leaving and the demise of the group in 1973. Sue Kim performed briefly with her brothers before retiring professionally from music in 1991.

Ai-Ja married Charles Bullion. She fell ill and passed away in 1987.

Ai-Ja's sister, Sue Kim Bonafazio, was inducted in to the 11th Annual Nevada Entertainer/Artist Hall of Fame in 2015.

—*Susan Houston*

Doris Shoong Lee

Doris Shoong Lee left a remarkable legacy of philanthropy and achievement in Nevada and California in support of education and the arts.

Doris Shoong was born in San Francisco spending her early years in Chinatown. When she was five, Doris moved with her family into a house in Oakland designed by famed architect Julia Morgan, whose other works included the Hearst Castle.

Joe Shoong, Doris' father, emigrated from a small village in Guangdong, China to the United States at the turn of the century. Doris explained, "He came over here with no language, no money, no relatives," during the years of the Chinese Exclusion Act. Within a few years, Mr. Shoong founded the National Dollar Stores, a chain of dry goods stores, which he ultimately expanded to include properties throughout the western United States and Hawaii.

Their shared Chinese heritage was very important and throughout her school years Doris was required to study Cantonese for several hours every day in addition to her schooling at Our Lady of Lourdes and Holy Names High School.

Doris recognized her family's legacy by supporting the endowment of Oakland's Shoong Family Chinese Cultural Center and sponsoring the construction and renovation of the delightful Dragon Slide and Treetop Tea House at Children's Fairyland.

She enrolled at the University of California Berkeley in 1936 when she was only sixteen-years-old, but left when her parents decided she and her sister should attend Lingnan University near her father's former village in China.

Both young girls soon found themselves stranded when the Japanese invaded in 1937. They were able to escape when the steamship *President Coolidge* aided in the emergency evacuation of Americans. Doris recalled standing on the deck of the ship and watching the Japanese bombs explode during the Battle of Shanghai.

Doris returned to attend Stanford University. She married a fellow student when she was nineteen-years-old and had three children: Richard, Judy, and Lisa. Her youngest daughter, Lisa, was disabled and Doris was steadfast in her care.

In 1960, Doris became a member of the executive committee of the National Dollar Stores. Her involvement with the family business intensified upon her father's death in 1961. In her words, her duties were "management of books, advertising, accounting. And I took to accounting like a duck to water."

As her first marriage ended and her children

DECEMBER 20, 1919 — AUGUST 26, 2018

grew older, Doris spent more time stewarding the National Dollar Stores and met Theodore B. Lee, whose father had also emigrated alone at a young age from China to California. After Theodore Lee graduated from Harvard University, he returned to California and obtained both a JD and a MBA from UC Berkeley and worked as a prominent real estate attorney.

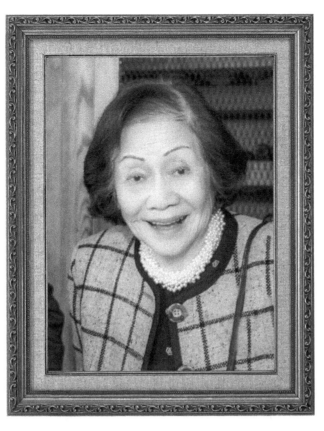

Doris married Ted in 1969. Theirs was a loving, productive, and devoted partnership, which lasted almost fifty years. They formed the Urban Land Company in 1972. The privately held real estate investment firm includes their sons, Gregory Lee and Ernest Lee, as active members.

Urban Land Company owns a wide range of properties in California and Nevada, including the Eureka Casino properties in Mesquite and Las Vegas. Doris remained deeply involved with both of her sons in the management of the family company until her brief, final illness.

Doris served as trustee of the UC Berkeley Foundation, endowed the Theodore B. and Doris Soong Lee Distinguished Professorship in Real Estate Law and Urban Planning, and made other substantial financial contributions to UC Berkeley, including the Founders of Berkeley.

Ted and Doris active at Harvard University, where they have been donors to athletics and the Fairbanks Center in East Asian Studies.

Visitors to the Asian Art Museum in San Francisco have seen numerous exhibitions made possible by the financial support of Theodore and Doris Lee. Doris was a member of the Asian Art Commission from 2001–2012 and served as its chair in 2004–2006.

She also served on the board of the Asian Art Museum Foundation for ten years, including as its chair from 2004–2006. As she explained, "I think we have one of the most valuable collections outside of Asia. We are one of three all-Asian museums in the Western world. We are positioned to be a very important institution, not just in San Francisco, but for the world."

She was a founding member of the Las Vegas Philharmonic and served on its board for eight years. She was also a founder of the Smith Center and sponsored live music for performances by the Nevada Ballet Theatre. To honor her father, Doris donated the land and funds to create and maintain the Joe Shoong Park in Las Vegas.

When UNLV's Boyd School of Law was created, Doris and her husband established its first endowed professorship. In 2012, the UNLV Lee Business School was renamed to recognize her generous support. Doris loved being a member of Nevada Women's Philanthropy and working with others to make Las Vegas a stronger community.

After a short illness, Doris Shoong Lee passed away at home in Las Vegas in the presence of family members. Her life was well lived, and she left a remarkable legacy of philanthropy and achievement.

—*Denise Gerdes*

Mary Moss Longley

Mary Moss Longley, who dubbed herself 'a Depression Baby,' was born in Dyer, Arkansas. Prior to her birth, her father, Charles Moss, and her mother, Gladys, 'hoboed' around the country looking for work. Her father's dream was to run the family farm in Dyer, Arkansas with his brothers, but the Great Depression changed that. Once Mary and her older sister Martha were born, the family travelled to other states where they had relatives. These moves were frequent, taking them to Little Rock, Arkansas, and Pittsburgh, Pennsylvania, back to Dyer, then returning to Little Rock. The next change of locale was to Bakersfield, California, where Charles worked an oil rig. The family then travelled to San Jose, California, causing the Moss family to earn the title of true 'Depression Vagabonds,' but Mary loved these times with her many aunts, uncles, and cousins. When back in Dyer, Arkansas, Mary graduated from high school, after which time the family put down some roots in California between Bakersfield and San Jose. An industrious Mary worked in the Del Monte canning factory in the summers to earn tuition money for San Jose State College.

On a blind date Mary met James Kent Longley, recently discharged from the Navy. He and his brother Ted were both attending Stanford University when the brothers went on a 'double' blind date. Mary introduced Ted to her friend, Virginia Rust, and it was love at first sight for both couples. For the next two years the four of them went everywhere together, driving into San Francisco on double dates to attend plays, the ballet, dances, and concerts. It was these experiences that unleashed Mary's love of the Arts. Mary and Kent married on June 3, 1950, honeymooning on Catalina Island, followed by Ted and Virginia marrying in the same month. The two newlywed couples moved to Henderson, Nevada, where Kent and Ted worked in their father's business, Longley Construction Company. It was not long until the four of them moved into the Las Vegas area. They bought homes next door to each other on Ninth Street, an area considered to be on the edge of town. The two couples lived there for the next forty years, raising their respective families. Mary and Kent Longley became parents of four children: Kathryn Lynn, James Vance, John Kent, and Laurie Beth. Life was good for this close-knit family, living on the edge of town.

NOVEMBER 28, 1929 – JUNE 14, 2017

Being born with a need to be in service to others, Mary soon found her niche by working tirelessly for Griffith United Methodist Church and the Church Women United. If there was a job to be done or an opportunity to serve, Mary was

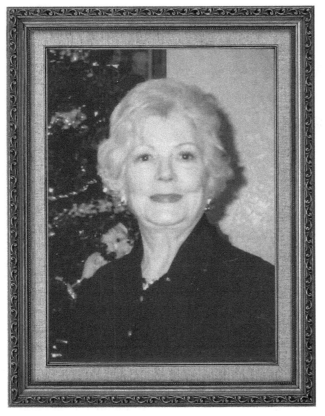

the first to volunteer. She often chaired church dinners for over 100 people with seemingly no strain at all. She oversaw the Candy Striper aides at Southern Nevada Memorial Hospital, while holding down several Salvation Army Women's Auxiliary chairmanships. She was a proud member of the Mesquite Club of Las Vegas since 1973, serving on the executive board and chairing many committees. She especially enjoyed singing in the Mesquite Club choir, under the direction of Gladys Martin. The group called themselves 'Gladys' Martinis and her Olives!' The Mesquite Club and Mary were a match made in heaven, where she could not only assist wherever needed, but she could share her natural gift for entertaining, hostessing, and decorating at the many Mesquite Club events. Still she found time to be an ardent supporter of the Nevada Ballet Theater, the Las Vegas Philharmonic Symphony, and the Nevada Opera Theater. Being community minded, the Longleys were very faithful Patrons of the Arts.

Her sense of pride in her country prompted Mary to become a member of the Daughters of the American Revolution, using her Patriot ancestor James Adams of South Carolina as proof of her lineage and eligibility. She took her passion for her heritage one step farther; learning that she was eligible to join the Colonial Dames Seventeenth Century, she joined through an ancestor who arrived in America prior to 1700.

When her husband retired in 1988, the Longleys built a lovely home in Boulder City, which commanded a stunning view of Lake Mead. They became very active in the Boulder City Grace Community Church. Even though they were getting up in years and Mary's health was failing, the Longleys always saw to it that their church Christmas dinner was held in their lovely home. Mary became a member of the Silver State Chapter of DAR and the Boulder City Chapter of the P.E.O. Sisterhood.

Mary Moss Longley exuded style and grace combining them with compassion and sincerity. Her dedication in giving to others was one of her strong suits. The many organizations she joined were the fortunate beneficiaries of her kindness and hard work, as Mary Longley was driven to serving others to the best of her ability. She was no doubt responsible for untold amounts of financial help that these organizations gave to the community, as she wholeheartedly gave of herself. She epitomized the gentle qualities of a charming southern lady, while at the same time rolled up her sleeves like a Rosie the Riveter and got the job done. She not only made a difference in every group that she affiliated with but she made a distinct difference in the lives of those she touched. Mary was an inspiration to others, and those who came in contact with her felt they were better for having known her.

—Joan Dimmitt

Frances Ruth MacDonald

Frances was born in Philadelphia, Pennsylvania and graduated from high school there. There must have been a spark in her nature as she was hired to be the assistant to the owner of a school specializing in practical nursing.

During her young professional years she met her future husband, Richard MacDonald Sr., forever referred to as Mac. They married and Frances' nature took over as she attempted to organize his vacuum cleaner sales business.

Frances and Mac had two children, Richard and Doug.

The couple loved to travel and it was said, humorously, that there was a 50/50 chance they would move to wherever they vacationed.

On one of those trips in 1958 the young family journeyed across the United States to Las Vegas for the first time. Frances, Mac, and the entire family in tow—complete with her mother, Edith—landed in Las Vegas ready for action. On one of their first nights out on the town, the young couple walked into the Desert Inn and found themselves shooting craps at the same table with Frank Sinatra and The Rat Pack. They knew this was to be their new home!

One year to the day, the MacDonald family pulled into Las Vegas towing a U-Haul trailer behind a 1952 Cadillac. Their two children, mother Edith, and all their worldly possessions in the U-Haul completed the scenario.

The Sahara Hotel hired her to manage their coffee shop. She soon met and became friends with numerous entertainers and others in positions of importance in hotel administration as everyone eventually stopped by for a bite.

A typical day started with work and then dinner with the family, but then the night lights glowed and off Frances and Mac would fly in to the nightlife of Vegas. Lounge shows were enjoyed, followed by breakfast somewhere in the wee hours; the next day might produce a wild adventure of horseback riding through the desert or perhaps some target shooting.

In the mid 60s, Frances and Mac vacationed in Hawaii and true to their gypsy nature, the island of Oahu soon became home to the MacDonald family. Frances discovered another talent—direct sales. She rose to the top of a very successful business of cemetery plot sales, a booming market in Hawaii at the time. She made such a 'killing' in the cemetery industry that she was able to set up an override for herself, her husband, and a good friend— the top three sales agents in the entire market.

The next logical move for Frances was to move to land sales. She became one of the top real estate professionals in Honolulu and in 1971,

MAY 5, 1924 –
JANUARY 8, 2017

Frances, Mac, and their oldest son, Rich, formed MacDonald and Associates Realty.

With more of that sparked energy to harness, Frances opened a new business: a jazz nightclub called Brino's in the Waikiki Illikai Hotel. Their youngest son, Doug, was becoming a fine jazz guitarist and she often featured his talents. But after two years of real estate by day and jazz clubs by night, it all proved too much, even for Frances. The family made a decision to sell Hawaii and move back to Las Vegas where their other son, Rich, had moved only months earlier.

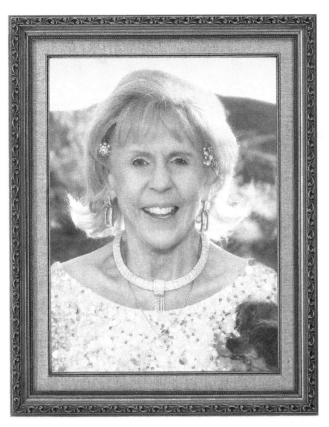

While they still lived in Hawaii the MacDonald family began to acquire Vegas valley property in large parcels at incredibly attractive prices. They sold interests in Las Vegas land as well, which proved to be wildly successful for the family. In fact, Frances and her family became one of the largest private landowners in the Las Vegas valley!

The new decade of the 1980s produced fortunes for the MacDonald family; the land they had acquired they now sold as home sites, making Macdonald Highlands and MacDonald Ranch of Henderson some of the largest subdivisions in the state.

You'd think Ms. Energy would be content to rest on her assets. She and Mac grabbed Las Vegas again by the social graces and called all their entertainer friends and acquaintances to announce they were back to party once again!

Legendary were the parties held at Frances and Mac's penthouses. Although they loved the MacDonald Ranch area, the couple was more prone to the city nightlife, making their home on top of buildings.

The Regency Tower on Bel Air in the Las Vegas Country Club was a favorite haunt on so many occasions, particularly New Year's Eve.

When the stylish Turnberry Towers on Paradise Road were built in the early 2000s, Frances moved Mac over to the Tower One Penthouse. And the lavish parties continued. It was not uncommon to have 200 to 400 people in attendance with many of them being entertainer friends who stopped by to perform after their strip shows. Bars were aplenty, food was sublime, and the entertainment was Vegas' finest because they were all Frances and Mac's friends!

Although the couple lived high in the Turnberry, they also held court was below—in the legendary Stirling club. They were fixtures of fun for everyone lucky enough to know them.

Frances survived her beloved Mac and continued to frequent her favorite haunts, such as Peiro's. She would sneak in a good game of chance when she could as well.

Frances passed at the young age of ninety-two. She was close to her beloved family of two sons, three children, and great grandchildren.

The MacDonald legend lives on in the magnificence of MacDonald Ranch.

—*Susan Houston*

Betty Van Winkle Mahalik

Transforming lives was Betty Mahalik's passion. As a professional certified coach, corporate trainer, public speaker, entrepreneur, and published author, she taught people how to communicate effectively, set goals, manage stress, and deal with change. Betty also served in the Nevada Chapter of the National Association of Women Business Owners, the Las Vegas Chamber of Commerce, Nevada Professional Coaches Association, and the Las Vegas Summerlin Rotary Club.

Born Elizabeth Elnora VanWinkle in Albuquerque, New Mexico, she was nicknamed Betty from the start. Her family moved to Las Vegas in 1962 when her father got an accounting job at the Nevada Test Site. Betty started her journey of encouraging others while she supported the Clark High School teams as a cheerleader.

Betty earned a bachelor's of science degree in Broadcasting & Mass Communication in 1975 from the University of Utah and worked as a television news reporter and anchorwoman in 1978–79 at the KVBC station in Las Vegas. She was also a familiar face on PBS pledge drives, acting as host for many years.

Betty took graduate-level courses in counsel-

August 20, 1953 – October 12, 2014

ing at UNLV while working as a communications specialist at the college from 1979 to 1984.

She founded her company Dynamic Solutions Coaching and Training in 1987 and ran it for twenty-five years, providing coaching and training to hundreds of people and helping them transform their lives. Betty worked with groups from public utilities, convention attendees, hotels, government agencies, professional organizations, chambers of commerce, and other businesses.

In 1989 Betty graduated from the ten-month Leadership Las Vegas program hosted by the Las Vegas Chamber of Commerce and served on several planning teams for both the youth and adult leadership programs. In 1998 she completed a two-year program for professional coaching with Coach University.

In 2001 she wrote and self-published a communication tips booklet called *101 Secrets of the Master Communicators*. Betty also began writing a weekly online blog with motivational messages called Monday Morning Coach which she published to subscribers in weekly emails and through her Dynamic Coaching website.

In 2004–05, Betty served as president of the Nevada Association of Women Business

Owners Southern Nevada chapter. She oversaw the group's annual Women of Distinction Awards ceremony, which benefited the Women's Development Center. Betty was quoted in a newspaper article at the time saying, "The significance of these awards is that women have made incredible contributions to not only the business community, but the greater community at large." In 2007, Betty was chosen and honored as the recipient of the Women of Distinction Award in the Human Resources, Training, and Development category.

Betty earned the Professional Certified Coach (PCC) designation from the International Coach Federation in 2007 and became active with the local Federation chapter and the Nevada Professional Coaches Association. Also in 2007, Betty's inspirational theories were published in Volume three of *101 Great Ways to Improve Your Life*, which she co-authored with leaders in the personal development industry.

Then Betty wrote *Living a Five Star Life: A Path to Greater Joy and Reaching Your Full Potential*. So much of Betty's attitude about life shines through in this book. Betty's introduction in the book states, "With your decision to read Living a Five Star Life, you have embarked on a journey to the heart of yourself."

An editorial review of her book stated, "Betty Mahalik is a life coach who has written a book that is loaded with wisdom and life-changing insights. It takes you on a journey into your own heart and empowers you to live your life with greater joy, authenticity, and fulfillment."

In 2009 Betty became a certified coach with Compass Life Coaching, a company that provides accessible and affordable life coaching programs and services. Constantly wanting to improve her skills, Betty continued with her studies at the Institute for Social & Emotional Intelligence and received her certification as a social and emotional intelligence coach in 2012.

Betty was active in the Las Vegas Summerlin Rotary Club as a program chair. She worked with the International Relief organization ShelterBox and was appointed as this organization's first volunteer ambassador in Las Vegas in 2012. Betty said, "I am truly excited about the opportunity to let people know about the ShelterBox program and to help raise funds to support their global relief efforts." In 2013, Betty served as rotarian president and was named Rotarian of the Year.

A few words of wisdom from Betty's writings: "Just three steps: challenge the belief, make the commitment, take actions consistent with your goal … and you're on your way! And maybe, just maybe, that 'impossible dream' you've held for so long is already on its way to being born."

After a courageous thirteen-month long fight against breast cancer Betty passed away at home at the age of sixty-one. Staying positive throughout, she journaled the events in hopes of helping others understand the battle. Betty's passion will live on as her articles, blog posts, and books continue to transform lives.

—*Michele Tombari*

Ruth McGroarty

uth McGroarty believed in the rights of individuals and planted many seeds within the community of Las Vegas and Henderson through her charity work. She had unparalleled strength, deep faith, with a wry and wonderful sense of humor. She saw no obstacles, only opportunities.

Ruth Palmer McGroarty was born in Greencastle, Indiana to Lula Etta Burke, a direct descendant of Edmund Burke, and John Thomas Palmer. She married James Michael 'Jim' McGroarty (deceased 1989) in 1940 in Beverly Hills, California, with the then-Monsignor Fulton J. Sheen assisting in the Mass.

Ruth worked with Coldwell, Cornwell, and Banker for several years and then became a stay-at-home mom before moving to Las Vegas, where she became active in the Las Vegas community.

Ruth helped build St. Anne's Catholic grade school in Las Vegas in 1954 and started St. Ann's first PTA as president and was assisted by Mary

**JUNE 13, 1918 –
FEBRUARY 8, 2015**

Barnett, her close friend of over fifty years. The Saint Anne Catholic School Community, a ministry of Saint Anne Roman Catholic Church, is committed to the fundamental obligation to teach and live the Gospel message as well as preparing students to be productive, responsible, and effective members of the world community. The school prepares students for lifetime service to God and the quest for knowledge.

Over the years, Ruth and her husband built Crestview Estates, Bel Air, and many other custom homes throughout the Las Vegas valley. Crestview Estates is just one of the developments that features a neighborhood in Las Vegas consisting of mostly large homes that are very reasonably priced. It is to this day a well-established community that continues to attract interest from buyers looking in the Las Vegas area.

Ruth started the Construction Control Corporation in 1954, which disbursed millions of

Ruth McGroarty saw no obstacles ... only opportunities.

dollars for banks, owners, and savings and loans in construction projects for over fifty years.

Ruth was the second female licensed contractor in Southern Nevada. Qualification for a contractor's license is determined by written management and trade examinations, extensive and detailed investigation of the applicant's qualifications, background, ability, experience, competence, general character, and established proof of financial responsibility. The process provides some assurance to the Board and to the public that a licensee is competent and qualified at the time of initial licensure.

Ruth was also the first female insurance broker in the state of Nevada. Insurance brokers are trained professionals in insurance and risk management solutions that help individuals and businesses find insurance policies that best meet the needs of their customers.

Ruth opened and worked in the sales department at Caesars Palace and then moved to the Landmark Hotel, working in the casino junket department.

Ruth's charity work was always a part of her life. She was named Mother of the Year in 1979, was a member of the Catholic Daughters since 1984, built her own charity Life Line Pregnancy Assistance project, and left her mark on the community as well on the many lives she helped.

Ruth McGroarty—great-grandmother, grandmother, mother, wife, friend and mentor, a resident of Las Vegas for over sixty years—passed away in her ninety-seventh year.

—Denise Gerdes

Marie McMillan

A true pioneer in women's aviation and a resident of Clark County, Nevada for over fifty years, Marie Elizabeth Stever Daly McMillan was born in Exeter, California to Eva Marie and James Martin Stever. From as far back as she could recall, Marie was totally captivated with listening to, observing, and studying aircraft. As a Campbell high school student she also had a passion for studying flight history.

Marie attended the University of California, Berkeley. While a student there she continued to show an interest in aviation when it was the exception for a lady to do so. She acquired an associate of arts degree while there and remained there working on campus. During this time, July 1945, she married her high school boyfriend, Duke Daly, in San Jose, California. The couple had two children, Michelle and Jack Daly. They bought a ranch in Fresno, California.

Marie was employed next by the National Laboratory in Livermore, California, where she worked with physicists. The Dalys traveled back and forth from Livermore to Las Vegas, working at the Nevada Test Site. In 1959 the family moved their houseboat to Lake Mead and built a house in the Twin Lakes area

of Las Vegas. Her husband passed away in 1961. Meanwhile, Marie was running the ranch in Fresno, California and working at the Nevada Test Site.

Marie's children were away at private schools when she met Dr. James McMillan one night while both were taking flight lessons. He was a dentist providing dental service to those at the Nevada Test Site. By 1963 Dr. James (Mac) McMillan and Marie were married and she never looked back. It is important to note that they were an interracial couple in the 1960s: he was a divorced dentist and father of two and she a widow with two kids; he was a leader in the civil rights movement of the era and she became his steadfast partner.

In 1963 Marie's dream of someday flying an airplane came true! At the North Las Vegas Airport, then known as Thunderbird Field, Marie completed ground school and took her first solo flight on Memorial Day of that year. In 1970 she received her private pilot's license at the age of forty-four. She then went on to earn her U.S.F.A.A. Commercial Certificate, her Single Multi-engine Land and Sea License, her Instrument and Glider Ratings License and her Certified Flight Instructor Certificate. In

AUGUST 1, 1926 —
MARCH 24, 2019

1978, she set her first flight speed record from Fresno to Las Vegas. She went on to set a total of 328 U.S. National Records and 328 International/World records.

Marie is a world record holder with The Federation Aeronautique International and set records for Speed over a Recognized Course in the Caribbean and over Mexico. She was the first woman to establish records in Mexico, second only to Charles Lindbergh. The watch she wore on that flight is now displayed in the Rolex Museum in Geneva. She was a U.S. Delegate to the Federation Aeronautique International World Conferences in Czechoslovakia, India, Bulgaria, and Hungary.

She then became a certifying representative for the Federation's record-breaking Voyager around-the-world flight. She was a member of the Flying Ninety-Nines, instructing and mentoring many young female pilots. She instructed many flight students over twenty-five years including teenagers and the Las Vegas Metro Police. She served as the Clark County Department of Aviation public information representative at McCarran Airport and contributed to her community by speaking to young people and civic organizations.

Marie carried out various mercy missions carrying doctors, nurses, medical supplies, and equipment to Mexico while directing Liga International, Inc. She also worked with Wings for Direct Relief, shipping medical supplies to South America via a California port.

Marie then continued her education, earning a bachelor's degree in anthropology and ethnic studies from UNLV in 1994 and a bachelor's in gerontology from UNLV in 2004.

She received many awards including the Angel Derby, Award of Merit, the Amelia Earhart Medal (twice), various Powder Puff Derbys Las Vegas, Award of Merit, Woman Pilot of the Year, Foremost Women of the 20th Century, Notable American Women, National Aeronautique Association Elder Statesman of Aviation and 99 International Forest of Friendship. She was a member of the National Anthropology Honor Society (Lambda Alpha), National Omicron (Psi Honor Society), Order of Artic Adventures North of 60 Degrees Chapter, the Federal Aeronautic International, National Aeronautic Association, Civil Air Patrol, Soaring Society of America, Women in Aviation, and Silver Wings Fraternity.

Marie's husband of thirty-five years passed away in 1999. By that time Marie was a highly acclaimed and accomplished seventy-three-year-old. Yet that did not deter her from doing much more community service. The last twenty years of her life she continued to grow and make a difference in the community as well as Clark County, her adopted home for over fifty years.

—*Mary Gafford*

Patricia Starks McNutt

'Pat' was born to DJ and Agnes Starks in Conklin, Michigan. The family included her brother John and her sister Nancy Starks (Prince) in Stanton, Michigan, with its folksy, small-town atmosphere.

From age three, Patricia grew up living near Robert 'Bob' John McNutt. As a child she considered him a friend. Yet she never would have guessed that Bob would become her suitor, her husband, and her partner throughout her adult life.

After her high school graduation Patricia attended Michigan State College. It was then that she decided to change her profession to nursing. She then attended and graduated from the Butterworth Hospital School of Nursing.

During this time, Pat and Bob began dating. According to Pat, Bob became amazingly handsome, especially in his service uniform during World War II. That was when their friendship blossomed into love.

Having attained her degree in nursing in the spring of 1947, she married Bob McNutt on July 12, 1947. The newlyweds lived in various parts of Michigan for a number of years and then moved to Scottsdale, Arizona with their two daughters, Marcia and Jane.

OCTOBER 20, 1925 –
OCTOBER 20, 2017

Once the McNutts were settled in Arizona, Pat became interested in home economics. To this end, she attended ABU in Phoenix while carrying out her full-time duties as wife and mother.

It was in 1962 that the McNutts relocated to Las Vegas, Nevada. Pat became the director of the Foxtail Girl Scout Council and worked as camp advisor. During those years she felt she had found her niche in life. Working with youth was a tremendously rewarding undertaking for her.

Pat McNutt enrolled in the Southern Nevada University, now called University of Nevada Las Vegas. The same year her daughter, Jane McNutt McCoy, received her diploma from Clark High School, Pat completed her college degree in elementary education. A teaching position in a local elementary school was offered and accepted soon thereafter.

Although both Pat and Bob worked fulltime, they and their daughters prided themselves on sharing many great experiences throughout the years. They enjoyed boating, camping, and traveling together; all enjoyed a well-rounded family life. Many experiences occurred at the First Presbyterian Church of Las Vegas, which was located on West Charleston Blvd at the time. Both Pat and Bob

were Skippers for the Nautilus Mariners of the church.

Because of her dedication and endless volunteer hours as a member of the Presbyterian Women's United group, she was made an Honorary Life Member. At one time an ordained elder of the First Presbyterian Church of Las Vegas, Pat was junior and senior high school director, a Sunday School teacher and an advisor to the Nevada Youth Presbytery. She served both as moderator of Presbyterian Women in her church and of the entire Presbyterian Women in Nevada. Selected as director of the First Presbyterian's Private Academy school, Pat saw the enrollment go from 33 to 180 students over a six-year stint. At that time there was a horrific church fire, which led to the closing of the private school.

During her teaching years, Pat was quite respected. As an active member of the teachers' union of the Clark County School District, she served as vice president. This organization continuously strove to improve the quality of student education and the quality and morale of the teachers.

After serving as vice president of the Las Vegas branch of the American Association of University Women, she was elected president 1988–1990. During this time, equal pay and treatment of women in the workplace was of high interest. The organization was and still is emphasizing the importance of women working to reach their full potential in all walks of life.

For many years Pat was quite active with her sorority Delta Kappa Gama. She served two terms as president of the Gama Chapter of Delta Kappa Gama Sorority International. Also, her contributions of time and talents were noted throughout the organization. As a result, she was awarded the Rose of Rose Recognition, as well as a certificate of appreciation for all her efforts.

During her years teaching, Pat received an award for assisting in the creation of the Clark County School District's Master Plan for Excellence in Education. In fact, she was active in myriad conferences, planning activities, and parent-teacher activities while teaching at CCSD.

In 2008 Bob McNutt, the love of Pat's life, passed away. Thus she moved from their home to the Las Ventanas Residence for Senior Citizens.

Pat's grief at losing her husband did not deter from her community service. She continued volunteering time to her church, sorority, the Mesquite Club, and numerous other organizations. She gave countless hours striving to make a difference in Clark County until her health failed.

—*Mary Gafford and Jane McNutt McCoy*

Maya Miller

Maya Miller, noted Nevada activist and philanthropist, was born in Los Angeles, California.

As May grew up, she had an ever-quenching thirst for knowledge. She first attended and graduated from Principia College located in Elsah, Illinois. She earned her master's in English from Cornell University in New York, and then began her doctorate at Stanford University.

It was when she was at Stanford that she met and married Richard Miller, an oil engineer. In 1945, soon after her marriage, Maya and Richard moved to the Reno, Nevada area in Washoe County. Maya taught English at the University of Nevada, Reno.

After a few years of teaching, Maya began a family: her daughter, Kit, and her son, Eric. Maya and Richard then shifted their energy toward parenting.

Maya had an interest in politics and was spurred on to activist activities during the late 1950s in the Washoe County community. At this time, Maya inherited a large amount from her parents. Her concern for the environment led her to co-found the Foresta Institute for Ocean and Mountain Studies with a mission to motivate youth about the importance of conservation. To this end, the Millers held summer youth camps at their ranch for quite a few years.

During that period, Maya financially backed numerous foundations and leaders that in her opinion promoted the following: women's rights, conservation, and racial integration. By this time, Maya and her husband were divorced.

Maya was noted for her organizing support of and active involvement in League of Women Voters, and was on the local Board until 1969. Then she resigned so she could actively protest the Vietnam War. President Nixon added Maya Miller's name to the 'enemy list' because of her negative comments and protests about the war.

Maya's activism continued in the 1970s. It was then that she protested the denial of a black woman being allowed to take a census taker's job. That action led to her arrest.

Maya was involved in the creation of Lake Tahoe as a state park in 1971, and participated in the dedication ceremony.

In 1973, Maya worked with a Nevada welfare group in Carson City, Nevada. When Nevada legislators ate lunch in front of welfare marchers, they offered the marchers their food scraps! Maya was so outraged—after

JUNE 29, 1915 –
MAY 31, 2006

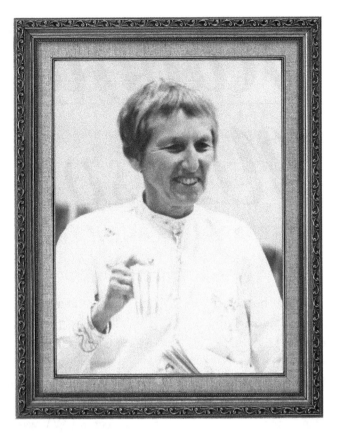

her comments she lost her lobbying privileges and was forced to apologize to the Nevada State Legislature.

In 1974 she ran and lost the race for United States Senate against Harry Reid. She won the support of Senator Reid, however, who admired her for her fervent concern for a better United States.

Maya was a strong force in the creation of the Women's Campaign Fund in Northern Nevada. Maya was determined to achieve parity for all women in public office.

The Nevada Women's Fund was founded in 1982. Its mission was to strengthen Nevada's community with empowered women. Its inception was in Northern Nevada, but Maya made sure its impact was felt throughout the entire state with nearly $6.6 million raised for the cause. Maya was instrumental in getting educational grants as well as funds for aging, mental health, and anti-violence via this funds.

At the beginning of the Gulf War in 1991, Maya was in her 70s, and as a member of Madre, an international women's human rights group, she assisted in getting $100,000 in female and infant supplies and medicine into Iraq. She even drove the truck herself from Bagdad to Jordan!

Since 2000, Maya Miller was involved in the establishment of Nevada's Women's Lobby, a nonpartisan coalition that promotes equal rights for women. Ironically, when it established the Maya Miller Egalitarian Award, she was the first honoree.

The myriad contributions of time, energy, and money given to her adopted state are amazing and too voluminous to mention all of them. Some include: American Association of University Women, Emily's List, Global Exchange, Citizen's Alert, Progressive Leadership Alliance of Nevada, opponent for Nuclear Dump in Nevada.

Throughout her years in Nevada Maya was highly respected for her determination to stand up for women's rights, for the down-trodden, and for anti-violence. She definitely was a pacifist who stood up for her beliefs, even when she was in the minority. She shall always be remembered in Nevada as a humble female philanthropist promoting Nevada and human rights.

—*Mary Gafford*

Naomi Millisor

Naomi Udell Millisor was born in Beloit, Wisconsin and graduated from Beloit Memorial High School in 1956. Naomi's activism began early, giving swim and dive lessons in a Beloit municipal pool every summer as a teenager. Naomi married Ray Millisor when she was eighteen and moved to Phoenix, Arizona, then Yuma and finally Tucson. The family moved to Las Vegas on Nov. 1, 1961, where she lived until her death. She had three sons—Todd, Greg, and Brad—four granddaughters, and five great grandchildren.

Naomi was employed for twenty years with the State of Nevada, first at Employment Security, the Senior Investigator for the NV Equal Rights Commission, and finally as the D.U.I. Adjudicator at the DMV, and was always a member of A.F.S.C.E union.

Naomi became active immediately in Las Vegas with various civic activities. She joined the Easter Seal Society, serving as president of the Guild, providing swimming lessons to handicapped children and adults. She also gathered signatures on a petition drive to get a library in Clark County, which became a reality on Flamingo Road: the Clark County Library. She and others protested and were photographed at the Henderson City Dump while open burning, in clear violation of air pollution laws, shouting, "Why isn't anyone doing anything about open burning?"

AUGUST 30, 1938 — MARCH 15, 2017

Naomi joined the League of Women Voters (LWV) and was their office manager for many years at Christ Church Episcopal. She was the office manager for the LWV Open Housing office and served on the Economic Opportunity Board for twelve years, serving as chair in 1987. Her first project in LWV was 'Know Your Country' research, including interviews and discussion for a later study. Naomi conducted surveys of the public and compiled 3500 questionnaires to preserve Red Rock Canyon and Spring Mountain. She also coordinated bus tours of the area for legislators, BLM, State, and National Park officials. She participated in a LWV study to preserve Tule Springs and in 1964 was involved in a study on parks and proposed a County Park Commission. Naomi was in the Observer Corp of twenty-three members who attended county, city, highway, fairs, and recreation planning meetings. She was involved with the 1965 study of Appointment of Legislature and the 1965 study on Planning and Zoning, a two-year study, "An Evaluation of United States Policies Toward the People's Republic of China," and a study on Home Rule. Naomi was involved with many league activities, including the National Water Study publication, political education classes for Girl Scouts, League Day at the Legislature, the Evaluation of Childcare Centers in Clark County publication, the Welfare: Exploring the Myths film, the

Children in Trouble: A Look at Problems of Delinquency in Nevada publication in 1970, a Current Review of State Parks, in 1970, a Clark County, Nevada: A Factual Book on Local Government, a 1971 grant to hold the Nevada Air Quality Conference, and many 'Meet the Candidates' events. Naomi and others led the movement in the desegregation of the Las Vegas casinos. She proposed that the Nevada Legislature meet annually and held forums and open houses regarding full school integration. When the NAACP sued the Clark County School District, the League filed an amicus brief.

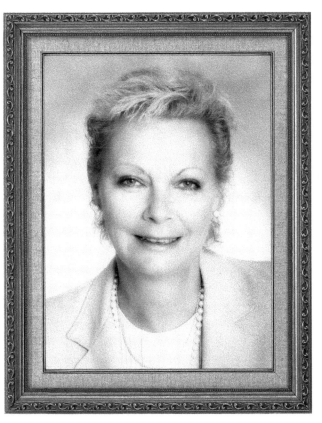

As her feminism blossomed Naomi became involved in the E.R.A. campaign, which was a brutal loss for the state and the nation. She also became coordinator for the Las Vegas chapter of the National Organization of Women (N.O.W.) and the state coordinator in 1984, the same year she was elected delegate to the Democratic National Convention in San Francisco. Later, she served on the steering committee for the Campaign for Choice and Pro-Choice Advocacy in 1990. Naomi gathered more than 1000 signatures for the Referendum Petition to keep abortion safe and legal in Nevada. Along with other activists, she marched each Saturday morning for six months to protect clients at Family Services Clinics. She also marched on the Las Vegas Strip for welfare rights. Naomi participated in the March on Washington twice and started boycotts and demonstrated in front of the Supreme Court.

Naomi was a registered Republican, but after learning about issues in the League said, "Oops, wrong party," and was re-registered by Harriet Trudell as a Democrat in 1974. In that year she became the office manager for the re-election campaign for Governor Mike O'Callaghan. Naomi served in the same capacity for many other campaigns, including Bob Coffin's campaign for Congress against John Ensign in 1996.

Since 1976, Naomi has been a member of both the Clark County Central Committee and Nevada State Democratic Central Committee, a member of Women's Democratic Club, Paradise Democratic Club, Henderson Democratic Club, and many others. She served as the Entertainment & Tour Director for the Nevada State Democratic Party bus trips to Tonopah for more than twenty years. Naomi was elected treasurer of the Nevada State Democratic Party in 1986 and 1990. Naomi was employed as the office manager of the Nevada State Democratic Party from April 1999 until her death.

Naomi Millisor possessed a wealth of information about Nevada, Clark County, and Las Vegas. She was called incessantly for information about a plethora of subjects, most notably the political parties and candidates. She mentored many people through the years, and her sage advice is sorely missed.

—Denise Gerdes

Bernice Jenkins Moten

Bernice Moten was the first black elected to the Clark County School Board and was an outspoken advocate for the rights of minorities and the poor.

Bernice Moten, who also went by the name Birdia Bernice Jenkins, was born in Ware County, Georgia. She moved to Las Vegas when she was twenty-four-years-old to teach at Madison Elementary School. At that time blacks were only allowed to teach at predominantly black schools in Southern Nevada.

She taught at Madison Elementary School for eight years, then at Matt Kelly Elementary, and then William Orr Junior High School. She also taught at University of Nevada, Las Vegas for two years.

During these years and throughout the 1960s, Bernice raised money for scholarships for needy children that she witnessed first-hand in the teaching career. She worked endlessly to make it possible for needy children to obtain a good education in Clark County, Nevada.

Bernice was a Clark County School District social sciences teacher from 1958 until 1970, when she was appointed the equal education consultant to the State Department of Education, where she conducted teacher training

APRIL 16, 1934 —
APRIL 20, 2000

sessions and worked to close the cultural divide between various ethnic groups and races.

Bernice decided to run for the Clark County School Board in 1972. She had good reason to do so, since there was no high school and only one junior high school in the black community at that time, and all but one of that area's elementary schools had been shut down.

Bernice ultimately ran for the Clark County School Board in District C, which included large populations of black residents in West Las Vegas and North Las Vegas. She campaigned for new schools in the black community, the improved teaching of job skills in public schools and lower pupil-teacher ratios.

As the only minority member of the School Board, Bernice Moten strongly voiced opposition to the school district's desegregation plan developed after U.S. District Judge Bruce Thompson of Reno ordered Clark County schools to desegregate in 1972.

The plan was for white sixth graders to be bused into sixth grade centers in predominantly black West Las Vegas and for black first through fifth graders to be bused to predominantly white schools around the valley.

Bernice Moten did not like this plan. "We

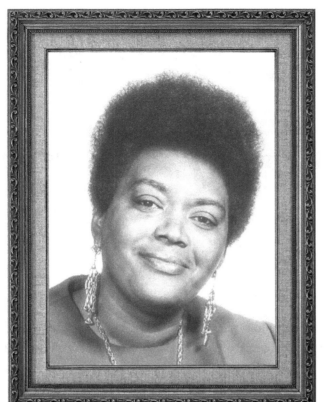

West Las Vegas residents never asked for this plan. Busing is breaking up the sense of community in our children."

Reverend Marion Bennett, a longtime friend of Bernice's, supported the district's desegregation plan at that time, but said Bernice's fears had merit. "I have to admit she turned out to be right," Bennett said. "While some diversity was achieved through desegregation, the school district failed to follow up on programs to improve education for blacks and just shipped our kids out of West Las Vegas. Bernice was a totally committed schoolteacher, dedicated to achieving a better quality of life for West Las Vegas."

Bernice Moten collected 57 percent of the vote to defeat Reverend Leo Johnson, Lamar McDaniel, and Owen Woodruff. In her May 1976 announcement that she was stepping down from the Clark County School District Board five months short of her term she said, "This is my 20th year in education. I'm tired of it now." At that time she decided to continue her education at the University of Pittsburgh on a Carnegie Foundation grant.

In the 1980s Bernice returned to Nevada and served as an administrative assistant to Governor Richard Bryan. Bernice remained in Nevada as a Las Vegas resident for the rest of her life.

Bernice Moten was highly acclaimed in the State of Nevada. She received many awards through the years, including Teacher-Mother of the Year in 1970 and an award in leadership and commitment from the League of Women Voters in 1976.

She did human relations work for the Ministerial Alliance and the National Association of Colored People (NAACP) and was a member of the NAACP, League of Women Voters, the PTA, and the Frontier Girl Scouts.

Former Governor Mike O'Callaghan remembered Bernice Moten as "a very bright person with a good grasp of government. Her ability to argue without anger was her greatest asset."

"She was a pioneer educator and a highly regarded community activist," said Governor Richard Bryan. "Bernice was outspoken and committed to the unvarnished truth. She would never sugarcoat her opinions."

In 2000, Bernice traveled to visit her son, Fred, in New York City and then to Georgia to spend time with a friend where she fell in her friend's garage and broke her leg. Later, following surgery of a heart attack at a Georgia hospital, she passed away.

Bernice Moten led the way for black women in Las Vegas and Clark County and the State of Nevada and will be remembered as an outspoken advocate for the rights of minorities and the poor.

—*Denise Gerdes*

Barbara Mulholland

Barbara Mulholland was proud to share her birthdate with President Lincoln, which inspired the nickname, 'the Baberaham.' Barbara Linden Mulholland was born to Rene Linden and Mildred Caccavo in Detroit, Michigan. In 1948, when she was six-years-old, her mother passed away. Her father then married Rosanne Rudesill. They raised Barbara and her four siblings in a Detroit suburb, Grosse Pointe, Michigan. Barbara attended high school and college in Michigan and in 1965 moved to New York City to pursue a career in advertising.

Barbara quickly acclimated to New York, and even took a cab to the hospital for her daughter Megan's birth, because her husband, Tim, was at work. With her contagious laugh, engaging smile, and warm personality, Barbara made friends wherever she went. After all, she never met a stranger.

In 1970 the family moved to Wilton, Connecticut. Barbara gave birth to a daughter, Heather, and a son, Patrick, while the family lived there and enjoyed their home "with a small red barn in back."

Following a divorce in 1977, Barbara and her three children moved to Las Vegas. Once there, Barbara worked at Saks Fifth Avenue, in the casino business at the Tropicana Hotel, and for the

FEBRUARY 12, 1942 –
JUNE 17, 2016

Las Vegas Pro-Am Golf Tournament, as it was called then. With determination and perseverance and high value for education, she put her three children through Bishop Gorman High School.

In 1983 Citibank opened a credit card processing operation in Las Vegas and Barbara was the fifth employee hired in an operation that would eventually employ thousands of people. At that time, the bank was the second largest private sector employer in Nevada. Barbara became the senior vice president for community affairs, or as she liked to put it "I give away the bank's money."

But Barbara did so much more in this position. At the peak of her leadership in community affairs, the bank's philanthropic contributions averaged $5000 to $15,000 per year per charity, about $1 million a year. When she needed to turn down organizations' requests for funding, she would then help them with advice and mentoring, showing them guidelines and procedures that would demonstrate to future potential donors that they would be responsible in spending their (gifted) money.

One example was her support of Foundation for an Independent Tomorrow, started by Janet Blume to help train the unemployed to get jobs. Mulholland suggested the foundation's efforts might include basic financial education, like how to write a check and how to reverse

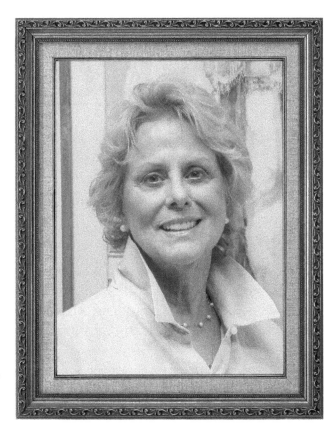

bad credit. Blumen listened and the bank provided computers so clients could complete vocational plans online.

Under Barbara's leadership, many local organizations benefitted. Citibank's philanthropy supported many diverse organizations including Communities in Schools, Nevada Ballet, Three Square, After-School All Stars, and many others. The organizations did not just get financial assistance; they got Barbara. With her tireless dedication came training and expertise focused on transparency, efficiency, and accountability. By educating non-profit organizations, she revolutionized philanthropy in Las Vegas. She retired in 2014, but her impact on the community and charitable giving continues today.

After her retirement, she briefly indulged her passion for drawing by taking classes at UNLV. However, it didn't take long for her life's work of helping others to take center stage again. Barbara became a volunteer at WestCare Foundation's Women and Children's Campus, where programs and services across the continuum of health and human services are offered to improve the lives of vulnerable women and children. With Barbara's help, they recently celebrated the largest grant the facility has ever received, and as a result more women and children's lives will be touched, changed, and saved. Barbara would say, "The women and children need help more than I need flowers."

Shannon Carducci lamented after her passing, "I had the honor of meeting this amazing woman over twenty years ago. She was such a beautiful spirit and lit up a room with her smile and grace. She was truly beautiful inside and out. I loved running into her over the years and getting those amazing hugs and squeals of joy. Her beauty and heart lives on in her daughters. She will be missed by so many that loved her. I pray for peace and comfort for Megan, Heather, and Patrick, grandkids, and the rest of her beloved family. My heart is broken for you all. She was a true class act!"

"The sunshine has gone out of a lot of people's lives, including mine," said longtime Las Vegas attorney Stanley 'Stan' Hunterton, Mulholland's companion of twenty-five years. "She was a persistent optimist who never gave up on helping anyone."

—*Denise Gerdes*

Laura Myers

Throughout her career, Laura Myers bounced between humanitarian work and journalism, taking her all over the world. And she loved both paths.

Laura was born in Las Vegas and was raised and educated mainly in Northern Nevada, graduating from the University of Nevada, Reno.

Her journalism career began in 1984 at the *Reno Gazette-Journal*.

"She was a consummate professional," said former U.S. Sen. Richard Bryan, then governor of Nevada. "Her stories were always fair and balanced. She represented what a journalist ought to be in terms of her standards and her professionalism."

"All the traits that served her so well over the years were evident—alert, fair, thorough, fast, hard-working, fearless, always up for the next assignment," said Brendan Riley, the AP correspondent in Carson City in those days. "I really enjoyed working with Laura. Anyone who has covered a legislative session in this state knows that the pace can be unrelenting, the demands extreme. Laura made it look easy.

"Seven years later, Laura moved on to Washington, D.C., and had an assignment as a top AP editor at the Democratic National Convention in Chicago," Riley said. "She worked on a story with such intense focus that you could sense it across the crowded pressroom."

AUGUST 26, 1961 — JUNE 19, 2015

She spent more than seventeen years on and off with the AP starting in 1987 in the Reno bureau. She later worked in San Jose and San Francisco, helping with coverage of the Los Angeles riots in 1992, before Johnson tried to recruit her to the wire service's Washington, D.C., bureau.

Instead, Myers took a few years off to work as a Peace Corps volunteer in West Africa.

In a hand-written note to an AP hiring manager sent from Kenya in 1995, she noted her travels. "The air atop Mt. Kilimanjaro sure is thin, and the Victoria Falls in Zimbabwe is something to behold!"

With the Peace Corps she learned French and taught villagers to farm fish. Several months after the 1994 Rwandan genocide, she managed logistics at a refugee camp in what is now the Congo.

"Laura was ferociously interested in the world and in the stories people had to tell. She left journalism to go to film school and luckily, I was able to talk her into coming back to help with coverage of the wars in Afghanistan and Iraq," said Kathleen Carroll, executive editor of the AP.

"She worked relentlessly with reporters and editors in the field, asking smart questions, stitching together bits of intelligence from reporters scattered around the world to frame interesting, intelligent stories. She made us better for a very long time and we were lucky to be her colleague."

Myers was the political editor for the AP during the 2000 presidential election. "She was literally my right arm," said Sandy Johnson, president of the National Press Foundation.

Johnson said the story was "in the hands of the best political editor possible."

Later, Myers led the news agency's foreign affairs, military, national security, and intelligence coverage as the country reeled from the Sept. 11 terrorist attacks and went to war in Afghanistan and Iraq.

"Myers was the first to arrive and last to leave and worked through Christmas leading coverage when a tsunami hit Indonesia in 2004," Johnson said.

She spent nearly a year training journalists at Arabic and French-language newspapers in Algeria and built houses for Habitat for Humanity in Uganda and Mongolia. She traveled to China for a fellowship and studied filmmaking at New York University and acting at the Atlantic Theatre Company, volunteering for a theater company in Washington, D.C. by building sets and managing lighting.

"And this is all while being the hardest working journalist I've ever worked with," Johnson said.

After leaving *The Associated Press* in 2008, Myers taught English in rural Egypt.

Johnson said she tried to coax Myers back to Washington, D.C., but Myers opted to become the *Las Vegas Review-Journal*'s lead political

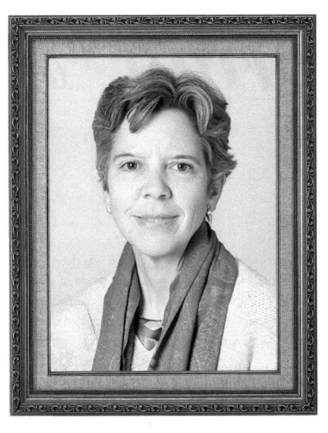

reporter in 2010 when she covered the U.S. Senate race between Sen. Harry Reid and Sharron Angle, the state's caucuses in 2012 and the 2014 midterms dominated by Republican victories in the state.

"She was somebody whose courage and tenacity was like nothing I've seen in a journalist," said Michael Hengel, executive editor of the *Review-Journal*.

The newspaper gave Myers its 2014 Editor's Award for Excellence, and also nominated her as the Nevada Press Association Outstanding Journalist of 2015.

The *Las Vegas Review-Journal*, where Myers had been the newspaper's lead political reporter since 2010, reported that she had been diagnosed with colon cancer in 2013. Hengel said Myers was still working up until the last few weeks, drawing on reserves to report political stories for the paper.

One of her close friends was former *Review-Journal* City Editor Laura Wingard recalled that, "Laura had political insights way beyond her years, and her energy and persistence in pursuing a story was unbelievable. But journalism wasn't her life. Laura, at her core, was a humanitarian. We often joked that she was 'the good Laura' and she was. Good at journalism and good at making the world a better place. And she was a good friend who will be terribly missed by me and so many others."

Laura passed away at the age of fifty-three.

—*Denise Gerdes*

Georgia Neu

Artistic director, program director, actress and Las Vegas' first lady of Professional Community Theatre.

"To stop acting because I have a theatre company is ridiculous, a silly concept," said Georgia Neu.

How can one describe this multi-talented woman who came to Las Vegas, Nevada in the early 1980s with the intention of starting her own theater company? She had a strong, no nonsense determination to break through the barriers that she found when she arrived.

Las Vegas was filled with Strip entertainers and actors, some formally trained, but all were dominated by a culture that was deemed somewhat amateurish with actors who received little pay or recognition. Their talents were dominated by artistic directors who took all the credit for the hard work of their companies. Georgia saw this and was determined to change things. Armed with professional credentials and experience as a professional actress, dancer, and singer on Broadway, she had the knowledge and tools to be a successful artistic director in this 'frontier town.' Georgia was motivated and encouraged to set a new standard for community theater and beyond.

Georgia was born in Cincinnati, Ohio in the late 1940s. She started out as a classical dancer. She earned her degree in musical theater from the University of Cincinnati. Later on, she also earned her master's degree in education from Sierra College in Reno, Nevada.

She was determined to survive in the competitive world of show business even though she also was qualified to take a job in the teaching field . She often made enemies of those who tried to discourage her, but she gained the reputation of being fair and compassionate, especially to the students and artists under her care.

She burst onto the Las Vegas community theater scene taking on the role of Elizabeth Proctor in *The Crucible*, by Arthur Miller. According to the critics and arts reporter, Paul Atreides, of the *Las Vegas Review-Journal*, she stole the show and the community was hooked, begging for more of her performances. She took roles in several local companies including *The Lion in Winter*. In 1986, Georgia, encouraged by her success, approached the staff at Spring Mountain Ranch, Super Summer theatre, to mount a production of *Guys and Dolls*. She also made this production her debut as the artistic director of the newly formed Actors Reparatory Theatre. It was eventually billed as the only professional acting company in the city of Las Vegas. It was opined that before Georgia arrived, there was no professional theater company, but from her example many younger actors and directors have found their voice. Today there are numerous professional community theaters in the Vegas Valley.

She preferred the model of reparatory rather than open casting. She was interested in developing the professionalism of the same actors by teaching them to play characters that seemed out of their personal scope, thereby

JULY 30, 1949 – AUGUST 26, 2014

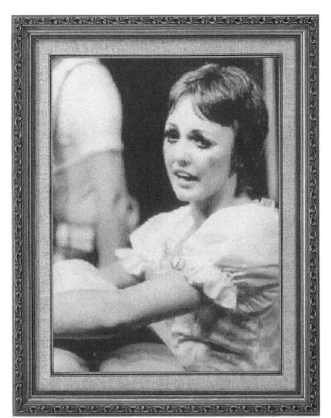

achieving more depth of meaning to the plays. She believed this could not be achieved without the reparatory method. Open casting required the choosing of new personnel with each production. Georgia chose high quality actors to participate in her company. She produced plays that were available directly from Broadway using playwrights such as David Mamet, Wendy Wasserstein, Arthur Miller, Shakespeare, Ibsen, and Shaw. She also produced, directed, sang, and acted in musical theater productions with live musical accompaniment including: *My Fair Lady*, *Fiddler on the Roof*, and *Man of La Mancha*. As her popularity grew, the performing spaces became too small to accommodate a larger audience. She then became instrumental in convincing the Clark County Library to expand their facilities to include a performing arts auditorium and stage. What we see today is in part due to her stubborn efforts and vision. The majority of the Clark County Library branches now have performing stages and auditoriums.

Georgia was committed to empowering women through her work as an actress and teacher. Many of her plays encouraged the liberation of women from their traditional, subordinate housewife roles. She acted in the *Heidi Chronicles* by Wendy Wasserstein, "Shakespeare's Women," a series of excerpts from Shakespeare's plays, and in plays by Ibsen from the 19th century, such as *A Doll's House*. In the era of the 1910s through the 1990s, the theater and plays were written that encouraged young women to take charge of their own lives and learn the tools, through education, to challenge the established order of things. Art and the theater helped to create the social change that came about because of her contribution and that of other committed, professional artists.

This still remains a 'work in progress' for other Georgia Neu archetypes to take up the torch.

Unfortunately, insurmountable debt and lack of financial support forced the closure of ART in 2001; however, Georgia kept on going and worked for the betterment of society. She became the regional director of the Anti-Defamation League in 2010. She was also program director for Nevada Humanities between 2006 and 2008 and program manager for Nevada Humanities at University of Nevada at Las Vegas from 2008 to 2010. In her journey to make a difference in Nevada, she was honored with awards by Women of Achievement, Women of Diversity, and Women of Distinction.

—*Norma Jean Harris Price*

Jean Evelyn Slutsky Nidetch

Jean Nidetch was an American business entrepreneur who, as an overweight housewife, enlisted her friends to help her stay on a diet that led to her weight-loss empire, Weight Watchers. Founded on May 15, 1963, Weight Watchers changed the way that we approach dieting. After receiving a glowing endorsement from Oprah Winfrey, by the beginning of 2018 there were a record 4.6 million members.

Born in Brooklyn, New York to David Slutsky, a cab driver, and Mae Slutsky, a manicurist, Jean grew up in New York. Her mother often used food as a way to comfort her children. As a result, Jean became a compulsive eater. Nidetch graduated from Girls' High School and received a partial scholarship to Long Island University. However, because of a lack of financial resources, she did not attend. When her father died in 1942, Jean dropped out of a business course at City College of New York and began working. Her first job was at a furniture company in New York, and she later worked for a publishing company as well as the Internal Revenue Service (IRS), where she met her husband, Mortimer. They had two children, David and Richard. Richard died in 2006.

Jean struggled with weight throughout her early years, and after a friend mistook her for being pregnant, she decided to finally lose the extra weight. In 1961, after trying many fad diets, she lost twenty pounds on a diet recommended by the New York City Board of Health. However, her resolve began to weaken, and so she invited several overweight friends to her Queens, NY, apartment to be a support group. She finally realized that she needed a community to hold her accountable. Within two months, forty women were attending the meetings. Before long, her group developed into weekly classes that emphasized personal responsibility, physical activity, and a diet containing fish rather than red meat. Because the women met to talk about their progress and to keep each other accountable the program worked. By October of 1962, Jean had lost seventy-two pounds and had reached her 142 pound goal weight. The other participants also met their weight-loss goals. Nidetch had attracted, by word of mouth, hundreds of people who wished to join the group.

In a movie theater in Queens in 1963, Weight Watchers was launched and soon became a weight-loss empire. There was a $3 membership fee, and members were provided with a nutritional diet that banned sweets, fatty

OCTOBER 12, 1923 –
APRIL 29, 2015

foods, and alcohol. The psychological component, however, was the revolutionary part of the Weight Watchers program. Members were provided with AA-style meetings, supportive books and magazines, journals, camps, and television forums. Nidetch developed rules for members and recruited group leaders. Her business thrived, and by 1968 it operated franchises nationwide and completed a sold-out initial public offering. There were five million people enrolled in the program. Weight Watchers became a huge success. In 1978 Weight Watchers was sold to the H.J. Heinz Company. By the year 2000 there were over twenty-five million members in twenty-nine countries. Today the company is world-wide.

From the very beginning, Nidetch was the inspiring face of the corporation. She had a perfect platinum blonde hairdo, a flawless style, and a no-nonsense approach to weight loss. The plan was successful, and she was the living embodiment of its success. She wrote several books and became a celebrity. In 1971, she divorced her husband, moved to Hollywood, and dated Fred Astaire. One of her best friends was Maya Angelou. The ten-year anniversary celebration of Weight Watchers was held at Madison Square Garden, and many celebrity guests, including Bob Hope, were present. In 1975 Jean married again, but only for a few months, to a bass player she met on a cruise

After the sale of Weight Watchers, Jean Nidetch remained on as a consultant to the company. In addition, believing in education, she established scholarship programs at UCLA and UNLV. She also paved the way for women in the corporate world. Having achieved the success that she did, she wanted to share it with other women, helping to empower them so that they could bypass the obstacles that she faced when she was starting her business.

From 1991 to 2006, Jean Nidetch lived in Las Vegas and was a beloved member of the city's philanthropic community. In 1993 she gave one million dollars to UNLV to build the Jean Nidetch Women's Center. The Center plans and promotes events to raise awareness of issues facing women on campus. A scholarship program, as well as many other programs, are her legacy, helping thousands of women through their UNLV years. Jean also was a supporter of the UNLV Foundation, Opportunity Village, and the Nevada Ballet Theater.

In the early 1990s, Congresswoman Shelley Berkley met Jean and spoke highly of her. She said, "She was very confident in her abilities, and with good reason. She was a pioneer when it came to women in business."

In 1993, UNLV granted an honorary degree to Jean Nidetch. In 2006, she moved to Boca Raton, Florida to be closer to her son, where she died from natural causes.

—*Nancy Fiorello*

Janet Michael Nitz

Janet was born to Agnes and Darrell Michael in Brookings, South Dakota, where she was raised and met her husband, Owen W Nitz. They were married on August 2, 1957.

In 1960, the couple settled in Las Vegas, Nevada, where Owen began a successful law practice. Jan began a life of raising her daughters and serving her family, including working and tirelessly volunteering for the community.

Jan worked as a court clerk for the Honorable John Mowbray, District Judge of the Eighth Judicial Court, and was active in some of the most famous political campaigns in Nevada, including working for U.S. Senator Howard Cannon, for U.S. Senator Harry Reid (early on for his Las Vegas mayoral campaign), and working on the campaigns of Senator Richard Bryan as he ran for state assembly, attorney general, governor and ultimately, as his campaign funding accounts manager, when he twice successfully ran for and was elected to the United States Senate.

Jan was a tireless volunteer and supporter

**OCTOBER 19, 1938 —
JUNE 20, 2014**

of many local charities, including the Mesquite Club, the Service League, the Junior League, Attorneys Wives, and finally the Assistance League of Las Vegas. Together Jan and Owen attended countless charitable functions, including the Foundation for Independent Tomorrow (FIT), Chefs for Kids, Juvenile Diabetes Research Foundation (JDRF), Junior League, Opportunity Village, Andre Agassi Foundation's Grand Slam for Children, Nevada Ballet Theatre, UNLV Foundation's annual event, and many others, always generously donating to each cause.

In September of 2005, following the terrible calamity and loss of life and property caused by Hurricane Katrina in Mississippi, Jan organized a donation program and filled a large semi-truck load of much needed clothes and personal items which was then driven to the IP Casino Resort & Spa in Biloxi, Mississippi, and distributed to the many survivors in need of help. From 2005 to 2009 Jan and her husband flew almost weekly to

"... If you were a friend, you were treated like family; if you were an acquaintance, you were treated like a long-time friend."

Biloxi, Mississippi as it recovered from Hurricane Katrina.

Jan and Owen traveled the world over during their fifty-seven years, both together and as a family. They visited all the continents except Antarctica, adding Cabo San Lucas and Mazatlan, Mexico in 1970.

Jan was a model hostess and together with Owen (always the life of the party), held legendary parties over the years. According to those who knew her, when in Jan's house, if you were a friend, you were treated like family; if you were an acquaintance, you were treated like a long-time friend. Between 1989–2000 she and Owen annually hosted a very popular and patriotic 3rd of July Party for 250 to 300 or more of their BFFs (Best Friends Forever). The parties were a throwback cookout celebrating family, friends, and our country. On three different occasions she hosted the University of Wisconsin Marching Band, Bucky Badger, and the Wisconsin cheerleaders in her backyard and private park for a pep rally and a celebration of collegiate life that included the generous donation of an instrument to the

school band. These occasions included dancing an old fashioned mid-western polka with Owen and all the invited Cheese Heads as the band played on. Jan also hosted an annual Christmas Eve open house, three weddings, countless Easter egg hunts, birthday parties, anniversaries—any event that needed a party, Jan was up to the task as the most gracious hostess.

Janet Eileen 'Jan' Nitz died on the last day of Spring after a valiant, hard-fought ten-month battle with cancer. Flowers or donations in her name to her favorite charity, Opportunity Village, were suggested.

Jan spread love and joy throughout the community during her seventy-five years of life. That love was returned tenfold by the many friends who sent cards, flowers, cooked meals, or took the time to visit while she fought her battle. In her memory the family suggested that to all who knew her: Please don't hesitate to volunteer, host a party, or just give a friend a big hug or a stranger a warm smile.

—*Yvonne Kelly*

Carolyn J. Randall O'Callaghan

Born Carolyn Jean Randall in the city of Twin Falls, Idaho, Carolyn attended University of Idaho at Moscow, where she met Michael O'Callaghan. Carolyn was an excellent athlete, winning tournaments in bowling and pro-am golf championships. Her athletic days were numbered, however, when she took a bad fall on the icy sidewalk in Carson City, causing her to endure several months of back surgery and recovery. In 1954 she married Mike and soon moved to Las Vegas where her husband was offered a teaching position at Basic High School.

Carolyn was a lady of many interests. In the late 1960s she worked as a school bus driver. A collector of fine guitars, she taught music and guitar in Carson City. In 1970, her husband ran for and was elected as the first governor from Southern Nevada. She embarked on an eight-year journey as the First Lady of Nevada alongside her husband.

According to Carolyn, her role as first lady was to support her husband so he could run the state. In her taped interview for the Women of Diversity, Nevada Women's Legacy, she described herself as a 'busy body.' One memory she shared was regarding the prisoners who were permitted to work at the Governor's Mansion. She believed in second chances and mentored the workers without judging them or telling them what to do with their lives.

She hosted such events as blood drives and benefits for charities at the Mansion. She tells of Halloween Nights, one in particular where they had a 125-pound pumpkin with a carrot nose. She referred to the people of Nevada as "one big family." According to her son, Tim O'Callaghan, Carolyn always "considered the mansion as the people's house."

Carolyn is described as a caring and compassionate person. On one occasion she invited protestors picketing against her husband's motorcycle helmet stance to come inside the Mansion for coffee, hot chocolate, and lunch. She explained to her husband arguing that, "They came all the way from Las Vegas and it's cold outside."

DECEMBER 15, 1935 – AUGUST 7, 2004

As Nevada's first lady, Carolyn engaged in activities including helping hospitals and the homeless. She loved to cook for her family and she loved helping anyone in need.

While she enjoyed her time as first lady of Nevada, she was also happy to leave. She returned to Las Vegas with her family at the

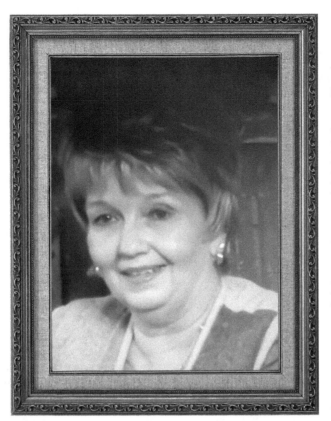

end of Governor O'Callaghan's second term where she settled into a new role as a co-publisher of the *Henderson Home News* and *Boulder City News* with her husband. She was said to be instrumental in the success of the papers, engaging early on in the advertising and circulation. She was helpful in all areas of production. In 1988 she was working at the paper when the Pepcon blast happened in Henderson, Nevada.

"It was organized chaos," Carolyn said in a 1998 interview. "I was leaning over a page doing one of any number of items that seemed important … when the first one of two booms hit. Dust flew and it felt like the roof lifted and dropped." She sprang into action. 'BOOM' read the headline in that Thursday's edition of the *Home News*.

Carolyn's husband, Governor Mike O'Callaghan, died March 4, 2004 from a heart attack during mass services. Throughout her life she "quietly took charge," and this time was no different. Her husband's death was said to be hard on Carolyn; however, she hid her pain from the public and tried to carry on as normal.

Carolyn took the reins as comforter-in-chief. She shared in his achievements such as the Mike O'Callaghan Middle School, the Mike O'Callaghan Federal Hospital, and the Mike O'Callaghan – Pat Tilman Memorial Bridge.

Carolyn was recognized with her husband by Headsup Guidance Center of Nevada, a division of O'Callaghan Family Services as "A legacy of the preservation of basic human dignity … more valuable than silver or gold."

She was known as the O'Callaghan Family Matriarch. Her children are also her legacy: Michael O'Callaghan, Esq. Tim O'Callaghan, Deacon, Brian O'Callaghan, Colleen O'Callaghan-Miele, Editor, and Teresa Duke.

"Whether it was Carolyn's husband, her children, or the broader Nevada Family, there was no one in this state more consumed with doing good for other people than Carolyn O'Callaghan," said *Las Vegas Sun* Editor and President, Brian Greenspun. " … She taught all of us to be better people …"

Governor Kenny Guinn called her a "wonderful first lady, wife, mother, and grandmother." Former Assembly Speaker Joe Dini called Carolyn a "very gracious lady" and an "outstanding mother and a real asset to the state."

Mike O'Callaghan, Esq. remembers his mother as "a class lady, an outgoing woman who knew how to party," further stating she carried "the sophistication that the Governor's Mansion needed."

Tim O'Callaghan remembered how his mom would get up early, put on a pot of coffee, and sit at the kitchen table with the mailman, milkman, and others discussing the issues of the day.

Daughter Teresa Duke said, "She was a lonely person in a crowd, but she found solace in her grandchildren."

Senator Reid summed it up when he said, "She died of a broken heart."

—*Cynthia Dianne Steel*

Rene O'Reilly

Honored by Clark County in 2001, 'Mother of the Year,' Rene O'Reilly was recognized for her valuable and longtime contributions to family, and for her community service. This woman personified caring, courage, and foresight in her commitment to many throughout her life. Even as she faced death, she never ceased thinking and working on behalf of others.

Ms. O'Reilly was born and raised in St. Louis, Missouri. She came to Las Vegas in 1969 when her husband, John, an Air Force attorney, was transferred to the legal office at Nellis Air Force Base. The family remained in Las Vegas during and after her husband separated from the military. Mr. O'Reilly went on with his legal profession, and was later appointed to the Nevada Gaming Commission where he later assumed the role of Chairman of the Commission.

Rene engaged her life in volunteer work while supporting her husband's professional and volunteer activities as they raised their four children. Her children said of their mom, "They were raised with love and understanding and without judgment." Rene was a strong supporter of the importance of education, encouraging and supporting her two sons, Bryan and

**OCTOBER 1, 1945 –
JUNE 14, 2012**

Timothy O'Reilly, and two daughters, Molly and Erin, as they pursued their education resulting in the completion of their college bachelor degrees. Rene and her husband focused their philanthropy on education, helping non-profit youth organizations and supporting the University of Nevada at Las Vegas (UNLV).

Ms. O'Reilly was a volunteer worker at University Medical Center (UMC) caring for neonatal critically ill babies. She also worked with We Can, an organization that addressed the issues of child abuse and neglect. In addition, she worked with the Assistance League in helping to provide clothing to needy children. She was always there for any child in need of help, opening her arms and doors to her children's friends who needed a bed to sleep in, or just someone to listen. She was the shining light to her four children and her seven grandchildren who called her Nana.

She was also a member of Junior League and Legatus and past president of the Clark County Attorneys' Wives Association.

As a Eucharistic minister at Our Lady of Las Vegas, she and her husband developed a program for couples preparing for marriage through a program called 'Engaged Encounters.' Together they instructed engaged

couples on the importance of a solid foundation for a successful partnership in marriage.

Perhaps her greatest legacy began when she was diagnosed with breast cancer in 1985. She fought the disease and survived the cancer. Unfortunately, she was again diagnosed in 1995 and 1996. Again, she set out to battle the disease while continuing her work in the community. They treated the cancer with chemotherapy, but because the doctors didn't know where the cancer had originated, they knew this treatment wasn't going to save her life as she was fighting a throat and lung cancer.

At sixty-one-years-old, this brave woman had to again face and fight this disease. Rene finally and courageously enrolled in a clinical trial study, the only one of its kind in the United States at that time. Dr. Dipnaring Maharaj from his Boynton Beach, Florida practice directed a clinical study whereby patients were infused with white blood cells to attack the destructive cancer cells. The donors needed to have B-positive blood, be between the ages of twenty and thirty-years-old and have no close history of cancer. It was very difficult to find people to meet the criteria necessary to pursue the treatment, which in no way assured that Rene would be cured. It was a long shot, but she went forward with the help of her son David Lee and the encouragement of her husband to pursue the project. They took up the

challenge to find participants who were able to meet the criteria for this stem cell research. When UNLV found out about the difficulty finding donors in Florida for this project, a grassroots effort was initiated by Sarah Saenz, at that time undergraduate student body president. She arranged to have CSUN post on their website the need for donors here in Las Vegas. Rene was initially resistant to the idea of advertising for help through the university system, because she didn't want to call attention to herself and her illness. She finally agreed to the process because she felt the research might at some point help others. Even after receiving help from the Las Vegas community and numerous other sources, Rene O'Reilly passed away.

Ms. O'Reilly's legacy was her pioneering spirit in the development and groundbreaking of stem cell clinical research study, and use of stem cell cancer and regenerative medical research. She had hoped her participation in this research study might benefit future cancer victims.

A hero and crusader for cancer research, Rene gave as she always had, her everything to help others. She has been a 'one of a kind' in leading our Las Vegas Valley in the way of using stem cell research in treatment of cancer. Although as yet there is no complete cancer cure, the progress which has been made is owed to unselfish and courageous people like Rene O'Reilly.

—*Lois Evora*

Trudy A. Parks

rudy Anise Parks was born in Los Angeles, California, into a family of civil servants. With close relatives in law enforcement, politics, and social work, Trudy always knew her path would involve community service.

Bernard C. Parks, her father, worked in law enforcement, as did her grandfather, Earl Parks. Bernard also was active in politics, while Trudy's mom, Carolyne 'Isis' Fuqua, had been a singer, songwriter, and minister. Trudy's grandmothers, Gertrude Parks and Leola Williams, did social work and helped community organizations.

After graduating in the early 1980s from St. Mary's Academy, an all-girl Catholic high school, Trudy began college to study social work. She knew she wanted to serve young people.

Trudy married Karl Jackson in 1985 and had two children, Gabryelle and Nicholas. After divorcing, Trudy and the children relocated to Las Vegas, Nevada with its lower cost of living in 1993. Working fulltime, Trudy managed to raise the children and still pursue her college degree. In 1995 she and Reginald Allen, her life partner, had a son, August. Trudy adopted son Zak in 2002.

In May 2000, Trudy's twenty-year-old niece, Lori Renee Gonzalez, was slain in a gang-related incident in Los Angeles. The devastating event strengthened Trudy's resolve to be a problem solver, not a passive observer.

So Trudy changed her major to focus on establishing and developing programs. She also began working for After School All-Stars, which keeps at-risk kids in positive activities during normally unsupervised times.

That job led to additional employment with WestCare Nevada, a live-in facility for young Las Vegas females with acute drug problems and extensive behavioral and emotional issues. While at WestCare, Trudy noticed that within thirty days of completing the program, a high percentage of teens would return. After spending time with returnees, she realized the high recidivism rate was linked to a lack of tools to help clients make the transition from a childhood of abuse and neglect to healthy adulthood.

Trudy graduated summa cum laude from the University of Nevada Las Vegas in 2005 with a bachelor's degree in recreation and leisure. She formulated a business plan to launch group homes. Her organization was called Next Step: Xposure to Life Group Homes, providing troubled teens with shelter, tools and the skills to take their 'Next Step' toward becoming viable, independent adults. Trudy wanted to 'Xpos' her teen clients to the

AUGUST 2, 1964 –
AUGUST 21, 2010

vision of a productive, positive future.

Trudy went on to partner with her mother, who had a doctorate and co-founded The Foundation for the S.T.A.R.S., Souls Taking Action Reaching Souls. This non-profit reaches out to underprivileged youth in inner cities. As a result, Trudy's Next Step: Xposure to Life Group Homes became a branch of S.T.A.R.S.

In addition to her own children, Trudy also had an assembly of foster children whom she influenced positively, and who loved her very much. Through her group homes, Trudy cared for more than ninety young people.

In December 2006, she opened her first group home location in Las Vegas. The Lori Renee House, named after Trudy's beloved niece, was a safe and nurturing home for young women, ages fourteen through eighteen. But Trudy continued to build her dream, launching four more houses by 2009. Because of the increasing number of young women in need of these services, the Little Sisters House opened its doors in January 2008 for girls ages twelve through eighteen. In October 2008 Trudy opened Fuller House to help and house young males ages eleven through eighteen. In November 2008, Caring Adolescent Mothers (CAM) House opened to give shelter, prenatal care, parenting classes and encouragement to teens who are pregnant or have newborns. Trudy created the Sibling Houses in April 2009 to help minimize the pain of separation when the foster system separates siblings into different homes after being taken away from a parent.

Trudy also developed a program called Empowered Women-A Sisterhood, to expose Next Step teens to the benefits of networking with other goal-oriented young women. Participants design and carry out community service projects around Las Vegas and take trips to other cities.

Sisterhood members shared their life stories in innovative forums, and came to recognize their strengths, embrace their pasts, and raise their self-esteem. Trudy designed the sisterhood to inspire young women to love themselves and live extraordinary lives, regardless of how their lives began.

Trudy also launched a weekly teen talk radio show on the Internet, which allowed the youth of Next Step to discuss topics of interest to their age group.

Upon her death, her group homes were forced to close, as no one with the proper credentials and licenses was available to continue them. But Trudy's spirit continues to shine in the numerous lives she touched.

—*Denise Gerdes*

Wanda Lamb Peccole

Wanda Lamb was born in Alamo, Nevada, a small farming community about ninety miles north of Las Vegas. Her parents, William Grainger Lamb and Marion Paris Lamb, and grandparents, were one of the original pioneer families who settled in Lincoln County, Nevada in the early 1900s, where her parents were ranchers. The family was quite large with seven boys and four girls: brothers Floyd, Sheldon, Bill, Phil, Larry, Ralph, and Darwin and sisters Myrtle, Erma, and Fae. Wanda attended Alamo Grade School and Pahranagat Valley High School.

Shortly after she graduated, she moved to Henderson in 1945 with her mother and brothers. She first went to work at the City of Las Vegas Fire Department, and then became the personnel director for the City of Las Vegas. During this time, she met William 'Bill' Peccole, who was a City of Las Vegas Councilman. They were married on January 24, 1953. The couple had three daughters; Laurie was born November 1953, Lisa born in 1955, and Luann was born in 1957.

With three of her cowboy brothers active in Nevada political offices, Wanda was always a political activist and community supporter of the

NOVEMBER 6, 1928 –
JUNE 15, 2011

growth of our city. Hostessing parties attended by well-known Nevada politicians and professional people, those who contributed to the early growth of Las Vegas, Wanda was one of the many people who shaped the city and state that she called home.

Wanda was a devoted student of life and the arts. Her support ranged from the UNLV Library, The UNLV Center for Performing Arts, and the Wanda Lamb Peccole Center for the Arts at the Meadows School in Las Vegas, as she always gave back to the community she loved.

Wanda and Bill had a vision for Las Vegas and started the Charleston Plaza Mall, Las Vegas' first indoor shopping center, and later developed the Westland Mall.

She and Bill were the driving force behind and were responsible for the development of some of Las Vegas area's most beautiful communities. In 1993, the Peccole Nevada Corporation was established by Bill and Wanda to bring to reality their dreams and carry on their legacy. Along with their daughters, Laurie Bayne, Lisa Miller, and Leann Goorjian, and their sons-in-law, Bruce Bayne and Larry Miller, they set out to establish a master planned community on 3,000 acres located

on the west side of the Las Vegas Valley.

Beginning with the construction of Canyon Gate, a residential golf and tennis country club development, followed by Peccole Ranch, a planned community of over 2,000 homes with an elementary school and many community parks and walking trails, the community grew.

As advocates of education, community safety, and the arts, Bill and Wanda donated the land for the Sahara West Library in Peccole Ranch, the Durango Fire Station, and later established the Wanda Lamb Peccole Center of the Arts at the Meadows School.

Wanda worked as an advocate for the people of Nevada as a political activist and community supporter. She was very involved with the politics in Clark County and was a member of the Women's Democratic Club. She was a campaign manager and advisor for many local candidates.

Wanda and Bill developed a state-of-the-art medical and surgery center, and the Thomas & Mack Medical Plaza, which brought medical convenience and services to the community.

Queensridge was the next project that evolved in 1995, where 1,000 acres of desert was transformed into a private, guard-gated enclave that surrounds a twenty-seven-hole Johnny Miller/ChiChi Rodriguez designed golf course. This unique golf course was built on arroyos and foothills, utilizing the land and its resources in a way that was ahead of its time. With large custom and semi-custom homes, this community enjoys lush landscaping, rose gardens, lakes, and breathtaking views of the Spring Mountains, Red Rock Canyon State Park, and downtown Las Vegas.

Bill Peccole lived to see the development of most of his beloved property and passed away in 1999, three days shy of his eighty-sixth birthday.

Wanda Lamb Peccole loved music, poetry, and was a superb cook—especially Italian cuisine. Her last years were spent traveling with her grandchildren and sharing her stories and love with them.

Wanda passed away at the age of eighty-three. She was a wonderful mother and 'Nona' to seventeen grandchildren who were blessed by her life. She leaves behind both a heritage and a legacy that will not be forgotten: "Home Means Nevada."

—*Denise Gerdes*

Sandy Colón Peltyn

Sandy Colón Peltyn started life in San Juan, Puerto Rico and little is known of her youth except she excelled in the arts and humanities at the Inter-American University in San Juan.

Gifted vocally, she had a talent that afforded her a means to leave Puerto Rico. Sandy traveled to Europe and the USA to perform and settled in New York City where she met and married Roger Peltyn. The couple moved briefly to California.

Roger was a young engineer whose career took off after he and Sandy moved to Las Vegas in 1981. He was sought after for the building of most of the strip mega-structures, from all of Wynn's properties to the Venetian, Tropicana, Stratosphere, and others.

Roger joined and commandeered practically every arts organization and Sandy soon followed with her own style of winning over Las Vegas.

If you hired Sandy to be your party hostess or be involved with your event you were assured a wild success.

Sandy would schedule a pre-party, then dinner, then dessert and coffee and then (!) an 'after-glow' party which could run in to the very wee hours.

There was always something she had cooked up for a grand finale.

JUNE 4, 1956 – DECEMBER 1, 2018

Legendary was her BOO BALL held annually as her son R J's Halloween birthday bash. Hundreds would be entertained by gold-painted, almost-dressed gorgeous cocktail servers. Disco dancers would loom high up over your head. Various food displays would be available everywhere. Costume contests with valuable prizes would bring out the kinkiest in most who vied for a prize. After midnight the BOO BALL store would open to buy fantastic items with complimentary 'R J' money.

Perhaps even more grand in scale was her ambitious charitable project—the Foundation of Excellence—established in 2002 with the help of many of Sandy's friends. Sandy nominated notable Las Vegas women to be honored at an annual gala. Senoras of Excellence was born and soon followed the Senores of Distinction for gentlemen.

She was appointed to: Hispanic Leadership Committee by Florida Governor Jeb Bush; the Advisory Committee on the Arts of the Kennedy Arts Center, by President George W. Bush; the Nevada State Board of Medical Examiners; the Board of Directors of Independent Nevada Doctors, by Governor Kenny Guinn; the conceptual committee

144

to launch The Lou Ruvo Brain Institute; Governor Sandoval's inaugural ball committee; the Board of Directors and of the Foundation for Dignity Health, St. Rose Dominican Hospitals; Chairman of the Board, the first Latina so honored, at Dignity Health, St. Rose Dominican Hospitals by Senator John Ensign; one of twenty-four commissioners to perform a feasibility study to develop the National American Latino Museum Commission, by President Obama; the Advisory Board, the Western Governors' University of Nevada; the Advisory Board of Domingo Cambiero Corp; Public Member of the Nevada State Board of Architecture; advisor to the Miss Nevada Pageant 2015; Las Vegas Founding 50, and the Confrerie of La Chaine des Rotisseurs, Las Vegas Chapter.

Her many awards include: Twenty Most Influential Women in Southern Nevada, *Las Vegas Magazine;* Twelve Most Influential Hispanic Women in the Nation, *Temas* Magazine of New York; Hispanic of the Year, Latin Chamber of Commerce, on the cover of *Los Hispanos* magazine. Volunteer of the Year–JDF, Tribute in the 2007 U.S. Congressional Record, U.S. Representative Jon Porter; "Who's Who,"

Travel & Tips magazine; "Who's Who," Southern Nevada Business; Honoree, College of Southern Nevada; Woman of the Year, Epicurean Club; Woman of the Year, Foundation for an Independent Tomorrow; Philanthropist Badge, Girl Scouts of Southern Nevada's Desserts Before Dinner gala; knighted 'Dame of Grace' into the Order of St. John; and Honoree, Philanthropist of the Year, Botanica Las Vegas.

Sandy was fluent in Spanish, English, and Portuguese. She was a volunteer substitute teacher at some point in her life.

Her everyday job was principal of Business Development and Public Relations at DeSimone Consulting Engineers in Las Vegas. She was responsible for securing projects in Las Vegas such as: Tropicana Hotel redevelopment, MGM, The Vdara, Cosmopolitan Resort & Casino, and World Market Center, among others.

Kids for Homeless, Magic Cares, and K-9 benefited from her efforts. Siegfried and Roy were instrumental in aiding her later in two events.

Sandy lost her husband in 2004. She had two sons: R J and a stepson, Michael. A sister Isabel Colon was very close to Sandy.

—*Susan Houston*

145

Mary Markeson Perry

A truly unforgettable Nevada female pioneer who resided right here in Las Vegas, Nevada for many years was Mary Markeson Perry. She was fondly known as 'Mama Maria' and was a true restaurant pioneer within Clark County, Nevada. She passed away at age 102. With an impressive background in culinary arts and restaurant management, she opened a number of food establishments with her family's assistance.

Mary was born in Fort Williams, Ontario, Canada. From her early years she learned cooking with an Italian flair from her family. This talent that she and her sister shared would pay off one day.

In 1937 Mary met the love of her life, Albert F. Perry. They were married in 1937 when they were about twenty-years-old. They're marriage was without a doubt made in heaven, as they remained married for seventy years, until Albert passed away in 2007. Mary Perry was a spry ninety years of age at that time.

MARCH 13, 1917 –
MARCH 27, 2019

How this couple ended up in Las Vegas, Nevada was due to health issues within the family. The Perrys had been living in Niagara Falls, New York, and then moved in 1943 to Clark County. Albert first took a job at the Stauffer Chemical Company in Henderson, Nevada. Mary, with a restaurant background, first worked in the hospitality industry. From that type of work, Mary teamed up with her sister and brother-in-law, Angie and Lou Ruvo, to open their first Italian restaurant in 1955. It was called the Venetian Pizzeria and it was located on Fremont Street. Several years later the restaurant was relocated to West Sahara Avenue.

In 1973 Albert, Mary, and their daughter, Lorraine, as well as the rest of her family, proudly opened what was to be known as the original Bootlegger Restorante. That establishment was opened at the intersection of Tropicana and Eastern.

In 2000, the now renamed Bootlegger Bistro moved to its present location at 7700 Las Vegas Boulevard South.

All of this culinary history, along with the innumerable successes, are attributed to the first quaint, little restaurant that Mary and Albert opened in 1949, and to Mary's sharp culinary background.

Over the years many culinary awards have been presented to Chef Mary, including 'Nevada's 1st Restaurateur of the Year' in 1983 and 'The International Chef's Hall of Fame 2013 President's Award.' Also, Mary Perry has been noted for her culinary accomplishments nationally on many television programs.

Mary was seen on Anthony Bourdain' *Parts Unknown*. Other programs where she was recognized include "Buzz Feed's Bring Me Facebook Page" and *Vegas Cakes* on Food Network.

Mary's daughter, Lorraine Hunt-Bono, former lieutenant governor said, "My mother touched many lives. She was a great inspiration and mentor to me, my son Ron, and his family, and to other family members and friends. Her deep spiritual energy created an aura around her that, once in her presence, you knew your life would be changed forever for the better. Our family called her 'our living angel on earth.' She came from humble beginnings, survived the Great Depression, worked hard, and was able to live the American Dream here in Las Vegas."

This unforgettable Nevada woman was a true Nevada pioneer.

—*Mary Gafford*

Frances Josephine 'Jodi' Peterson

Frances 'Jodi' Peterson, born in rural Minnesota, was given up by her mother, who, for financial reasons, was unable to support her, and was raised in foster care in rural Minnesota. As a teenager, she also spent some time living in a Catholic orphanage. By the age of twenty-one years she was no longer a ward of the state. Despite a difficult beginning in life, Frances turned out to be resilient and resourceful, obviously undeterred by the obstacles life had handed her, and destined for an eventful future.

Perhaps, in part to her upbringing in the countryside, Frances was an avid animal lover. She had many animals in her life, and she loved them all. Her other great love was airplanes; she earned her private pilot's license at the young age of sixteen years. Soon after this accomplishment she was able to buy her first airplane. During her lifetime Frances owned and flew many airplanes including, among others, a military surplus B-17 bomber and a glider. She also owned a bi-wing aerobatic plane in which she performed stunts and in 1968, won

JULY 12, 1924 –
SEPT. 10, 2012

an award under the name of Jodi 'Ace' Gooding at the Nevada State Fair in Reno.

Frances' adventurous spirit and entrepreneurship were in full play throughout her life as evidenced by her many forays into business and relationships. For a short time in her twenties she was a cocktail waitress in Reno, then in the early 1950s she landed in Las Vegas where she was a waitress on the Las Vegas Strip. Next she started a wild animal export business in Costa Rica, where she lived in a jungle hut for several years and shipped monkeys into the United States. It was here that she earned the moniker 'Jungle Jodi.' Her partner at the time, who was like a father to her, was Charles 'Combat' Hudson, the most-decorated bombardier over Europe in World War II, author of the book *Combat*, and later a successful businessman in Los Angeles and Las Vegas. Before she returned to Las Vegas for good, she also spent some time on an avocado farm in California.

We know that Jodi was married at least three

times. One of her ex-husbands was Billy Parker who described her as a 'class act' and a great lady. After returning to Las Vegas and in her sixties she rented a room in her home to man who had read her 'room to rent' ad. To their mutual surprise her renter turned out to be James Cole, an old friend from her orphanage days. They lived together from that time onward.

Later in life, Jodi leased and managed the Tonopah, Nevada airport and owned a popular restaurant at the Oxnard, California airport. She had become successful at buying properties, beautifying them, and then selling them, including one near Ash Meadows National Wildlife Refuge.

Jodi was blessed with many great friends in her life who described her as generous, independent, a hard worker, and the best friend a person could ever have. At age eighty-eight, then a fifty-year Las Vegas Valley resident, she passed away peacefully at her home of twenty years. Jodi will be missed greatly and remembered fondly by her many friends.

—*Yvonne Kelly*

NOTE: In the face of cholera epidemics, the Civil War, and other hardships of pioneer life, many children living in Minnesota in the 1800s were left in need of parental care. In response to that need, the Sisters of St. Joseph opened the first Catholic orphanage in St. Paul in 1856.

Margaret 'Peggy' Comstock Pierce

It is almost impossible to understand what motivates anyone to go into politics, much less a diminutive woman with a few semesters of a Community College under her belt. But there was Peggy Pierce, a native of Milton, Massachusetts, a formidable politician, residing in and serving in the legislature of the State of Nevada from the years 2003–2013.

Peggy had a beautiful voice with dreams of becoming a professional singer. After high school, she went to San Francisco to study with the hopes of being 'discovered.' Apparently, not 'discovered,' Peggy came to Las Vegas to try her luck.

"Reality hit her when she got here. She realized she didn't have the personality for it," said her older sister, Catherine Moyer. "As outspoken as she was, she was really quite a private person." To support herself, she took food service and hotel jobs in Las Vegas and ascended the ranks of the union. She was elected to the Assembly in 2002 and represented a Western Las Vegas district south of Summerlin. During that time she also worked at a job at the United Labor Agency of Nevada.

Peggy was the seventh of eight children and the daughter of an Episcopal priest who was active in the Civil Rights movement. So fighting for the rights of others was in her genes! Peggy advocated and served fellow union workers in Nevada and legislated for higher taxes on the state of Nevada's mining industry, as well as the state's big businesses. In fact, she was one of two lawmakers who broke ranks with Democratic leadership before a special session in 2010, insisting that the state should raise taxes in the depths of the recession.

In 2011, Peggy pushed for steep tax hikes on cigarettes and alcohol and fought to remove 60 percent of the deductions mining companies can claim. In 2013, when business lobbyists opposed a tax plan that aimed to raise money for education, Peggy did not mince words.

"You guys haven't liked anything in the quarter of a century I've lived in this state," she said, adding that should the margins tax become law in January 2015, "you'll have no one to blame but yourselves because all you ever say is no!"

AUGUST 14, 1954 – OCTOBER 10, 2013

Whether her colleagues and fans agreed or not, it was a typical feisty response from Pierce, nicknamed 'honey badger.' Her tweets are worth looking at; for besides all her suffering, she maintained a sharp sense of humor.

Peggy was a relentless proponent of workers' rights and would stand up to the most powerful interests in the State. That was Peggy's legacy. One lawmaker said, "It's going to be really hard without her." Another added: "… she was respected on both sides of the aisle as a hard worker who cared about the people behind the issues."

A relentless proponent of workers' rights, the environment, and more taxes on the mining industry, Pierce was a champion for the people who don't otherwise have a voice; she was incensed about Nevada's tax structure that soaks the working class as well as the poor.

Those who worked with her said she forged ahead for liberal causes at times when her colleagues held back to chart a more centrist course or wait for the green light from the business community. Some of her achievements include coordinating a charity golf tournament that raised $100,000 for the Nevada Cancer Institute; working on air quality problems in Clark County; and coordinating the Helping Hands Project at the Culinary Union to assist 16,000 workers who were laid off immediately after the September 11, 2001 terrorist attack. She was affiliated with the Sierra Club; American Civil Liberties Union; Member, Amnesty International; and former Member of the Clark County Air Pollution Hearing Board.

"She was a huge fighter and overcame a lot of struggles with her health; she showed up at the legislature having just had chemotherapy, because she knew how important it was to represent her constituents." Democrats and Republicans alike praised her, including Governor Brian Sandoval.

Peggy's dream and obvious talent was to be a singer. But someone knew better and put her where she did more good than any singer ever could.

—*Barbara Riiff Davis*

Wendy Plaster

 \mathcal{I} f you looked at new homes in Clark County over the past three decades you most likely witnessed some of Wendy's creativity. Wendy and her husband, Richard Plaster, carved out a highly successful life providing Las Vegans with more than 12,500 homes in the forty-plus years they were the dynamic force behind Signature homes. They employed several hundred employees over those years.

Wendy was born to Roberta 'Bobbie' Korf and Jack Albert Berman in Chicago. The young family moved to southern California when Wendy was five-years-old. She had three siblings: Hilary, Steven, and Mari. In elementary school Wendy had a crush on actor Richard Dreyfuss.

After graduating from Beverly Hills High School in 1965, Wendy went on to study at the University of California, Berkeley and graduated in 1969 with a BA in Russian Literature. She later earned her teaching credentials from the University of Southern California and very briefly taught seventh grade.

Richard's family immigrated to California through Canada from his birthplace in England. As a student, he traveled extensively to such exotic places as India, Iran, and Afghanistan, but came home to study at Stanford and UC Berkeley.

UC Berkeley indirectly brought Wendy and Richard together. An old girlfriend of Richard's at Berkeley happened to be Wendy's dorm mate and friend. To reconcile some old business, the friend brought Wendy as moral support to visit Richard after he'd graduated from Berkeley and had moved back to his parents' home in Santa Monica while he looked for work. Wendy and Richard hit it off and three years later married.

In 1973 a young couple—really two hippies blessed with an intellect honed from Stanford, Berkeley, and USC and not too much more— left California for the distant climes of Nevada, primarily because of a job offer for Richard. They were young, restless, and open to the unlimited possibilities that Las Vegas might offer.

To make ends meet, the highly educated and talented Wendy took a waitress job in the coffee shop at the MGM Grand Hotel and Casino, now Bally's. At Richard's encouragement, she subsequently got into real estate and had a successful career in general brokerage.

Richard was offered an executive job with Lewis Homes in Las Vegas, which provided a

MAY 11, 1947 — JULY 30, 2016

good foundation for Plaster. When Wendy became pregnant she started working in new home sales for Richard, who was then sales manager at Lewis.

Signature Homes (DBA for Plaster Development Company, Inc.) was founded by Wendy and Richard in 1978. This was also the year Wendy gave birth to the first of their three children: Brian, Morgan, and Jillian.

Signature Homes built condominiums, apartments, and single-family homes resulting in 12,500 new dwellings in Las Vegas valley. Wendy's role in Signature Homes was significant. She developed the marketing plans to sell the homes and worked with the designers for the interiors of all the model homes in the new home tracts offered for sale to customers.

Upon the measurable success of their home-building business, Wendy and Richard turned their talents, time, and passions to philanthropic endeavors in Las Vegas. They served on several boards—the Smith Center for the Performing Arts; the Las Vegas Philharmonic, of which Wendy was a founding member; and the Nevada Ballet Theatre, of which Wendy shared the duties of co-chair with founder Nancy Houssels from 1991 until Wendy's passing in 2016.

Wendy joined the board of The Meadows School after she served proudly as room mother when their children were enrolled there. She served fourteen years on that board.

Several local charities were the lucky recipients of Wendy's hard work and talents—Nevada Women's Philanthropy, Foundation for an Independent Tomorrow, Nathan Adelson Hospice, DISCOVERY Children's Museum, SMILE TRAIN, Rape Crisis Center, Domestic Crisis Center, HELP of Southern Nevada, and the regional board of Planned Parenthood.

While Wendy loved her friends and organizations, the wellspring of her love was focused on her family. Diagnosed with lung cancer in January 2015, she impressed doctors, family, and friends with her incredibly positive attitude as she continued with her work. She emphasized the creation of as many memories with her grandchildren as she could manage in her last years.

Wendy and Richard celebrated forty years of marriage in October 2015 just prior to her passing.

—*Susan Houston*

Sarann Knight-Preddy

Sarann Knight-Preddy was born in Eufaula, Oklahoma to Carl and Hattie Chiles. Her father was African American and Spanish and her mother was African American and Creek Native American. To acquire a high school education at Dunbar High School she stayed with relatives in Okanagan, Oklahoma.

At age seventeen she fell in love with an 'older man,' Luther Walker. Since her parents disapproved, they eloped! Sarann and husband Luther had two sons, James and Richard, while living in Oklahoma.

In 1942, during World War II, Sarann's father relocated to booming Las Vegas, Nevada with so much work available. Sarann, husband Luther, and her father arrived in Las Vegas in 1942 and the men found work in Henderson at the Basic Magnesium plant. A year later her mother and two sons joined them.

Sarann turned her energy to duties of wife and mother. Daughter Janice and son Glynn were soon born. Yet this young mother was anxious to join the booming workforce. For six months she attended a business school in California and resided with relatives, leaving her four children with her parents and husband.

Upon her return, Sarann became a keno runner. Then she moved up to being a dealer of table games at the Cotton Club and Cactus Club. She and her husband divorced.

Next she met and married Bill Scruggs, a substitute teacher. They moved to Hawthorne, Nevada, 300 miles away. In November of 1950 Sarann bought Hawthorne's Lincoln Club and renamed it the Tonga Club, making it the only integrated club in Hawthorne. She bought a lovely home next to the town's banking president, joined Eastern Star, the NAACP, and various other organizations. She was a highly respected entrepreneur in the gaming business. She was credited with playing a vital part in bringing integration to Hawthorne and nearby Babbitt.

Late 1950s brought a boom to Las Vegas and a recession to turbulent Hawthorne as the ammunition depot had closed. This hugely successful lady with gaming savvy sold the Tango Club and returned to Las Vegas where her father was assisting in construction of the integrated Moulin Rouge Casino and Hotel.

She worked as a dealer at El Morocco, the Town Club, and Jerry's Nugget. At this time she met and married her fifth husband, Joe Preddy, a younger man. Then suddenly the city of Las Vegas prohibited women dealers.

JULY 27, 1920 — DECEMBER 22, 2014

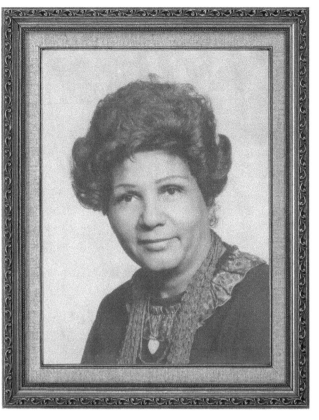

During these times she purchased Rueben's Diner, which was renamed the People's Choice and it was! Next she bought a cleaners company and renamed it Sarann's Cleaners.

Then came bad luck. A car wreck left her hospitalized for four months with fear she might not walk again. Yet her determined survival spirit got her on her feet.

The 1960s brought integration to some casinos. Sarann proudly saw the NAACP carrying out its mission while she was on the local board.

Sarann lost sons Richard and Glynn to cancer and her beloved husband Joe Preddy died of a heart attack. In 1981 a granddaughter was kidnapped and murdered. Yet she maintained a positive outlook on life.

Sarann Knight-Preddy is credited with serving KCEP, the Black Radio Station. As a member of Gama Phi Delta Sorority she founded Alpha Rho Chapter for professional black women and twice served as president. From 1964 to 2009 she assisted with the annual Ebony Fashion Show held in the Sahara Casino. She hosted countless church and organizational groups. She started the Black Women's Democratic Club. A very active member of NAACP, she often served on their board. Her husband, Joe Preddy, her father, and she formed a partnership to purchase and preserve the Moulin Rouge. They succeeded in getting their first integrated Las Vegas casino recognized with a historical marker.

A political activist, she gave time and money toward the election of Lawrence Weekly as county commissioner as well as for city councilmen Ricki Barlow and Frank Hawkins. She was also an active supporter of Howard Cannon.

As first president of the Black Chamber of Commerce she helped form the Black Historical Society. She was a personal friend of Governor Bob Miller who appointed her in 1990 to head the Nevada Motion Picture Commission.

Recipient many times of the coveted Ambassador of Peace Award over her last thirty years, she spoke at numerous organizations. She was recipient of a community service award from the historic Mesquite Club also.

In 2010, the University of Nevada Las Vegas awarded her with an honorary doctorate in Humane Letters. This really made Sarann proud. She felt she had made a difference in her community.

With Nevada's Sesquicentennial the Women of Diversity Organization encouraged Sarann to reflect on her life. Thus evolved a reflective autobiography of her life in Nevada, *72 Years in Las Vegas*.

Sarann was a true inspiration to her family and friends. Sarann's desire was to make a difference and show her belief in humanity. Yes, Sarann Knight-Preddy shall long be remembered as a role model for all in Nevada!

—*Mary Gafford*

Norma Jean Price

Norma Jean Harris Price was born and raised in Riverside, California, the eldest of seven children of Wanda Wynema Hughes and Raymond Maurice Harris. She graduated from California State University in San Bernardino and was a teacher in the Riverside County School system for many years. She met James W. Price and when they decided to elope in 1973, they made a quick weekend trip to Las Vegas and were married in the Entertainment Capital of the World. Soon after their marriage, Jim accepted a job with the Nevada Power Company, a move that made Las Vegas their permanent home. Norma became a teacher in the Clark County School District and subsequently served twenty years as a peace officer for the Nevada Parole and Probation Department, retiring in 1997.

From those who knew Norma well, she has been characterized as a free spirit, never failing to find something interesting about anything or anyone that she came her way. Norma loved traveling to new places, along with making many visits to her extended family.

OCTOBER 7, 1935 – JUNE 19, 2018

Being a philanthropist of the arts, music, painting, and ceramics kept her very busy and active in the Las Vegas area. She was an ardent supporter and volunteer for the Nevada Opera Theater, a top priority with Norma. Starting in 1986, she was a dedicated member of the Nevada Opera Theater chorus and enjoyed singing in various operas. Her love of children was evident when she became a regular volunteer with the Nevada Opera Theater Children's Outreach program. She visited many elementary schools in Clark County for the purpose of educating children to interact in musical performances. For these many trips to area schools, Norma would load up her white truck with a portable piano keyboard, costumes, and boxes of props for a performance for the children. Teaching school children to share her love of music was a special priority with her.

Singing in the Memorial Day ceremonies at the Southern Nevada Veterans' Cemetery was very important to her, as well as visiting and performing at the Southern Nevada Veterans Home in Boulder City, Nevada. Norma took great pride

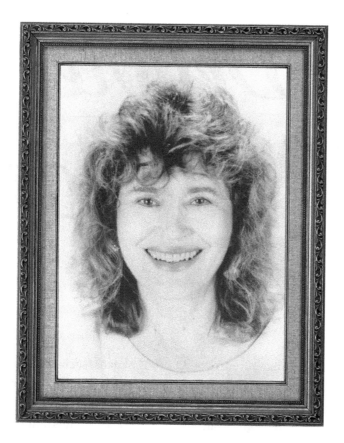

in showing her gratitude to the military veterans for their service, evidenced by the many times she sang with the chorus at the Southern Nevada Veterans Home.

She took pleasure in bringing a smile to the faces of the many veterans at any venue where they were being honored. Included in her realm of community service, she sang as an opera chorus member on many occasions at Nathan Adelson Hospice, her way of bringing joy to the patients with song.

She was an ardent supporter of the Marjorie Barrick Lecture series at the University of Nevada Las Vegas, the Southern Nevada Sierra Club, the Horticulture Society, the C5 Coalition, and the Community Cat Coalition of Clark County, the National Organization of Women, Planned Parenthood, the Democratic Latino Caucus, the Plan B Art Group, and the Shade Tree Women's Shelter. She was an ardent supporter of National Public Radio (KNPR) and gave them a large share of her time not only as a volunteer, but financial support as well.

Being an aficionado of Nevada history, one of her pet organizations of which she was a member was the Southern Nevada Women's History Project. She actively participated by writing several biographies which were included in Volume 2, *The Steadfast Sisters of the Silver State*. At the time of her death, she had submitted biographies to be included in Volume 3.

Norma passed away in Las Vegas. At a private Celebration of Life service at her home family and friends congregated; remembrances were spoken, and a musical tribute was performed by Ben Litvinoff, whose rich tenor voice would have brought a smile of approval from Norma. She had been especially creative in designing pieces of ceramic art ware; each attendee at the remembrance gathering was given a gift of a piece of ceramic ware that had been hand made by Norma.

It is evident that Norma Jean Harris Price not only left an indelible mark in the community by her exemplary service and support of so many, but she left many lasting memories in the hearts of her loving family and many good friends.

—*Joan Dimmitt*

Debbie Reynolds

Star of stage, screen, for more than seventy years, Debbie Reynolds called Nevada home for more than twenty of those years.

"I have truly called Las Vegas my home," said Reynolds as she tried to find a suitable locale for her multi-million dollar Hollywood memorabilia collection including Marilyn Monroe's famous white, billowing subway-grate dress and Judy Garland's ruby red slippers were two of the more notable of the 3,000 costumes and 10,000 props in the trove.

Reynolds paid 2.2 million dollars for the old Paddlewheel Casino Hotel to secure a permanent home for the collection and envisioned building a theater with the help of Todd Fisher's expertise.

The Debbie Reynolds Hotel and Casino situated on six acres with a 196-room capacity, the hulk of a building in dire need of repairs. Reynolds said the kitchen was flooded, the sewers were backed up and "Some of the rats weren't such good swimmers!"

She poured millions of her own money into the project and purchased much of the needed hotel furnishings from the old Dunes and Bally's hotels inventory.

Reynolds mortgaged her Las Vegas home and borrowed and begged from friends, many of them

APRIL 1, 1932 —
DECEMBER 28, 2016

Las Vegans, such as Phyllis McGuire, to make the hotel's planned opening date in 1992.

Reynolds hired local talent such as comedian Rip Taylor to entertain the curious locals who stopped by to pay their respects to the Hollywood legend. She paid all the talent but never took a salary herself.

All who worked with Ms. Reynolds noted how selfless and elegant she was at all times—no matter how dire the circumstances—and dire they became. The casino was closed in 1997.

Her beloved collection of Hollywood memorabilia was auctioned for pennies on the dollar to pay for the accumulation of debt. Debbie stood proudly by as ever with a "The show must go on!" attitude.

Born to a small, very poor family in El Paso, Texas, she and her parents had to share a filling station bathroom in the early years.

Showing talent such as the ability to mimic famous voices, Mary Frances Reynolds and her family moved to Los Angeles in 1939 to seek fortune and a better life.

Reynolds was 'discovered' when she won a 1948 Miss Burbank contest and soon she secured a contract with Warner Bros. "When I started," she said, "I didn't even know how to dress. I had no taste, no training, but had a realistic sense of

values based on faith and hard work."

She had an early hit record, "Aba Daba Honeymoon" (1950), the first sound track recording to become a gold record.

Not yet twenty years of age, Reynolds made the hit movie *Singin' in the Rain* (1952) with Gene Kelly saying, "He made me a star." This is where Kelly helped her hone her dance routines.

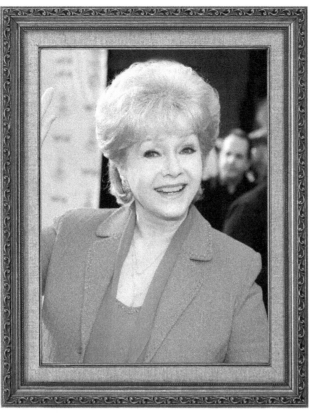

Her recording of the song "Tammy" in 1957 reached gold status, which earned her the title of best-selling single by a female artist.

Reynolds appeared in many successful movies, musicals, and television performances. Some notable ones are: *The Affairs of Dobie Gillis* (1953), *The Tender Trap* (1955), *Tammy and the Bachelor* (1957), *Unsinkable Molly Brown* (1964), *How the West was Won* (1962), the Broadway musical *Irene* (1973) and multiple television productions, such as *Will & Grace* and *The Debbie Reynolds Show*.

At thirty-one-years-old, Reynolds was nominated for an Academy Award for her role in *Unsinkable Molly Brown*.

In 1988 Debbie released her first autobiography, titled *Debbie: My Life*. In 2013 she released a second autobiography titled *Unsinkable: A Memoir*.

Debbie helped create a charity to aid mental illness victims called The Thalians and later served as its president.

On December 28, 2016, Reynolds was hospitalized. Called a 'severe stroke' by son Todd, it took Reynolds' life one day after her only daughter Carrie Fisher (*Star Wars*) died unexpectedly from heart complications.

Reynolds's three marriages flamed tabloid-like headlines. Her first to Eddie Fisher ended with Eddie flying straight in to the arms of Elizabeth Taylor. The next two marriages, to shoe magnate Harry Karl and then to Richard Hamlett, each ended financially disastrously.

Her final film appearance was in *Bright Lights: Starring Carrie Fisher and Debbie Reynolds* (2016), a documentary of Reynolds' relationship with her children, co-produced by her son.

In 2018, her son pledged $1 million to establish the Debbie Reynolds Performing Arts Scholarship at UNLV to benefit students who pursue a performing arts degree.

Her daughter Carrie Fisher produced one granddaughter, Billie Lourd.

NOTABLE AWARDS

University of Nevada, Reno, May 17, 2007. Honorary Doctor of Humane Letters for her unfailing support of the UNR Dept. of Fine Arts.

Harvard University's Hasty Pudding Woman of the Year, 1995.

Grauman's Chinese Theater, Hollywood. Debbie's hands and foot prints are immortalized.

Hollywood Walk of Fame Star, 1997.

The Screen Actors Guild Life Achievement Award, 2015.

Academy Award's Jean Hersholt Humanitarian Award, 2016.

—*Susan Houston*

Clarine 'Kitty' Rodman

"You know you have been around a long time when they start imploding structures it seems you just built yesterday, like the Hacienda, the Dunes, and the Sands."

Responsible for the construction of some of Las Vegas' biggest building projects in the twentieth century, Clarine 'Kitty' Rodman was a lady at all times, but she must have had a tough-as-nails interior judging by the amount of achievements she produced in her life.

Born in Virginia, Kitty was raised from a young age by an aunt and uncle after her parents passed away. A Woolworth's candy counter was the site of her first after-school job where she was promoted to floor supervisor.

Her high school teachers recognized Kitty's abilities and helped provide her with the monetary means to attend college through job guidance. One job was payroll supervisor at a construction company.

Kitty married her high school sweetheart, Leon 'Dick' Rodman, in 1946 after he returned from World War II. He re-enlisted in the U.S. Air Force to fight in the Korean conflict. In 1952, Kitty joined her husband when he was stationed at Nellis Air Force Base in Las Vegas.

In 1953, when a student in the Dana McKay College of Commerce, Kitty struck up a business relationship with Bill Koerwitz and Gus Rapone to form the Sierra Construction Corporation. She was appointed director as well as secretary-treasurer and soon became part owner in the company.

RKR Construction was a second corporation formed in 1959 to handle other building projects.

Sierra Construction grew to become one of the most important commercial construction enterprises in Nevada for the next fifty years and Kitty was its major force until her retirement in 2003.

Kitty built office buildings, schools, and banks as well as projects at the Nevada Test Site and Nellis Air Force Base in the early years.

Sierra Construction built all or a portion of such Las Vegas downtown structures as the Valley Bank Plaza (now Bank of America) and casinos—Golden Nugget, Binion's Horseshoe, Four Queens, the Mint Las Vegas, and the Fremont hotels and casinos.

Other high level projects built all or partially by Sierra Construction in the Las Vegas valley included the Flora Dungan Humanities Building on the campus at University of Nevada, Las Vegas (UNLV), the Las Vegas Convention Center, the Tropicana Las Vegas, Bally's Las Vegas, the Flamingo Hotel

JULY 5, 1925 – FEBRUARY 27, 2014

160

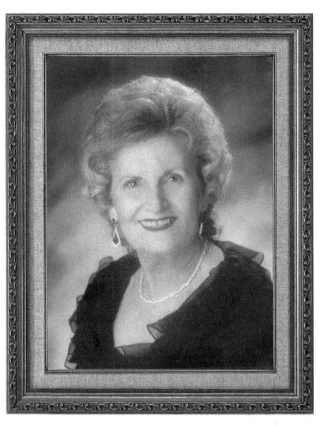

& Casino, the Las Vegas Hilton Hotel and Casino (now the Westgate Hotel and Casino), the Gold Coast Hotel & Casino, the Mirage, and the Santa Fe Station Hotel & Casino.

Sierra also built all or a portion of other major casino projects, which have subsequently been imploded—the New Frontier Hotel and Casino, the Hacienda, the Sands Hotel and Casino, the Dunes Hotel and Casino, and the Stardust Resort and Casino.

This is an impressive tally of eighteen hotel/casino projects constructed, in addition to the many other major commercial accomplishments over her fifty years of productivity.

Upon retirement, Kitty kept her energies harnessed and focused on charitable activities. She was a member of Zonta International and Executive Women International and she helped charter a Las Vegas chapter of Epsilon Sigma Alpha. These organizations are dedicated to furthering the philanthropic and educational interests of women throughout the world.

Another focus of her philanthropic efforts was Opportunity Village, a Las Vegas non-profit organization that provides services to all intellectually disadvantaged people. She was there for its formation in 1954 and helped support it through the decades. The Kitty Rodman Center was established in 2000 on the Henderson campus of Opportunity Village.

She served for twenty-five years as a member of the UNLV Foundation Board of Trustees. In 2011, she was elevated to Emeritus status in that organization. She also advised the UNLV President's Inner Circle and received the President's Medal in 1998 for her efforts.

Kitty was a founding member of the Jean Nidetch Women's Center on the UNLV campus and was the driving force that created the physical therapy program.

The Silver State Award is the highest honor the UNLV Alumni Association can award to non-alumni. The UNLV Alumni Association presented this award to Kitty in 2005.

For her achievement as being one of the first women to break in to the construction business, Kitty was inducted in 2007 into UNLV's Nevada Business Hall of Fame and also received UNLV's Honorary Doctorate of Humane Letters in 1995.

There is a residence hall on the UNLV campus in Kitty's name for her years of distinguished service to UNLV.

Sierra Construction was the first recipient of the Associated General Contractors of Nevada's first Skill, Integrity, and Responsibility (SIR) Award for its accommodating business climate.

Kitty passed away at the age of eighty-eight.

Kitty left a $12 million grant to fund the UNLV College of Education's Special Education Department to be used to fund scholarships. The largest donation in the department's history, her gift will be used to attract and train future special education teachers.

—*Susan Houston*

Lucille Savage Rogers

One true example of a contributor to the rustic self-determined spirit of the ladies who settled in the sparsely populated western state of Nevada would be Lucille Savage Rogers. She was born in Louisville, Kentucky. Her father, James Savage, a Methodist minister and mother, Lydia, were both highly educated and encouraged Lucille to strive continuously to gain a well-rounded education.

Throughout her early life, Lucille showed a genuine quest for numerous areas of knowledge. She became an accomplished pianist and organist and exhibited a knack for playing the piano by ear. A person could name almost any popular song and Lucille was talented enough to play the song in its entirety.

After graduation from high school in Louisville, this scholarly young lady attended Kentucky Wesleyan College. Next, she did graduate work at the University of Kentucky Lexington. As her interest in music grew, she attended the Conservatory of Music located in Cincinnati, Ohio as well as the Science Hill School Department of Music in Shelbyville, Kentucky.

After college in 1937, this accomplished Kentuckian met and married Frank Rogers in her home state. Their son, James Earl Rogers, their only child, was born in Louisville, Kentucky in 1938. James grew up to play an important role in the successful and progressive growth in the Channel 3 television station in Las Vegas, Nevada.

This Rogers family of three left Kentucky and for two years lived in Costa Rica and then settled in Los Alamos, New Mexico, where Lucille's father worked closely with the federal government test site. It was in this town that Lucille began her teaching career. She held dual positions teaching remedial reading as well as being the librarian.

In 1953 that the Rogers family relocated in Clark County, Nevada. Frank began work at the Nevada Test Site as a business manager and organizer. Lucille accepted a teaching position at the Jefferson School in North Las Vegas as a second grade teacher. She also continued her education, earning a bachelor of education at the University of Nevada, Las Vegas.

In 1954 this talented and innovative educator moved to the Paradise Elementary School where she taught for thirty-four years until her retirement.

Throughout the innumerable years she spent encouraging her students to continue their quest

1916 –
AUGUST 26, 2012

for knowledge, she is also credited with offering enthusiastic encouragement to the three-plus generations of elementary students she taught. Many of these youngsters have grown up to be exceptional leaders throughout Clark County. She herself set an excellent example by returning to the University of Nevada, Las Vegas, acquiring a master's degree in education in 1977.

Retirement brought many honors: a plaque placed over the classroom door of Room 11 where she taught. This school has since been changed to the School of Law for UNLV, of which her son Jim Rogers played a huge role in the creation. The Rogers family has made numerous monetary contributions to the UNLV Law School as well as the University of Nevada, Reno College of Engineering. This is in addition to a myriad of programs that have been beneficial to the University System and to the community. Jim Rogers served as Chancellor of UNLV for several years, refusing to take any salary. During his early years he worked in Panama on the Panama Highway.

Lucille exhibited the charm of a southern lady, always soft-spoken, kind, optimistic, dignified, and full of energy. She was devoted to her son and her grandchildren, Perry, Suzanne, and Kimberly. The family was her highest priority. Having only a brother, Montjay Savage, and no sisters, she always stayed close to her Kentucky cousin, Louellen Pyles. In Las Vegas she was especially close to her daughter-in-law, Cheryl Rogers Perdue. Her favorite pastimes were cooking Kentucky dishes and baking cookies. She traveled very little outside the country, preferring to provide family gatherings among her family and grandchildren.

Lucille is credited with strong civic and scholarship leadership. She is recognized for her past efforts in the annual March of Dimes drives and in the highly recognized Community Calendar. As a supporter of the Nevada Dance Theater and the Master Series, she was a true patron of the arts. Her outstanding qualities of leadership throughout Clark County led all who knew her to be in awe of her talents and accomplishments. Thus it is no wonder that Lucille Rogers received one of the highest honors in education, the naming of the Lucille Rogers Elementary School in 2001.

For her 90th birthday her son arranged a party at the exclusive Turnberry Place on Paradise Road. Many Las Vegas dignitaries were in attendance, as well as old friends and family. She entertained the group playing her old favorite piano songs, just as she had done many times before. All were impressed as not a note was missing.

Though Lucille is gone, she is not forgotten. Her legacy shall forever leave its mark on the hearts and minds of not only the thousands of students she taught and her extended family, but also those persons who had the opportunity to personally experience the difference she made in their lives.

—*Vera Knox*

Cecile Rousseau

Cecile Andrée was born in Biarritz, Pyrénées-Atlantiques, Aquitaine, France. Like many other young Basques, she left her seaside town in southwest France, hoping to find greater educational and career opportunities in Paris. However, this move to attend school in the 'City of Lights' had other consequences. She saw World War II firsthand through teenage eyes. After finishing high school, she pursued a career in fashion and clothing marketing, working with some of the best-known designers of the era.

Cecile married John Jacques Rousseau on April 10, 1964, and federal records show that Cecile entered the United States on August 25, 1967. She left the country for three months in 1970 to visit relatives, but once John completed his divinity degree, they served in United Methodist churches in California, Hawaii, and Nevada. Cecile used her time in these states wisely. With the help of affidavits from members of their church in Las Vegas, Cecile became a naturalized U.S. citizen through the Los Angeles District Court in March, 1973. She received a BA in English and French in 1975 from LaVerne College in Claremont, California. While working as a graduate assistant in 1978, she earned an MA in education and MA in French at the University of Hawaii. While the couple lived in Hawaii, John oversaw three churches including the Ewa Beach United Methodist Church.

Cecile's calling as a teacher led her to classrooms in public and private schools during their stay in Hawaii. She is noted as a teacher at the Hawaii School for Girls in the 1981–1984 city directories for Honolulu. In 1985, John was named the minister of Grace Community Church in Boulder City, Nevada, so the two returned to the mainland, reaching Boulder City on July 1st of that year. Cecile used her language skills to teach French and Spanish at two Las Vegas high schools: Clark High School and Cimarron-Memorial High School. After Las Vegas High School became the Las Vegas Academy for International Studies and Performing Arts on August 23, 1993, Cecile transferred there. At this magnet high school where students concentrated on languages, performing and visual (added in 1994) arts, Cecile designed and taught the French curriculum for language acquisition and the study of French culture. She was always looking for new teaching methods that would work with her students. Over the years, she participated in many state, national, and international professional conferences and associations that supported language fluency and appreciation. She was a founding member of the Las Vegas Chapter of the Alliance Française, serving as the charter

December 21, 1930 – August 3, 2014

... the memory of Cecile as a dedicated educator with a winning smile remains with all who knew her ...

secretary. Cecile was able to work with her husband as he served as the chairman of the Board of Trustees. Together, they helped plan events such as the Bastille Day Ball. Cecile also belonged to the American Association of Teachers of French and the Nevada Language Association. She willingly supported the work of other teachers through the Geographic Alliance in Nevada.

Cecile was also an active community member. She aided both men and women through her work with the Assistance League of Las Vegas and University United Methodist Church. Her involvement with P.E.O. Nevada Chapter V, promoted the advancement of women throughout the state. Cecile made many trips through the Las Vegas Club of Friendship Force International, a non-profit organization that coordinates home stays in sixty countries as a means of fostering global understanding.

Cecile's passion for education was matched by her love of music, cooking, and reading. She participated in reading groups of books written in both English and French. The French Book Club she started met monthly and focused on contemporary writers. It produced many lively discussions over ten years. A rousing trivial pursuit match or other intellectually challenging activity was often part of Cecile's social plans and she regularly acted as the hostess for these gatherings. Although Cecile loved all animals and had a dog, horseback riding was a treasured pastime. She thoroughly enjoyed being outdoors which included excursions to the Grand Canyon as well as the national parks in Utah such as Zion and Bryce and also Cedar Breaks National Monument. She owned property in Strawberry Valley, Utah, and invited friends to camp under 'her' stars.

According to Nevada marriage/divorce records, Cecile and John divorced in 1992, but remarried in Pioche in 1994. He passed away before her and is remembered through the John Rousseau Memorial Sunday School Class at the University United Methodist Church in Las Vegas. Cecile died at the age of eighty-three. Her obituary notes recognition given to her by the 'Ordre des Palmes Académiques,' an honor bestowed by France on French expatriates and others who make significant contributions promoting French education and culture around the world. However, it's the memory of Cecile as a dedicated educator with a winning smile that remains with all who knew her, including her son James.

—*Dr. Kay Moore*

Susan Scann

The Honorable Susan Scann had an impressive forty-year legal career and leaves a legacy of a dedicated jurist who always maintained high standards and a positive demeanor. She gave generously of her time to get legal representation for those who could not afford it. She served to help others through Rotary International and worked to promote ethics and professionalism through the Clark County Bar Association.

Judge Susan Williams Scann Scannapieco was born in Riverdale, Maryland and grew up in Salt Lake City, with her parents, Philip and Mary Williams, and her four sisters, Sharon, Mary Lou, Melanie, and Joanne.

She received her BA degree from the University of Washington in 1968 and later her Juris Doctor from California Western School of Law in 1976. While there, she served on the Law Review and authored case note Tucker v. Lassen Sav. and Loan Association.

After passing the bar in California and Nevada, she moved to Las Vegas in 1977 to start her career at the Law Firm of Jones, Jones, Bell, Close, and Brown (now known as Fennemore, Craig, Jones, Vargas). She later became partner at Deaner, Deaner, Scann, Malan, and Larsen (now known as Deaner, Malan, Larsen, and Ciulla).

Susan married Bob Scannapieco, a local Las Vegas musician and teacher, in 1980. The couple had two children, son Brian and daughter Kathryn.

Judge Scann had many outstanding accomplishments including; services as a member of the Clark County Fee Dispute Committee, President of the Southern Nevada Association of Women Attorneys, service on the State Bar Ethics Committee, and the Clark County Bar CLE Committee. She was a founding member of the Clark County Bar Pro Bono Committee and a member of Rotary International.

Judge Scann received the 1995 Professionalism Award from the Clark County Bar Association. She also received an award for outstanding service in law and politics from the Clark County Democratic Lawyers Caucus. Judge Scann was the premier recipient of the award that was named in her honor. The Susan Scann award is given annually to a lawyer or judge who has exemplified dedication, commitment, and ethics in their conduct.

In 2010, Susan was elected as an Eighth Judicial District Court Judge, fulfilling a life-long dream. Judge Scann had an impressive forty-year legal career, including services as jurist in Department 29 of the Eighth Judicial District Court from 2010, and as an alternative Municipal

JUNE 28, 1946 –
JULY 16, 2016

Court Judge for the City of Las Vegas from 1980 to 2010. She practiced in civil court for thirty-four years before taking the district court bench.

Susan concentrated in real estate, commercial litigation, bankruptcy litigation, and creditor representation. Chief Judge David Barker said, "She's been a fixture in the legal community for years. Among fellow judges, Scann was a 'go-to expert' in understanding intricacies of the real estate law. Her door was always open," he said. "That's a nice thing to have when you're a judge because so much of what we do is pretty much isolated. Her presence on the district court bench will be greatly missed."

Chuck Deaner, who worked with Susan for more than thirty years, said her life's ambition was to be judge. He called her "a close friend, more than a law partner." She was "just a damn good lawyer and a very generous person."

District Judge Nancy Alf said she and Scann became friends twenty-five years ago, and while on the bench the two trained together in business law. She said, "It was an honor to serve with her. She brought honor and dignity to the court every day. I'm going to miss her every day."

Susan Scann often worked late into the night and on weekends to get the job done. Brent Larson, who worked with her for fourteen years at the law firm Deaner, Deaner, Scann, Malan & Larson, called her "extremely thorough and very conscientious of the needs of the client. She'd walk through hot coals if that's what it took to get them the justice they deserved. She was relentless. And even in the toughest cases, she kept an optimistic outlook."

Harold Gewerter recalled working with Susan when he was a young lawyer in the late 1970s and early 1980s. "She was the greatest mentor there could be because she cared about educating new lawyers. She always had time for the young lawyers in the firm."

Clark County District Attorney Steve Wolfson said, "Scann was a 'great' judge."

Susan Scann passed away after a yearlong bout with pancreatic cancer. She was an active parishioner at St. Francis de Sales parish and member of Catholic Daughters of the Americas. Susan was cherished and treasured by her eleven nieces and nephews. Her unrelenting love for family and friends will be sorely missed.

—*Denise Gerdes*

Gene Segerblom

Gene (Genevieve) Wines Segerblom was a native Nevadan, born in Ruby Valley in Humboldt County. Gene and her family moved to Salt Lake City when she was a baby, but the Great Depression brought them back to the Reno area where Gene attended junior high school. Her grandfather Bell owned the Buckskin Mine near Winnemucca, her mother taught in a one-room schoolhouse in Humboldt County, and her father ran the last horse-drawn stage in Ruby Valley.

After graduation from high school in Winnemucca, Gene attended the University of Nevada, Reno as a mechanical engineering student and graduated with an education degree. Gene met her future husband, Cliff Segerblom, at UNR, a football scholarship student with an art major. He was invited to the Wines' home for Thanksgiving one year when he was unable to go home to California. This was the beginning of a lifelong partnership.

Upon graduation, Gene accepted a teaching position in Boulder City, teaching high school government and civics. Cliff was also employed in Boulder City, serving as the chief photographer for the Bureau of Reclamation's Hoover Dam Project. When Cliff was sent to

MARCH 15, 1918 –
JANUARY 4, 2013

Panama on a project to enlarge the canal's locks, Gene married Cliff and accompanied him. Their first child, Robin, was born there. While there, Gene worked for an American newspaper, one of many writing assignments to come.

After their Panama time, the family returned to Boulder City to settle down, where their son, Richard, (Tick) was born. While the children were growing up, the family spent much time roaming around the state looking for stories. Gene wrote and Cliff provided visuals, over 200 articles dealing with Nevada's history and its geography. Artist/photographer Cliff Segerblom and Gene were published in *Arizona Highways*, *Nevada* Magazine, *Sunset* and *Family Circle*.

In the late 70s Boulder City was in conflict about a controlled-growth ordinance, which would halt the huge expansion going on in Las Vegas at the time. Gene said, "I felt we were running out of water, out of power, and did not have any definite plans where we were going to get any more, so I thought the ordinance was on the right track and said so. And people began hounding me to run for office." Needless to say, Gene won the seat on the city council. While serving on the Boulder City Council, Gene became involved with the Las

Vegas Convention and Visitors Authority, a natural interest from her many travels around the state. This interest prompted Gene to run for the Nevada State Assembly from District 22. On her first attempt she lost to the incumbent, but eventually won, and served in the Nevada State Assembly for four terms, from 1993–1999.

Gene was active in Boulder City as well, assisting the Boulder City Boys and Girls Club, serving as advisor to the Boulder City Museum and Historical Association, and continuing her membership in the Boulder City branch of the National Association of University Women. She was also a member of the Clark County Democratic Women's Club, the Las Vegas branch of the National League of American Penwomen, the Nevada Council of Senior Citizens, and the Board of the Southern Nevada Veterans' Cemetery.

Gene's position as advisor to the National Trust for Historic Preservation was an offshoot of the work her mother started decades before. Her mother, Hazel Bell Wines, while a member of the Nevada Assembly, helped pass a bill appropriating funds for the restoration of the Nevada Museum and Historical Library and preservation of important state documents. Through Gene's commitment, she was able to obtain funds for both the Boulder City Museum and the historic building it resides in, the Boulder Dam Hotel. Gene was also invited to join the Board of Trustees of the Outside Las Vegas Foundation, an organization dedicated to preserving and developing the natural, historical, and archeological aspects of nearby federal public lands.

Gene's life of service to the state of Nevada is no surprise. Gene's grandfather, W. J. Bell, was in the Nevada State Legislature between 1906–1914. Her mother, Hazel Bell Wines, was a Humboldt County representative to the Nevada State Assembly in 1935. Gene belonged to one of two families who have had three family members in the Nevada State Legislature. Her son, Tick, currently serves in the Nevada State Assembly, making it four generations in the Nevada State Legislature.

Gene is remembered for her smiling face and her love of Nevada, the people, the land, and all that is beautiful in Nevada.

—Denise Gerdes

Elinor Shattuck

*E*linor Lee Bullock was born in Salt Lake City, Utah. Although historical weather data records the daily high as only reaching 42 degrees, this might have been one of the warmest and happiest days of her mother's and father's marriage. Her parents, Edward Arthur and Catherine (sometimes spelled Kathryn) Patricia Gaz Bullock met at Granite High School and married on July 13, 1936, but were reported not living together in the 1940 U.S. Census. Elinor and her mother were living in her maternal grandmother's home and her father resided with his mother. According to the city directory the family was back together in 1941, but relations eventually broke. In June 1943, Elinor's mother married John Spitzer Glenn so by the time Elinor attended Las Vegas High School (1953–1956), she was using the name Elinor Glenn, although 'Elly' (later also seen as Ellie) sometimes appears in captions in the Wildcat Echo yearbook. She was a member of the Commercial Club, acting as vice president her senior year. She participated in the Thespian Club, a useful activity for a woman destined for a career in radio and television.

Elinor attended the University of Nevada, Reno and the University of Nevada, Las Vegas where she studied journalism. She was hired as one of the first women reporters for the *Las Vegas Review-Journal* and later became its director of public relations. She probably crossed paths with Frank Wadsworth Shattuck through her job, which led to a personal relationship and their dates in showrooms on the Strip. Bob Miller, governor of Nevada from 1989 to 1999, described an amusing anecdote from one of these evenings at the Riviera Hotel and Casino (in which his father was an owner) in his book, *Son of a Gambling Man*.

Born September 14, 1929, in Birmingham, Alabama, Frank attended Webster Groves High School in St. Louis, Missouri, graduating in 1947. He continued his education at DePauw University in Indiana, where he completed a degree in economics in 1951. Moving to Nevada in 1955, he became the administrative assistant to Governor Grant Sawyer in 1960. Elinor and Frank married in Hawaii while Frank accompanied Sawyer to the 1961 Governors' Conference. Frank resigned this government position in December 1962, to study law at Washington College of Law, American University (Washington, DC). Elinor got the opportunity to work in television at WTTG-TV5 in Washington, D.C. where she was an on-air promotions director.

After Frank received his license to practice law in Nevada in November 1965. The pair settled in Reno. Elinor could be spotted on KOLO-TV

MARCH 14, 1938 –
APRIL 21, 2013

at noon doing interviews and weather reports. Many articles in local newspapers demonstrate how Frank and Elinor pulled together to bring the Utah Civic Ballet from Salt Lake City to Reno for performances to benefit the Multiple Sclerosis Society. They also helped create a ballet guild to assist young dancers with scholarships and classes. Elinor provided publicity for the Action Committee of the Nevada Art Gallery in 1967 and in 1969, assisted with a statewide juried art show, she sponsored a finger-painting session for adults to promote enjoyment of the medium. In addition, she coordinated programs about women's legal rights for gatherings of the Women's Auxiliary to the Washoe Bar Association.

When Frank was named the corporate counsel for the Hilton Hotel Corporation in Nevada, they moved to Las Vegas in 1972. He later left that position to start a private business management consulting firm with Elinor's assistance. She returned to television, producing and hosting a talk show on KLAS-TV8 that interviewed guests from many walks of life. Following a similar pattern to her time in Reno, she became active in various community organizations. Elinor was instrumental in the Assistance League of Las Vegas receiving their charter in 1976 and she was a long-time member of the Mesquite Club, the oldest women's service organization in Las Vegas.

Elinor and Frank were married fifty-one years when she died at age seventy-five. Her memory was celebrated by her husband, their children, sons Timothy and Gregory and daughter Kristine, and many friends. Gifts supported the Operation School Bell program maintained by the Assistance League. In her honor, the Southern Nevada Chapter of NAIOP created the Ellie Shattuck Spirit recognition, which they added to their Spotlight awards in 2014. Elinor had participated in the Commercial Real Estate Development Association in Las Vegas for many years especially through member recruitment and fostering the award program.

Frank probably best captured the essence of Elinor's lifelong spunk and determination when he commented to a Reno newspaper in 1969 as she was recovering from a surgery in Saint Mary's Hospital that she "has been making the nurses rounds so much they are thinking of giving her a cap." Elinor was an inspiration to those who knew her professionally, but on her list of priorities, her family always came first.

—*Dr. Kay Moore*

Mary M. Shaw

Watercolorist Mary Shaw was born in Panama to Arthur and Rose Farrer Martell. Arthur was from Australia and managed a cacao plantation. Rose was of British Colonial descent; her parents owned a coffee plantation. They were residing on the cacao plantation near the remote town of Almerante, Panama when Mary was born. She grew up amid snakes, lizards, monkeys, and other wild and exotic animals, until age four when the family moved to San Jose, Costa Rica, a more cultural environment. There marks the beginning of Mary's academic interests in art, languages, and reading. She was placed in second grade. She then attended the French convent school Notre Dame de Sion for her secondary education. By graduation she had mastered the English, French, and Spanish languages. She also attended a business school where she learned secretarial skills. She was then hired as a bilingual secretary for United States Public Roads Administrations.

It was in this position that she met and married Rollin H. Shaw, an engineer from Meeker, Illinois, who was hired to assist in building the Pan-American Highway. They wed on October 16, 1943, and soon after that her husband joined the U.S. Navy. He was stationed with the SEABEES, the Naval Construction Force, in the South Pacific during World War II.

OCTOBER 29, 1922 — MAY 5, 2019

In 1944, after the birth of Charles, the family resided with the Shaw family in Colorado. When World War II ended, the Shaw family moved back to Central America, where Rollin worked in the Panama Canal Zone. Patricia Louise was born there.

The Shaw family increased with the birth of Nancy Jean in 1949 and Michael Kirk in 1953. Meanwhile, the residences included California; Albuquerque, New Mexico; Kailua, Hawaii; and finally, in 1953, Las Vegas, Nevada. Rollin Shaw worked at the Nevada Test Site in Las Vegas until his retirement.

Mary Shaw's interest in watercolor painting flourished with encouragement from accomplished watercolorist teacher Cliff Segerblom. She joined the Monday Morning Painters and attended the group for twenty-five years. She served as president of the NVOO Women's Club and was a member for over ten years. She next joined the Las Vegas Art League. From there she joined the newly founded Nevada Watercolor Society and taught painting to the group. She became a signature member of this art group. Over many years she served as an advisor, served as a board member and once served as president. During these years Mary attended well-known artist Jade Fon's workshop at Asilomar, California and participated in the

renowned Spring Mad Workshops at Myrtle Beach, South Carolina. She also traveled to La Bonita Art School in Italy and attended a two-month seminar. She was especially happy when invited to display her artwork at the National Theater in Costa Rica.

This accomplished artist joined the Mesquite Club in Las Vegas in 1980. At that time she taught watercolor painting at Reed Whipple Cultural Center for nine years, and then taught at the local art museum. She taught classes at the Mesquite Club, Sun City Summerlin, Las Ventanas, and at many other locations throughout Clark County until September 2018, when she was ninety-five-years-old.

Throughout her fifty-five years in Las Vegas, many of Mary's students have won awards, some have become accomplished artists, and some became teachers. Her greatest pleasure was the achievements of her students.

In 1989, 1990, and 1991 Mary Shaw was on the list of Distinguished Women of Nevada. Permanent collections of her work are at the *Las Vegas Review-Journal*, Southwest Gas Corporation, and at G. Winger, G.F.W.C. Both Nevada Frames and the Las Vegas Art Museum Shop have Mary's paintings on display. The Mormon Fort proudly displays Shaw's painting "First Las Vegas Post Office," which Mary personally framed.

Mary Shaw's paintings have been exhibited at the Boulder City Art Guild, Burke Gallery, Judy Bayley Theatre, Las Vegas Art Museum, Mesquite Club, and United Sates Department of Energy, as well as at many libraries and homes throughout Clark County.

The juried shows and awards Mary received are too voluminous to mention, as are the times and locations where she served as a juror or judge at art shows. Mary was also an active and highly respected member of many local organizations besides the art groups she attended.

Mary was a highly acclaimed artist with a zest for capturing colors, lights, and the shadows of nature within her paintings. Mary's friend, Sue Churchill, expressed it best when she described Mary's excitement while visiting the Red Rock Spring Mountain range on Highway 159. She said Mary would exclaim, "Oh, look at those extraordinary shadows! What color contrasts! Oh, what a scene and setting! My, a magnificent sight!" Mary would then hurry to paint the magnificent scenes, floral groupings, and clouds.

Mary Martell Shaw passed away while preparing for a Cinco de Mayo celebration. She will be remembered for her dedication to art, her angelic smile, and enthusiastic anticipation of another scene to capture on canvas!

—*Mary Gafford*

Amy Ruyko Simpson

Amy was born in Tokyo, Japan. During her teen years Amy was subjected to the trauma and adversities associated with life in Japan in WWII. She was in Tokyo in 1942 when the first bombing raid occurred and survived the fire-bombing that took place there in 1945. After Japan surrendered in September 1945 and struggled to rebuild, she suffered the hardships and deprivation that followed. However, Amy was by nature resilient and determined, characteristics which helped her survive the uncertainty and chaos in her war-torn country.

After the war, Amy found work as a secretary on a military base.

In early 1956, she met Peter Galloway, a nuclear engineer, working in Japan under contract. They were married in February 1957. A year later, in February 1958, Peter (known as Pete to most of his family and acquaintances) was reassigned stateside and they settled down in Sacramento, California. Their only son, Ryk, was born there in March 1960. Amy was devoted to her son and was always looking out for

his best interests. A firm believer in education as a basis for success in life, she made sure he was provided with every opportunity to succeed.

Amy became a naturalized citizen in February 1962. In March of that same year, Amy and her husband moved to Las Vegas, Nevada where he worked at the Nevada Test Site (NTS), located sixty-five miles north of Las Vegas. Pete died on January 1972 and Amy subsequently went to work for Caesar's Palace. She worked there until she met and married Burton J. Simpson on April 14, 1979.

Amy was a talented artist whether working in oils, watercolors or acrylics, and was a founding member of the Clark County Artists Guild in 2008, a 501c3 non-profit formed to foster and support the visual arts through exhibition and education. It was formed to encourage artistic expression and the creation of art for the benefit of members and society in general. This organization is still going strong today. The main purpose of the guild is to find places to market their artwork. When artists work together as a group many things are accom-

DECEMBER 1, 1929 – JULY 16, 2014

174

plished, including exchange of ideas, learning from each other, and sharing of experiences. Amy worked within the group to create synergy and learn from each other as they exchanged methodology and enjoyed the friendly member atmosphere.

Amy's paintings can be found in many states around the country, as well as in Japan, China, and Belgium. Her art includes many diverse art forms, including various mediums.

Amy's son, Ryk, offered some favorite memories of his mother:

"I painted in college after watching Bob Ross. Mom liked it and thought she'd like to give it a try. She started in oils when I got her an easel, paints, brushes, etc. one Christmas. She fell in love with it and was 100 times better than I'd ever hoped to be. She then took a few classes in acrylics, then watercolor. She enjoyed all three styles and didn't really have a favorite.

"Later on, just for kicks, she started painting on rocks, the backs of frying pans, clipboards, anything she could get her hands on. It was unbelievable what she used as 'canvases.'

"Mom had a stroke about fifteen years ago. She had lost motor control of the left side of her body. She had difficulty speaking, walking, fine motor, and daily activities, but her main concern was her inability to return to painting. She *loved* painting! All she wanted was to be able to hold a brush and paint again. It took about a year of physical therapy, but she was able to return to painting. She was obviously thrilled!

"When Mom was older and in poor health, she talked about going to heaven and meeting and painting with Bob Ross and Leonardo Da Vinci. I can picture the three of them sitting with a cup of tea, talking and painting. I love that image."

Amy was a woman of many accomplishments; she was skilled seamstress, had proven secretarial skills, and was an excellent homemaker. She was also a successful businesswoman and worked with her husband Burton until shortly after they retired. Amy was an outgoing person and had many local friends.

Amy lived to be eighty-four-years-old.

—*Yvonne Kelly*

Bettina Ruth Smith

'Tina' began her life in Los Angeles, California. Her mother, Ruth Ball, was destined to be a Henderson, Nevada socialite herself.

Los Angeles County was the location of inception of Tina's formal education. She attended Valentine Elementary School, then Huntington Middle School. In 1936, she graduated from San Marino High School. With a great interest in the arts and design, this spirited young lady attended Southern Pasadena State College and UCLA where her major was art.

On June 1, 1940 Tina married the love of her life, Robert Hallock 'Hal' Smith. Hal served in the United States Navy during World War II. Tina followed her husband during his basic training. When Hal went out to sea, Tina went to Henderson, Nevada to stay with her socialite mother.

After World War II ended, Tina and Hal moved to Ellensburg, Washington where Hal built houses in the construction business. In the early 1950s, Hal returned to service in the U.S. Navy during the Korean War. Tina, now a mother of three children, Vicky, Peter, and Christy, resided with them at bases where Hal was stationed. Upon his sea assignment, she again went to live with her mother in Henderson. By this time her mother was well known in the area for her annual ice cream social.

Upon retiring from the U.S. Navy, Hal, Tina, and the children made their home in Henderson. Hal became a successful businessman and politician, and Tina joined the local Republican Women's Group.

Tina was a dynamic community leader and was quite actively involved with the Park Village PTA Board from 1953–1955. Then at Basic High School she was made the Hospitality Chairperson. According to her daughter Christy, her parents were very strong on education, and not surprisingly, there is a Henderson school named the Hal Smith Elementary School.

Hal became a state assemblyman and then a state senator. He promoted Tina and other women to renovate the Governor's Mansion in Carson City. In 1968, Tina also began holding Governor's Mansion showers as fundraiser events in Henderson.

On March 17, 1975 Tina and forty-four other women signed a charter to found the Southern Nevada Museum Guild. The museum was located at 1830 Boulder Highway in Henderson. Currently the museum's curator is Mark Hall-Patton, who speaks highly of Tina Smith, the guild, and the countless hours that were donated

December 21, 1919 – March 10, 2018

to the betterment of the museum.

The first Southern Nevada Museum Guild meeting was held at the Jockey Club in 1975. On February 2, 1976 the first Annual Parade of Living History–Yarns of Yesteryear was held. The Museum Guild found it so successful that on September 6, 1976 a Poolside Fashion Show was held at Black Mountain. Guild ladies and others from Clark County wore vintage dresses and gowns as well as expensive wedding gowns, all clothing on loan from museum donations. These fashion shows continued each year, and were ranked number one on the social calendar year after year. They were held at various county clubs and casinos throughout the area.

One of the most memorable events was held at Logandale Ranch, owned by Wayne Newton. Newton was an admirer of both Nevada Congressman Hal Smith and his wife, Tina. Funds were raised at this Allied Arts fundraiser party and the money was donated to the Southern Nevada Museum.

Another Herculean project taken on by the museum guild and promoted by Tina was the Townsite House project. This was with the blessing of the Clark County Nevada Department of Parks and Recreation. Townsite today is known as Heritage Village located on Heritage Street within the confines of the Southern Nevada Museum. A number of vintage houses from Clark County were moved to the museum and were refurbished with furniture, utensils, etc. from the era. On October 4, 1986 the Heritage Village was dedicated.

In 1987 special recognition of the Heritage Village for its success was given by the Clark County Nevada Department of Parks and Recreation. To this day it is a big attraction at the museum. On October 26, 1987 County Commissioner Bruce Woodbury presented an award to outgoing Museum Guild President Tina Smith for service to the community. She also received the Governor's Outstanding Leadership Award. Over the years, Tina continued to donate many hours to the Southern Nevada Museum.

Another community service Tina undertook was to volunteer at Henderson's St. Rose de Lima Hospital. She is credited with helping to raise money for the building of an up-to-date emergency room at the hospital. Up until her death, Tina Smith continued to serve her community and the State of Nevada.

—*Mary Gafford*

Debbie Smith

Debbie Smith was born in Tucson, Arizona to Mr. and Mrs. Coy Maston Bilbrey. Her father was a veteran and she had six sisters and brothers. When Debbie was in the fourth grade, the family moved to Battle Mountain, Nevada. She grew to love Nevada in all its beauty and loved photographing the great Nevada outdoors. She later moved to Sparks, Nevada and made it her hometown.

Debbie married Greg Smith in 1974, her childhood sweetheart. Their first date was in the seventh grade! They were soul mates and the proud parents of three children, Olivia, Ian and Erin, and grandparents to the beloved Emma and Aanika.

When Debbie was twenty-two-years-old she was elected to a rural school board, and as a parent of three children, she was a lifelong advocate for public education. She was first elected to the Nevada State Assembly Washoe District 30 in 2000, and was voted in every election through 2010. She won a seat in the Nevada State Senate District 13 in 2012. Throughout the years, she won several 'lawmaker of the year' awards and was president of the National Conference of State Legislatures.

Debbie Smith was very active in the Legislature, including at the forefront of two major pieces of legislation in 2013: Brianna's Law, which requires DNA testing for those arrested for felonies, and another requiring schools to stock EpiPens, shots of epinephrine that counteract potentially lethal allergic reactions. She was also an electoral force, winning by twenty-one points in 2014, a year when many Democrats were ousted by a Republican wave.

Debbie was very involved in her community and organizations. She was a board member of Nevada Afterschool Network; a board member of the Education Alliance; Washoe County School District Parent Involvement Council member; consultant for Nevada Parent Teacher Association (PTA); on the advisory board for Northern Nevada Childhood Cancer Foundation; Sparks Chamber of Commerce member; and an officer in the Professional Employees International Union Local 29.

Debbie had many personal and professional achievements, including: Toll Fellow, 2010; Yale Women's Campaign School, 2010; Public Education Hall of Fame, 2009; Elected Official of the Year, Disability Advocates; Public Official of the Year, Nevada Association of Social Workers;

JANUARY 14, 1956 —
FEBRUARY 16, 2016

Legislator of the Year, School Counselor's Association; Western Legislative Academy, The Council of State Governments–WEST, 2002; Flemming Fellow, Class of 2002; Past President, Nevada PTA; Past Member, Lander County School Board; National PTA Board of Directors; Sparks Charter Commission; Freshman Lawmaker of the Year; Peace Officers Research Association of Nevada, 2001; life member, National PTA; former chair, Council to Establish Academic Standards.

Debbie was diagnosed with a brain tumor in 2015. She had successful surgery to remove the tumor at MD Anderson Cancer Clinic in Houston before returning for the final six weeks of session. She remained active in the political realm even as she fought cancer, sitting on the committee that drafted a 2016 ballot question on funding for building and maintenance projects for the Washoe County School District. She said she planned to return to the Legislature in 2017.

When Debbie passed away, Gov. Brian Sandoval said Smith "was an extraordinary public servant whose record of accomplishments and presence in the Nevada Legislature will remain unmatched for years ahead. We remember her legacy as a true Nevadan with a fierce devotion to her constituents and state, particularly to public education and the children of Nevada. I will personally miss her greatly and Nevada will miss her leadership." Sandoval ordered all flags on state buildings to half-staff until sunset on the day of Sen. Smith's.

U.S. Sen. Harry Reid said Smith "was the epitome of an ideal neighbor, friend, and public servant. A believer in the good of government, Debbie's advocacy for adequately funding our education system will be felt in Nevada for a long time. Northern Nevadans, no matter what party, had a fighter in the Legislature. Despite her difficult year, her positive outlook on life was admirable to all. She was my friend and I will miss her."

Reno Mayor Hillary Schieve said, "I was incredibly saddened today to learn of the passing of Debbie Smith. A Nevada resident for most of her life, Debbie was one of our state's strongest advocates for public education. Her work in the Nevada Assembly and Nevada Senate was marked not only by her dedication to bettering education policy, but also by her support of wildlife and conservation issues. I, along with my fellow Reno City Council Members, extend our sympathy to Debbie's family and friends during this difficult time. She will be missed.

"Today is a sad day for the city of Sparks and the state of Nevada. Senator Smith was an effective and principled leader and a champion of education, as well as a number of important human causes throughout our state. She was also a champion for her city, and I was always grateful for her strong partnership and advocacy on behalf of the citizens of Sparks. She fought for our citizens every day. She was so brave and strong as she battled her illness publicly."

—Denise Gerdes

Muriel Stevens

"Someone's in the kitchen with Muriel!" This could have been the one of the names of the locally and nationally produced television and radio programs on cooking and life that Muriel Stevens hosted for more than four decades in Las Vegas. Commencing in the 1970s, operating titles included, "Cookery and Conversation" on KLAV AM radio in the late 60s, "The Muriel Stevens Radio Show" on KDWN AM 720 and *The Muriel Stevens Cooking Show* on KVVU TV.

A lifelong passion, cooking for Muriel came easily. At age eight, young Muriel Godorov took to the duties of feeding her family in Philadelphia the town where she was born. At eighteen, despite a budding modeling career, Muriel met and married the love of her life, Maury Stevens.

With their two small children, Bruce and Robin, Maury and Muriel set their sights on the opportunities beyond Philadelphia and after brief stops in Denver and Los Angeles, the couple settled on Las Vegas as their new home.

Muriel was hired in the fifties as a weather girl, a news reporter, and a magazine writer and editor. Initially she wrote a column for the *Las Vegas Sun*, about community activities, food, and nutrition, really almost anything. Muriel achieved the position of Food and Wine editor at the *Las Vegas Sun* and contributed to that paper until her retirement at the age of eighty.

She developed the afore-mentioned "Cookery and Conversation," a daily call-in talk radio show that aired for over eight years. The show featured a variety of guests from not only the world of professional chefs but show business, sports, politics, and arts personalities as well.

Her media activities led her to cover most of the top social and cultural events in Las Vegas during the second half of the twentieth century. Muriel said that she sacrificed her once trim waistline by sampling all food, good and otherwise, offered in the name of reporting.

Muriel traveled extensively to discover other fine dining experiences for her audiences. She attended culinary schools worldwide when she had the opportunity.

In fact, it was known that Muriel was considered the number one food critic in Las Vegas and was consulted by many of the top chefs in Las Vegas before they opened a new restaurant or even changed their menu.

Muriel liked to say she brought fine dining to the masses. She also liked to say, "If you cook with love, they'll love your cooking," the theme of her successful television show.

The Muriel Stevens Show aired locally but was soon nationally syndicated by Trans-American Video Inc., the largest independent videotape company in the world.

Muriel's husband began to produce her tele-

December 22, 1925 — December 20, 2016

vision shows. Maury passed away at the age of fifty-nine in 1982.

Muriel's influence was extensive. She was the first Nevada woman member of the international gourmet society known as Le Confrere de la Chaine des Rotisseurs and was included in the membership of Les Amis d'Escoffier Gourmet Society and Les Amis de Vin. She served as the president of The National Association of Food Writers and American Women in Radio and Television. She was appointed by President Ford to the Presidential Consumer Advisory Council, one of only twelve to serve nationally.

In 1973, Muriel was awarded the first Achievement Award presented by the Nevada Chapter of American Women in Radio and Television. Other accolades included the 'Today's Woman' award from the National Ladies Auxiliary of the Jewish War Veterans and others from the Girl Scouts, Campfire Girls, the Junior Chamber of Commerce, and the Heart Fund. The Cystic Fibrosis Foundation also recognized Muriel for her achievements. At UNLV Hotel College, an annual $5,000 scholarship is in her name.

Her publishing and print achievements included *The Muriel Stevens Cookbook*, a collection of seventy-seven recipes featuring the culinary creations of celebrities such as Diahann Caroll, Juliet Prowse, and Shecky Greene.

She contributed to in-flight airline magazines for Delta, United, and Air West. At United, she was responsible for the selection of the magazine's 'Excellence in Dining' award.

Muriel edited the Las Vegas Zagat restaurant survey and contributed to the 2004–2009 editions of the *Unofficial Guide to Las Vegas*.

Muriel wrote a weekly column for *Showbiz* magazine, a *Las Vegas Sun* sister publication, that was placed weekly in more than 90,000 Las Vegas hotel rooms. She co-authored *The Unofficial Guide to Ethnic Dining* as well.

In the 1970s, she served as a consumer member to the Nevada State Dairy Commission, appointed by then Governor O'Callaghan. She served two terms on the board of advisors for the Southern Nevada Extension Service Nutritional Council and SOS, an anti-hunger program. She was a founding member of the Nathan Adelson Hospice in Las Vegas. The Lied Discovery Children's Museum board was another organization to enjoy her participation.

Stevens was an honorary member of the Food and Beverage Association of Nevada and the Fraternity of Executive Chefs of La Vegas. She was the first woman to receive the Food and Beverage Association's Autrui Award.

She was a regional judge for the James Beard Foundation Awards and in 1997, she contributed to *Playboy* magazine's '25 Best Restaurants in America' issue.

Muriel passed away at ninety-years-old.

—*Susan Houston*

Sandra Lee Thompson

Sandra Lee Bazonis was born in Hanover, Pennsylvania, the eldest of six children. She graduated from Delone Catholic High School and completed her education with a bachelor's degree in social work at Pennsylvania State University.

In 1973, while working as a reporter for a Connecticut newspaper, she met Gary Thompson, the editor of the newspaper. Mr. Thompson said, "The first thing I noticed about Sandy was how beautiful she was. She was also a very good writer. She always was a caring person. I think it had to do with her upbringing. She came from a poor family."

Sandra Lee Thompson and husband Gary arrived in Nevada in 1978. Already experienced as a newspaper reporter, Sandra found work at the *Las Vegas Sun* newspaper. She had her only child, Kelly Thompson, in 1980. Kelly said, "My mom was always trying to help children. I had a friend who lived with his mom, but she wasn't a good role model for him. My mom was able to go to court and have him placed with his aunt. My mom was my best friend," Kelly added. "She was my biggest fan, and having her in my corner made me stronger. She was so valuable to the community. Everyone loved her."

Over the years, Sandra worked in copy, features, and as the general manager. In 1997 she became the vice president and associate editor for the paper. That same year she was awarded the

Nevada Press Association's Story of the Year for "A Family Torn," regarding a local couple who lost guardianship of their daughter.

Sandy was known to stand up for the abused woman, to place the facts of ethically challenged elected officials in her columns, and to champion legislation for children. Her unfailing determination to protect children and to shine a bright light on the growing pains of the newly created family court served to benefit the entire community.

Five short years later, her life was tragically cut short from a traffic accident.

On 7351 N. Campbell stands a school, a proper tribute to the legacy of a great woman, The Thompson Elementary School. In his proposal to name a school after Thompson, Patrick Herron, former assistant superintendent with the Clark County District, recognized Sandy's efforts as a teacher, leader, and worker which led to a scholarship program for *Class!* Publications, the 'Mother of the Year' contest and hands-on workshops in the Sun Youth Forum.

The *Las Vegas Sun* included many such tributes in its "Remembering Sandy Thompson: 1948—2002." These letters capture the essence of Sandy Thompson.

Annie Griego, the mother of a murdered daughter, Donna Hernandez, commended Thompson for her clout and involvement with the Donna's House project. Donna's House was named for

AUGUST 24, 1948 –
AUGUST 9, 2002

Ms. Griego's daughter and provides a safe visitation exchange location for children in contentious custody cases.

Knight Allen credits her for bringing the need to raise child support caps in custody matters. One of Sandy's columns in January, 2001 read: "Raise Cap on Child Support payments." That year the legislature raised the cap and included a provision for inflation escalation in future years.

Retired District Court Judge Gerald Hardcastle noted that he read her column every Sunday. He wrote that it "was not uncommon to walk into the Family Court Building to find Sandy looking over a file. She was careful in her research and she was careful in choosing her battles." According to Judge Hardcastle, Sandy had no disregard or disrespect for family court; she just expected so much. Sandy turned her focus on the welfare of abused and/or neglected children.

"Whose voice will now speak out and comfort the parent/grandparents and help calm their fears concerning their children?" asked Toni Marchese. "Who will live up to Sandy Thompson's legacy? Sandy Thompson's heart was her voice!"

Al Dicicco, an advocate of Family Court Reform, in conjunction with the Coalition for Family Court Reform, expressed his heartache at Sandy's passing. He wrote, "Sandy took a stand for justice and for children. She filled the gap where children are often said to fall in divorce litigation. The loss of Sandy is immense, for it is also the loss of the children's voices. Fortunate are those who knew Sandy and confided in her with their broken lives."

The Sandra Lee Thompson Elementary School's website includes a category for its namesake.

According to the school's website, "Sandra Lee Thompson was more than a reporter who fought for a byline. Her life centered around creating change and using her words as weapons to protect the children of Las Vegas.

"She was a voice for kids and families when there was no other voice in the community," said Bill Gang, a former reporter at the *Sun*. "She was a marvelous person who supported her staff greatly and had a great sense of right and wrong."

Every tribute to Sandy mentions her great heart, her honest and well-researched articles, and her tenacious approach to bringing the plight of children to each reader.

—*Dora Ivanov*

Dorothy Tinker

orothy's love of animals brought her into prominence in Southern Nevada. For many years she had owned and operated the only pet shop in Las Vegas and was once president of the Silver State Kennel Club.

Place of birth for Dorothy Tinker was Ravenswood, West Virginia. Her parents were Estella and Edward Hewett Nowell, the city's local druggist. Dorothy attended elementary and high school in Ravenswood.

Dorothy began singing at the local Episcopal Church when she was eight-years-old. Her lovely voice prompted her to be a church soloist in the various cities in which she lived, including Ashtabula, Ohio; Cape Girardeau, Missouri; and Camden, New Jersey. Her distinctive voice emitted a definite calming effect, which would later be quite beneficial in her interactions with animals, especially dogs, throughout her adult life.

Dorothy met and married the love of her life, Almerin Tinker, in Ravenswood in 1920. Almerin became a noted newspaper publisher for many quality newspapers in various locations around the country. Always Dorothy would be his 'leg man,' traveling around to police stations, schools, various social clubs, and even court, gathering factual information for the various publications.

The Tinker family had two new additions, son David and daughter Nancy. Since Dorothy was stage struck at an early age and not able to accomplish anything with it, she was determined that her two children would receive the training she failed to get. David, an outstanding saxophonist, appeared on radio and the Philco television program at age eight. At age three, Nancy began singing and dancing, which brought Dorothy Tinker into show business.

For ten years while in the east, she produced shows for the U.S.O., Red Cross, Grey Ladies, and many more organizations. Each time they would get ready for a show, little Nancy would pack her bag with costumes and be ready to go.

"Stars of Tomorrow" was the name of the Dorothy Tinker production, in which she gave every young person an opportunity to entertain. Dorothy had as many as twenty-six acts working with her in the show. Dorothy emceed many of the shows, but needed others when her shows were held at the same time. She recalled one such instance when a young person who came to sing ended up singing and then emceeing the show. It was Eddie Fisher.

In 1951 the family moved to the small town of Las Vegas, Nevada and Dorothy put the entertainment work behind her and concentrated on helping her husband and then supporting the family.

What a move! The family arrived on a Saturday and by Sunday they had acquired a

CIRCA 1901 —
JANUARY 19, 1988

home for themselves, complete with a place for their menagerie of pet birds.

The word got out about Dorothy's soft heart concerning nature's creatures, both large and small. Dorothy soon began to raise birds and then dogs. With a smile and a delightful song in her heart, Dorothy began to call her newly purchased residence the Tinker Bird Ranch. That occurred within six months of the move to Clark County.

Dorothy began to be recognized as an authority on birds, so much that she began to appear on some of the local television shows. She first was invited to appear on Channel 8 with Beth Allen. Next she was invited by Channel 2 to talk about her bird-raising expertise. In actuality, Dorothy was destined to become one of the first clients to appear on Channel 2. Dorothy soon began her own program, deemed as an educational program that spoke to birds and the proper way to feed and care for them.

Meanwhile her husband, Almerin, had taken a position working for his brother-in-law at Tenth Street Motor Service, serving as a business manager, although he was not accustomed to this line of work. In 1957 he passed away.

Thus suddenly in 1957, Dorothy Tinker realized she was the head of the Tinker household. She opened a pet shop located at the junction of 11th Street and Fremont. The business immediately began to expand. By the next year, this humane woman constructed a large building on Las Vegas Boulevard South to accommodate the growth of her business.

Love of dogs and raising show dogs over the years had been a hobby for Dorothy. She had a special love for Maltese dogs, and her own International championship dog, Figgy. He captured championships in America, Bermuda, and Mexico. She had a waiting list for puppies from this champion. Accompanying Dorothy to many dog shows was her daughter, who became a noted dog groomer and traveled around the country grooming and showing champion dogs at many of the top shows.

At times Dorothy took pen in hand and wrote columns regarding pets and their care, which benefited many local residents. She also spent many hours as president of the Silver State Kennel Club, organizing acclaimed annual dog shows in Southern Nevada.

Dorothy Tinker will be remembered as an extremely kind, warm-hearted, and caring person for all of mankind and creatures of nature.

—*Mary Gafford*

Jean Tobman

In 1953 Jean and Herb Tobman decided to make the move from their home in New Jersey and settle in Las Vegas. Jean's parents had already located here in 1950 and subsequent visits impressed the Tobmans so much that, as Jean said in an interview with the Oral History Research Center at UNLV, "We drove back to New Jersey, packed up as quickly as possible to come to this beautiful, beautiful desert, because that was still what it was. It was maybe half a dozen streets." The Tobmans made the trip across the country with two little babies on board.

The Las Vegas Valley was a good fit for their needs. "The serenity, the warmth, just everybody knew everyone," Jean said in 2013. "There was no discrimination. Everybody got along so beautifully." According to Jean's daughter, Marilyn, "We never really understood what it was like to be segregated … because all of us and our friends (living on the Westside) went to Western High School. If you were on one side of the tracks you were considered part of Westside," she added. "We liked the weather and the freedom, and the life we established in the Pinto area of the Westside."

After arriving in Las Vegas, the Tobmans moved in with Jean's mother, Addie, who owned

FEBRUARY 27, 1926 — APRIL 23, 2016

a rooming house on North Eighth Street on Fremont Avenue. The tenants were mainly cocktail waitresses with young children and other young women who came to Las Vegas for divorces. The children all stayed home in the care of Jean's mother and played on swings in the desert dirt of the small backyard. Jean said "…it was not fancy living; it was just very nice and that's the way it was."

Jean insisted that the young women who roomed with her mother were all of good character, very businesslike, and their children very well behaved. She described their dress as everyday waitress outfits, no miniskirts or high heels or heavy makeup. "They were all young beautiful women," she added. Jean worked in the house with her mother and her husband worked with her father at the City Furniture Exchange on Main Street.

In later years the Tobmans lived in homes in Twin Lakes and Pinto Lane. The couple had three children, Marilyn, Janie, and Helen. The Tobman girls grew up keeping horses in the Pinto area. and riding them out into the desert, sometimes to the Strip and sometimes to the Silver Slipper for breakfast.

Entertainment for many of the adult residents

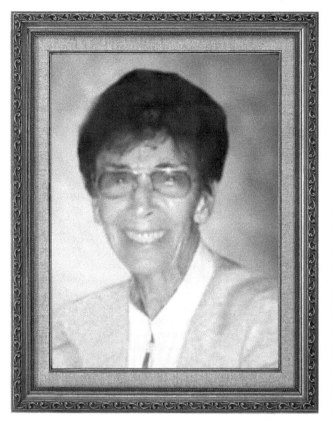

of the early days of Las Vegas existed in the showrooms of the local casinos. According to daughter Marilyn, "Lounge acts were really bigger than the showrooms," and unlike today, "Everyone dressed up for these occasions," she added.

In 1955, soon after Herb Tobman took out a $1,200 bank loan to open City Furniture Exchange, the store burned down. According to Marilyn "… our furniture store burned down and my father lost all of his records. We lost everything and he had to go to work." Herb needed a job, so he became general manager of the Moulin Rouge on Bonanza Road, the city's first integrated casino. He bought his first taxi about the same time, and the family's cab business was born. The furniture store reopened and was family-run for another twenty years. After Herb's death on March 14, 2006, Jean "jumped in and filled in my father's shoes" helping to run Western Cab Co., her daughter Marilyn said. "And they were big shoes to fill."

Jean Tobman's philanthropic endeavors included donating to the University of Nevada School of Medicine for an ongoing scholarship. UNR's medical school student lounge is named after the Tobmans. She also supported veterans and contributed to the business and athletic departments at UNLV. Jean and Herb were instrumental in founding WestCare, a Las Vegas drug rehabilitation clinic. Evolving from its origins as a single therapeutic community for men addressing drug addiction, today WestCare provides a myriad of programs for men and women, adolescents, families, and veterans and now has locations in eighteen states and three U.S territories.

Over the years Jean and her husband rubbed elbows with many famous Las Vegans, now part of early Las Vegas history. They interacted with politicians, casino owners, performers, showgirls, and just good people they claimed as friends, always without bias or prejudice. They worked hard, loved Las Vegas, and found much to approve of and much to regret about the changes they have lived through.

Jean remained involved in the family business and passionate about philanthropic causes into her twilight years, according to her daughters. She left many friends who remember her as a smart, warm, caring, classy lady who always had a smile and a helping hand for those who needed it. She was ninety-years-old when she passed away surrounded by family members.

The family will ensure Jean Tobman's philanthropic spirit lives on. "You know, she was the whole thing," her daughters said. "She was the matriarch and the glue for this family; now it's going to be up to the next generation to continue that legacy."

—Yvonne Kelly

Dorothy Tomlin

orothy Tomlin was the first choreographer on the Las Vegas Strip.

She began studying dance at age five in San Francisco, where she was raised. When she was ten-years-old, her teacher called up Dorothy to have a word with her. Her teacher said, "You don't have what it takes to be a dancer. You just don't have it in your blood." That's all that young Dorothy had to hear. Her mind was made up. That was her drive; she would be a dancer!

Dorothy's mother was the proprietress of a corset shop. Years later, she used her skills to sew Dorothy's wardrobe.

When Dorothy was sixteen, she managed a dance studio. She became known on the stage as Dottie Dee. At age eighteen she turned professional and went on the road.

She hit Las Vegas at age nineteen in 1941. She was a La Bard Dancer at the El Rancho Vegas Hotel. She came back to Las Vegas two years later and performed at the Last Frontier. Dorothy and her fellow dancers rode down the Las Vegas Strip on horseback to Fremont Street in order to buy their make-up.

Howard Hughes, owner of RKO studios, sent Dorothy beautiful girls. They were not trained dancers. Dorothy had a contract and was under the gun. Stressed and worried, she taught the girls how to walk properly on stage. They became the first line of showgirls, beautiful and stately. They became showgirls by default.

Dorothy was a very beautiful woman, a dark-haired beauty with all the necessary criteria. She'd had the opportunity to be in films and could have been in Cecil B. DeMille's *Ten Commandments*. Dance, however, was Dottie's calling.

Dottie then hit the road again doing a solo act. Soon after, her Dottie Dee dancers worked in San Francisco's North Beach area.

In 1943, Beldon Katleman of the El Rancho Vegas Hotel and Last Frontier booked Dorothy (Dottie Dee) as a solo act on the same bill with her previous La Bard chorus line. After a tour with her new chorus line, booked by the William Morris Agency, Dorothy returned to Las Vegas with her Dottie Dee Dancers. They worked there from 1952 through 1954.

SEPTEMBER 9, 1922 — MARCH 13, 2014

In 1952 she and her husband, Donald Tomlin, lived in a home near Water Street in Henderson. She lived there during the time that she worked dancing and choreographing the Dottie Dee Dancers at the El Rancho.

Dottie's husband was the business mind of

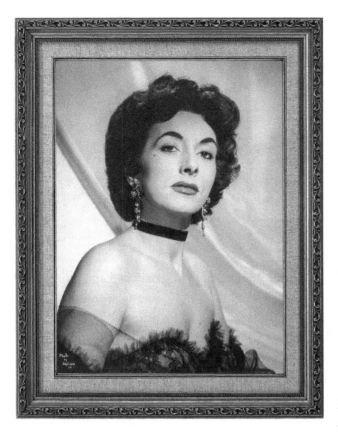

the duo. It was natural for him to assume the role of company manager. He owned Scotty's Men's Store. It was located on the west side of Las Vegas, conveniently next to the Moulin Rouge Hotel. Many of the performers enjoyed themselves at the Moulin Rouge after their shows on the Las Vegas Strip. So consequently Dorothy's husband's business flourished. Blessed with an entrepreneurial gene, he was one of the first to advertise on T.V.

Dorothy's son, Ron, photographer/artist said, "his parents lived all of their dreams." Ron was raised by his grandmother in San Francisco until his mother retired from dancing in 1955 at age thirty-two. At that time they moved to California.

Ron says that it was a stunning, vintage photograph of his mother that was his inspiration to pursue photography. He still has a pair of Dorothy's tap shoes. He says that the tap shoes and the collection of her photos are his most treasured possessions.

Donald and Dorothy were married for fifty-nine years. They lived their final years in a mansion of his own design. It was at the top of Sunrise Mountain with a spectacular view of the Las Vegas Strip.

The Tomlins' time in Las Vegas is well documented. There are publicity photos, newspaper clippings, pin-up shots, snapshots in their home, and show programs. There is a photo of Donald in a chaise lounge at a hotel pool observing his beloved Dorothy kicking up her beautiful legs with her line of dancers during their photo shoot with Lou Costello.

There's a photo of Dorothy on an El Rancho float that reads, "El Rancho Vegas presents THE GOOD OLD SUMMERTIME." There are fantastic backstage shots with Dorothy and the showgirls and other dancers. There are shots of Bud Abbott and Lou Costello performing their act on stage. Dorothy Tomlin's memorabilia can be found in UNLV's Special Collections where she and dozens of other dancers have conducted oral histories. Joyce Moore, archivist, says that for the first time visitors have come to the library to see images of their own mothers as dancers and showgirls.

Perhaps one day a permanent exhibit will exist of the dancers and showgirls—their return to the Las Vegas Strip.

—*Marilyn Mayblum*

Harriet Trudell

Harriet Trudell was a Democratic Party advocate, feminist, and civil rights activist. She championed women's rights to a degree that qualified her as a 'local legend' according to U.S. Senator Harry Reid. Her political acumen earned her the respect of local voters and noted legislators as she advised and supported many campaigns in Nevada.

Harriet Hope Hardbarger grew up in the segregated cities of St. Petersburg, Florida and Mobile, Alabama. Her mother died when she was ten-years-old, and her father raised her as a staunch Democrat. Her father was a plumber, and as such was a union organizer who taught Harriet the importance of fighting for equal rights. She recalled him saying over a meal, "Remember, children, you know what meat tastes like because there's a man named Franklin Roosevelt."

In 1948, when Harriet was sixteen-years-old, she accompanied her father to the Democratic National Convention in Alabama. At this convention, Herbert Humphrey's speech on civil rights opened her eyes to the extensive racism that permeated the South. "I came home from that convention a wild woman," she said. From that moment on, Trudell devoted her life to social change. In her twenties, she worked with the Florida branch of the American Federation of Labor and Congress of Industrial Organizations (AFLCIO) organizing unions while marching and protesting against injustice. During this period, Harriet marched and protested against various forms of injustice, and she was arrested several times in the process.

By 1962, Harriet had married and started a family and relocated to Las Vegas, Nevada. She focused her activism within Nevada working against nuclear waste, on behalf of school integration, welfare rights, the Equal Rights Amendment, and the Campaign for Choice. She ran many local and statewide political campaigns, including the 1968 Presidential campaign of Hubert Humphrey in Nevada. As Harriet's daughter Cindy Trudell recalls, "She'd drag me out of bed at 4:00 in the morning and take me to the bus stop to talk to the electricians about the candidates and hand out things for Humphrey. She never stopped working for people. People sometimes forget how hard my mom worked to support the [Democratic] Party and to make Nevada a better place."

Harriet put in four years as Nevada Governor Mike O'Callaghan's top aide in Southern Nevada and she also worked for the Southern Nevada campaign for George McGovern. She then served as the Southern Nevada Aide for Governor Mike O'Callaghan from 1974 to 1978. From 1983 to 1986, Harriet worked in Washington, D.C. as the Foreign Affairs Aide for Congressman Harry Reid.

Harriet was acknowledged as an expert grassroots organizer, who traveled across

August 22, 1932 – December 19, 2019

Tennessee, Virginia, South Carolina, and Louisiana recruiting women to run for public office. She served on the National Organization for Women's National Board and in 1992, she returned to Washington, D.C. to work as a lobbyist for the Feminist Majority Foundation. In 2000, Harriet returned to Las Vegas and continued her work in Democratic politics, serving as Political Director for the Nevada State Democratic Party in Clark County.

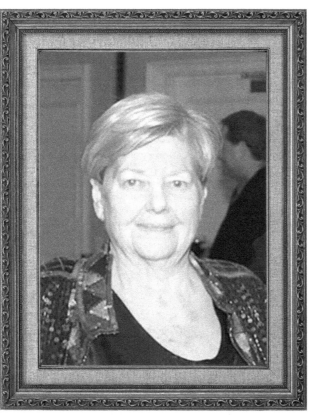

Harriet was not shy about sharing her opinions. Most Nevada Democrats of her generation knew they were in for it from Harriet when she thought they'd gone soft on a campaign promise or faltered at progressive change. As her longtime friend Karin Siena Rogers puts it, "Harriet didn't need jobs or titles. She had followers. She was a leader. If Harriet called up and needed help, even to this day 100 people would come running. She had that quality. She believed in her causes. On the outside, you would think she was stern and hard, but on the inside she was sweet and kind and caring for the underdog. She had a very soft streak that wasn't immediately recognizable because her fight for justice was so overwhelming. The fact is, you couldn't argue with her causes because her causes were social justice and human rights."

For Mikey Bilbray, wife of former Congressman Jim Bilbray, Harriet was a "fearless warrior, passionate … so passionate about her beliefs." The two became close friends during Harriet's successful effort to elect Mikey's husband to Congress. "Much has been made of her work on women's issues, but women's issues are human issues, and really with Harriet it was always about human rights."

Former Congressman Bilbray is adamant about Trudell's outsize role in his political success. Their door-to-door marathons were withering, but effective—and a learning experience for Bilbray. "She was just a great woman," he says. "I wouldn't have won without her. I'll always be grateful for Harriet. We're going to miss her."

Senator Harry Reid said he is indebted to Harriet Trudell. "She's a legend," Reid says. "She was involved in every cause known to woman. She was involved in everything. She was a spokesperson for the underprivileged and the underdog."

"Harriet Trudell was extremely close with the Reid family," said Sam Lieberman, second vice chairman for the Nevada State Democratic Party and a regent for the Nevada System of Higher Education. "Harriet wrote handwritten letters weekly to Harry Reid's office in Washington, D.C. or his home to share her opinions on what was happening in the Democratic Party or the state," Lieberman said.

The Southern Nevada Democratic Party is indebted to Harriet Trudell, and looks forward to the day another woman comes along to try to fill her shoes.

—*Denise Gerdes*

Carolyn Hayes Uber

Carolyn Marie was the first-born daughter to Marlin and Betty Hayes. She attended Chaffey High School, then Chaffey Community College in Alta Loma, California, where she met William C. Uber. They married August 29th, 1967.

Bill enlisted in the Air Force in 1968 at the height of the Vietnam War and was stationed at Ankara, Turkey. Even though pregnant with their first child, Carolyn joined him. She gave birth to Katrina (Tina) Marie Uber in a Turkish hospital.

A second daughter, Amanda Kathleen Uber, was born in Los Angeles, California in 1972.

Carolyn's adventures in Turkey began her life-long love affair with world travel—something she pursued until the last year of her life.

It was inevitable from early on that Carolyn would be involved in the book world. Her loves in life were books and family. Her sister, Sue Campbell recalled, "Her family used to tease her that she would read anything, including the cereal boxes at the breakfast table." Friends recognized the bookworm trait in her as well.

The family settled in Upland, California where Bill bought his parents' business, the Van Ness Water Gardens in Upland, which he still

**APRIL 16, 1948 —
SEPTEMBER 14, 2014**

operates today. Most of the business was mail order, with the catalog in need of updating, so Carolyn, while raising her daughters, took over the advertising and direct marketing for the water gardens company. In a cottage on the grounds of the business, Uber Advertising and Design was born. Her children napped and played alongside her while she taught herself the advertising business.

The company outgrew the cottage and moved into a series of offices in the Upland area. Over the course of about thirty years, it became one of the largest and most successful advertising firms in the Inland Empire. On the same day the business moved into a turn-of-the-century office building Carolyn had purchased and restored, a call came from the COO of the *Las Vegas Review-Journal*, Mike Ferguson, asking her to come to Las Vegas and start up Stephens Press, the book publishing arm of Stephens Media. The *Las Vegas Review-Journal* was owned by Stephens Media.

Years earlier, Carolyn began a publishing venture as an offshoot of Uber Advertising. She took on many book projects including Bill's book, *The Basics of Water Gardening*. While keeping her business and home in California, her new undertaking in Las

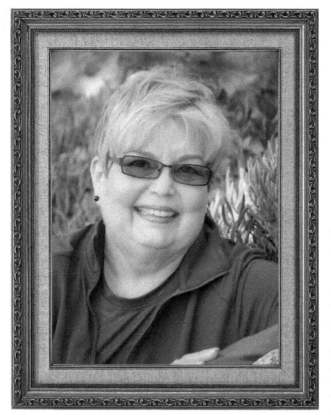

Vegas was intended to be part time. Even though it grew to become her full time job, she never stopped commuting every week or two back to Upland. Carolyn was considered a feisty and savvy publisher.

Under her guidance, Stephen's Press produced well over 200 books in the course of eleven years, including two books for Nevada Women's History Project highlighting women in Nevada history. Her last book, *Nevada: 150 Years in the Silver State*, became the official book commemorating the 150th anniversary of Nevada's statehood.

Stephens Press was one of the sponsors of the Las Vegas Writers Conference, which she loved attending and talking with up-and-coming writers and authors.

Carolyn was extremely proud of all the books Stephens Press published—the big important ones as well as the little insignificant ones. She loved working with wannabe authors and mentoring them. Her favorite moments were putting the freshly minted books in the authors' hands. She once said it felt like "placing the newborn baby in their arms."

According to Geoff Schumacher, author and former Stephens Media director of community publications, "Her M.O. was fostering writers. She could envision what a book would look like on the shelf before the author finished the second chapter."

In 2001, Carolyn was diagnosed with breast cancer and underwent treatment, which gave her eight years cancer free. Then in 2009, while feeling rundown, which she attributed to her grinding schedule of work and weekly commuting, she was diagnosed with acute myeloid leukemia.

She underwent aggressive chemo almost immediately. After her initial treatment in the local hospital she was blessed to be admitted into the renowned City of Hope Cancer Center for more specialized treatment that included a stem cell transplant in 2010. She went back to work in 2011. Her sister, Sue Campbell said, "You can't keep a driven woman down."

When her cancer returned in 2013, she enjoyed a trip to Ireland with her husband, Bill and and England with her sister, before going back to City of Hope for more aggressive treatment. She was a fighter to the end—and if she could—she would be in the office enjoying that moment with her authors when the book baby is born.

Carolyn had the emotional support of her husband, Bill, and daughters Katrina and Amanda, her father, Marlin Hayes, her brother, Phillip Hayes, sister, Sue Campbell, and close friends to the very end of her life. She called her three grandchildren her 'grand-darlings.'

—*Nancy Sansone*

Pamela Van Pelt

Pamela Van Pelt was a well-known community activist in Las Vegas. She accomplished great works and was listed as a member of "Who's Who in Black Las Vegas."

Pamela attended California State Hayward University and earned a bachelor of science degree in health services. She also received her master's of public administration.

Early in her career, Pamela chaired the advisory committee at the KCEP/FM 88.1, The Soul School Radio Station. This radio station is also known as Power 88, and provides Hip Hop, Soul, and R&B Music and Public Radio programs for four decades of service to the community. This radio station was formatted to fit the needs of its audience. Pamela occasionally hosted a talk show at KCEP/FM.

Pamela was a development director of the KUNR/FM public radio, a nonprofit station that was supported by large operation funds and relied on its audience for financial support.

She was also the director of development of the Nevada Opera Association, the oldest

JULY 20, 1945 –
JUNE 14, 2012

professional performing arts organization and opera company in Nevada. Ted and Deena Puffer founded the Nevada Opera Association in 1968 in Reno, Nevada. It's mission is to produce opera of the highest quality in Nevada and throughout the Eastern Sierra Nevada region for the enrichment and entertainment of the community, to offer outstanding educational and outreach programs to students, and performance opportunities to emerging artists.

Pamela was an ambassador for the Eisenhower Program, a teacher development program that impacts training in science and mathematics. The California Post-Secondary Education Commission participated in the program.

She served as a member of the Las Vegas Chapter of National Coalition of 100 Black Women. The Las Vegas Chapter was founded in 2004 to assist and promote as a catalyst for change in the lives of African American women. The organization offers valuable resources and networking opportunities in the community, and prides themselves in being

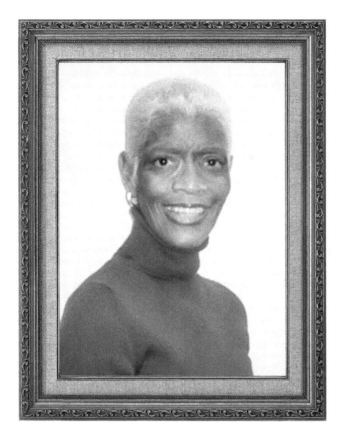

positive influences within the community. The National Coalition also advocates both nationally and internationally on behalf of women of color, providing events from lunches to concerts to the communities. These two organizations are well known throughout Nevada.

Pamela was the specialist of Grant and Resources for the Universities Cooperative Extension, and received a Grant and Resources Specialists Emeritus award from the University of Nevada, Reno on June 30, 2011. The Cooperative Extension dates back to 1862 to provide information to solve critical problems and issues. Pamela had been with the cooperative extension for fifteen years and taught grants-writing classes through the University of Nevada Las Vegas pro-

gram. This hands-on class effectively explained the ground rules of obtaining grants in the competitive world of many organizations striving for funds. Pamela was very happy to provide this class around the state of Nevada.

Pamela Van Pelt was a woman who believed in helping others and providing assistance to those in need. Her dedication and hard work with every organization she was a part of gave her further inspiration to continue her good works in the community, county, and state she served. The Pamela Kahn Van Pelt Scholarship Fund was established in her name through the Extended Hands Cancer Ministry.

—*Denise Gerdes*

Barbara Farrell Vucanovich

Barbara Vucanovich was born at Camp Dix, New Jersey, daughter of Major General Thomas Farrell and Maria Ynez White Farrell. Her father had supervised the building of the infamous Burma Road during WWII, later to work with Dr. Robert Oppenheim's Manhattan Project, which formulated the atom bomb. Barbara's maternal heritage bears mention. Her maternal grandmother's first ancestor to arrive in California was Corporal Jose Antonio Yorba, escort for Father Junipero Serra who established some of the missions in California. For his service, Yorba was given a land grant from the King of Spain, which is now Orange County, California.

Growing up in Albany, New York, she graduated from the Albany Academy for Girls and attended Manhattanville College of the Sacred Heart in New York City. She married at eighteen, but in a few years found herself headed to Reno, Nevada by train to obtain a divorce. During the residency period, she met Kenneth Dillon, a Yale Law School graduate. After obtaining her divorce, she returned to Albany, gathered up her two children and headed back to Nevada, where she married

JUNE 22, 1921 —
JUNE 10, 2013

Ken Dillon in Carson City in 1950. They later had three children of their own. Ken passed away in 1964 of a heart attack, leaving Barbara a widow with five children.

She got a job running a political campaign for a Basque candidate named Paul Laxalt. It was during his failed campaign for the U.S. Senate that she met and married native Nevadan George Vucanovich in 1965.

Paul Laxalt was later elected governor of Nevada, then winning his bid to the U. S. Senate, with Barbara serving as his Nevada District Representative from 1974–1981. In 1982, the second Congressional district in Nevada was created and Senator Laxalt urged her to run for Congress. With his endorsement, she won the Republican primary, going on to win the seat in the general election of 1982. With this victory she became the first female member of the House of Representatives from Nevada, serving a district that covered the seventeen counties in the state, including part of Clark County. On January 3, 1983, she was installed as a new member of the 98th Congress of the United States.

Shock soon set in when she was given a diag-

nosis of breast cancer. Of all the options, she chose a mastectomy, as it would mean a shorter recovery time in her new job. Noted for being tough, Barbara Vucanovich was back on the House floor six days later without missing any votes. This experience led her to introduce legislation to obtain funding for cancer research and to pass a bill urging early detection of breast cancer. She was the sponsor of a bill to extend Medicare coverage for annual mammograms for women; before then Medicare did not cover mammograms.

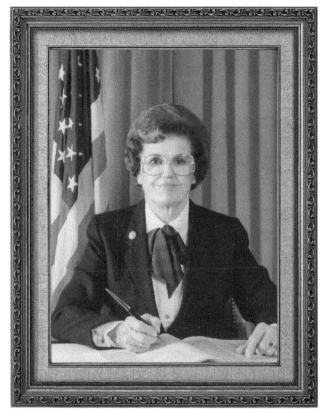

Barbara served on the Natural Resources Committee, an important committee for her rural constituents. She authored a bill called the Source Tax to prevent other states from collecting taxes on pension and retirement benefits from those who had moved to Nevada. She successfully cosponsored the repeal of the 55 mph speed limit, also important to rural Nevadans. She served on the House Appropriations Committee and chaired the Subcommittee on Military Construction, by which she arranged for millions of dollars to be infused into Nevada projects.

Barbara was elected the 104th Congress Republican Conference Secretary, the first Nevadan to serve in a leadership position in Congress. She served on the Presidential Debate Commission. She was popular with the voters, being elected to serve seven terms in Congress, the second longest term of any Nevadan in the United States House of Representatives. She did not seek to run for her Congressional seat in 1996, as her husband George had been diagnosed with leukemia and passed away in 1998.

After she retired from Congress in 1997, she served as a trustee of the National Council of Juvenile and Family Court Justices. She also was a trustee on the Board of Saint Mary's Health Network. President George W. Bush appointed her to the Commission of Select White House Fellows. And she served on the Board of Case De Vida, a home for unwed mothers. The University of Nevada, Reno awarded her an Honorary Doctorate of Humanities in 2004. The main post office in Reno was named the Barbara F. Vucanovich Post Office in her honor. She was also a member of the Daughters of the American Revolution.

In her own words: "It has been an interesting journey from my birth at Camp Dix, New Jersey, to Reno and Washington D.C. After a trip of fourscore years, my biggest hope is that I have been able to pass on the lessons I learned from my parents to my own children, grandchildren, and great grandchildren. The measure of my life, I believe, and the most satisfaction I have as I look back is that I raised a good and loving family, sometimes under difficult circumstances. I had setbacks of course, but I never felt defeated and I always felt that I was blessed."

—*Joan Dimmitt*

Sister Angelita Wasco

Sister Angelita (Anne) Wasco, a Catholic nun, noted for the bread she baked while in charge of the kitchen at Rose de Lima Hospital in Henderson, received honorable mention in the 1999 book, *The First 100: Portraits of the Men and Women Who Shaped Las Vegas*. Al Freeman, a Jewish man, charismatic publicist for the Sands Hotel and Casino, named the loaf after her. Their 'Angel Bread' story breathed life back into the financially struggling hospital.

Anne, sister's baptismal name, was one of eleven children who lived in Gaylord, Michigan, a farming community five miles from town. Anne's father did not believe in educating girls, but his boys went to high school. According to him, girls got married and had children so what good was their education beyond eighth grade.

Anne followed some of her siblings who settled in Detroit and began her high school education. To cover living expenses, she took on jobs—working in the school's library and cafeteria, and as a cook for a family of four. During her senior year, she became acquainted with Adrian Dominican Sisters, a congregation known as educated women with ministries in health care and social work. She followed her instincts and began her religious vocation, taking the name Angelita to honor her mother, Angeline.

MARCH 5, 1922 –
SEPTEMBER 9, 2013

On the other side of the country in Southern Nevada, the Basic Magnesium Incorporated (BMI) complex supplied the Federal Government War Department with magnesium, miracle mineral, used in munitions casings and airplane parts. When the war ended in 1945, the factory closed, and the surrounding area faced troubled days. Nevada community leaders looked upon their hospital as providing a necessary institutional anchor. A search began for private ownership of the original BMI hospital constructed to handle the medical needs of its employees and families.

News about the Dominican Sisters, who, in 1941, took charge of the hospital in Santa Cruz, California, caught their attention. They contacted Mother Gerald Barry, Prioress of the congregation, at the Mother House in Adrian, Michigan. She began negotiations and steps to assume responsibility for the small Nevada hospital. Sister Angelita, who started a home economics degree, was called into Mother Barry's office and learned her assignment changed. She was selected to oversee the hospital's kitchen.

In the summer of 1947, a small group of the sisters boarded the train dressed in full religious habit and journeyed 2000 miles from Michigan to the desert area, just shy of twenty miles from the glitz and glam of the Las Vegas Strip. It became known as

Henderson, Nevada, and the former BMI hospital was named Rose de Lima.

The economic base of the community was unstable, the population dwindled, and the patient count was low. Tension developed between the sisters and the remaining government doctors who, at first, failed to refer patients to the sisters. Sister Angelita laid off kitchen employees because of lack of funds and to make ends meet, nuns worked as health care providers during the day and at night, took on the hospital's maintenance and housekeeping duties. Times and conditions improved as the sisters gained the trust of the community and their patient count rose.

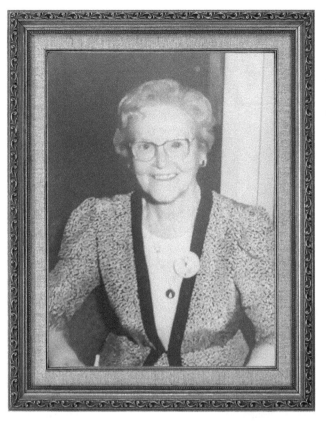

As a young girl, Sister Angelita was a good family cook. Transferring her baking skills to accommodate the larger hospital family was a challenge. After many attempts to perfect her family's 100-year old bread recipe, she finally corrected her technique mixing together the exact combination of simple ingredients—yeast, sugar, salt, oil, and flour. Her loaf was described as having a healthy, bready taste with a coarse texture, a nice, gorgeous brown top, cut well, and no air. Former patients and residents returned to pick up Sister Angelita's healthy homemade loaves and left a donation.

In 1957, while Al Freeman convalesced at Rose de Lima with war-related health problems, and had trouble keeping down his food, he salivated when the sweet aroma of freshly baked bread wafted through the hospital halls and into his ward. He started eating slices morning, noon and night—toasted, buttered, spread with jelly, or baked as buns.

While patient Freeman recuperated, its administrator confided in him about the financial difficulty facing the hospital. He knew nothing about baking or marketing bread but claimed it saved his life and began the hospital's first fund raising effort while maintaining his full-time position at the Sands. He took on the challenge of promoting the bread, which for a short period of time received national attention.

Freeman contracted a mill in the Mideast for the bread's premix package. Upon receiving their sample, Sister was disappointed it did not taste like her loaf. The vice president responded that, along with a series of chemical reactions that affected the finished product, slicing caused a 20 percent drop in flavor and an additional loss of 10 percent with its wrapping.

It was an enormous task facing both Sister Angelita and Al Freeman as serious problems kept popping up, such as copyright and trademark registration, timely delivery of engraved plates for wrappers, and the local grocery store closing. Their effort came to an end. On the positive side, the free publicity was immeasurable and, in the 1960s the first Rose de Lima Hospital Community Board was organized offering support to the sisters and their hospital.

Through 1957–1961 the Jewish publicist and the Catholic baker rose to the occasion, creating good memories and a hospital's folklore, The Angel Bread story.

—*Joan McSweeney*

Mary Wesley

orn in Quintan, Mississippi, Mary was the second of eleven children. When she was sixteen, she left her home and school to move west with her sister in search of better opportunities. Her mother had given her permission to leave so that she would have a better chance at making a living for herself. In her later years, Wesley said she regretted not earning her high school diploma, which she was very close to achieving before making the move.

Upon arrival in Las Vegas, she quickly found work and was soon able to support herself. Wesley settled in the historic West Las Vegas, married, and by the time she was twenty-three had given birth to eight children—among them two sets of twins.

After a divorce, she found herself working two jobs to take care of her family and support herself and the children. "I was working day shift as a maid at the Showboat and night shift as a cocktail waitress on the Westside." She later told Annalise Orleck, author of *Caesar's Palace: How Black Mothers Fought Their Own War on Poverty.* "I was paying one check to the baby-sitter and the other for rent. I just couldn't do it." According to her daughter, Sha'Londa Adams, "that was what pushed her into activism."

A proud, hardworking woman, Wesley initially did not want public assistance, but with eight mouths to feed, it was extremely hard to make ends meet, so she finally gave in and accepted the help.

Fellow Las Vegans Ruby Duncan, Alversa Beals, and Rosie Seals found themselves in similar straits. When Nevada slashed the amount of welfare given to women with children, these Las Vegas mothers were outraged.

After doing some research the women learned how other states handled their welfare programs. According to Duncan, "California, for example, was one of the great states that looked out for the whole family group. They didn't discriminate against mother and father or whole family households. Nevada, at that time made sure no one had income; fathers could not be in the household or involved with the children." Duncan, Beals, and Seals and Essie Henderson joined Wesley and founded the Operation Life movement and became known as the Westside Mothers.

Adams later said that her grandmother hadn't sought an activist role in the community; it came out of necessity. "They were poor, black, and hungry," and the government was threatening to shut down the minimal welfare assistance available to families.

The group held protests to urge further enhancement and protection of welfare programs in Nevada. The movement, which at one point offered childcare, job training, and other community-oriented self-help programs, also helped open

JANUARY 31, 1937 –
SEPTEMBER 13, 2016

more work opportunities for women.

"Lots of those women went on to became nurses working in health care, construction, and putting on their own businesses," Duncan said. Before, "none of these opportunities were available. We weren't thinking about doing this type of stuff."

The movement's seminal moment came March 6, 1971, when the mothers and their children, along with

"She was funny, she was warm, she was brave, she was strong, she was sweet. She was such a great woman ..."

entertainers, civil rights leaders, film stars, and welfare activists from across the country organized a march along the Strip. They had one goal in mind—to shut down tourism and gambling and force the state to hear their voices.

Onlookers described the scene as Caesars Palace gamblers quickly picked up their money and left the casino floor and dozens of low-income mothers and their children zipped through, chanting, singing and clapping—closing the location for about an hour.

According to Annelise Orleck's book, *The Politics of Motherhood: Activist Voices from Left to Right,* Wesley was one of the marchers that day along with fellow movement leader Ruby Duncan, actress Jane Fonda, entertainer Sammy Davis Jr., and Reverend Ralph Abernathy, leader of the Southern Christian Leadership Conference.

Wesley's biggest dream was to open a restaurant. She had been cooking since she was a young girl and that dream came to fruition briefly in the 1980s when she opened a soul-food restaurant, Mary's Diner, on Jackson Street.

Later, Wesley became the family's unselfish matriarch, the glue that held the family together, her granddaughter said. She gave up the diner to raise the grandkids after she took custody of the fourteenth. She put aside her own goals in order to keep her grandchildren together. As her own children moved on to 'sow their oats,' Wesley "took on the job of raising seventeen grandchildren," Adams said.

One of the chief constants in the grandchildren's upbringing was Wesley's insistence that education be paramount. "Education was so important to her. It was ingrained—go to school."

Duncan remembers her friend for much more than her activism.

"She was funny, she was warm, she was brave, she was strong, she was sweet. She was such a great woman," Duncan said. "I'm very proud of her."

Her parents were her main drivers and inspiration. Her mother had given her independence and Wesley's father, who died on Christmas Eve when she was three, lived through the stories her mother would tell the children.

It was through those tales that she learned so much, her granddaughter said. Respect and character were ingrained from something her father would tell the family, "Never say sir or ma'am to a white person just because of their color, but out of respect and not out of fear."

As far as their upbringing, education was always key.

—*Theresa Johnson*

Karen Wheeler

When Karen Wheeler was born in Kansas to Wayne and Nelda Wheeler, the doctors predicted she would not live more than a year. She was two-years-old when she was diagnosed with Spinal Muscular Atrophy 1, a form of Muscular Dystrophy. They were wrong. The doctors did not know her fierce, independent, and determined spirit infused with a quick and snarky sense of humor. It was her spirit and her art that kept her going.

When she was five and other children played outside, art captured her interest and filled a need to express herself. "Art is the only thing I can really do on my own without asking for help. Everything else in my whole day is dependent on someone else," she told PJ Perez at the *Las Vegas Weekly*.

Karen's determination came in handy. When she applied to college, some faculty members were hesitant to accept her, thinking she would not be able to fully participate and keep up the pace. Karen Wheeler told Steve Bornfeld of the *Las Vegas Review-Journal*, "Because I was always this severely incapacitated, some teachers didn't know how to deal with me. It was fear-based. They thought I'd have a seizure in their class," she says, remembering one instructor who tried to keep her out of class. "I sent her a note and also sent it to the director of the handicapped center and it went in her job file. I graduated in spite of her." Graduate she did with a 4.0 grade point average with a master's degree in art from California State University, Fullerton in 1981.

Karen moved to Nevada in 1990 and initially lived with her sister. She eventually moved into her own apartment that was decorated with her art, memorabilia, and her parakeet, Spanky. In 2013, David, her long-time caretaker who had been with her since the 1970s, passed away. This was a pivotal moment in her life as she lost the one person who enabled her to live independently. Karen's ability to attend art openings or rock band concerts as well as other events became more limited.

Karen's art medium was watercolor and was at the nexus of surrealism and photo-realism, although she also worked in oil, acrylics, pencils and ink. She was a purist as white had to be the paper without pigment; no other white application could be used. Her work was executed with precision, even when the theme was whimsical.

It would take her six months to a year to complete one small painting in the last years of her life. Each painting had to fit on her wheelchair table. She designed a sling-like device to aid her in controlling her arm during painting and had a holder for the brush. Her technique she called 'layering' which

JULY 15, 1955 –
2018

202

defies the translucent look of most watercolor paintings and yields a colored pencil appearance. Each painting also has a rose; sometimes it is part of the painting's subject, but more often it is hidden. The rose symbolized Karen. She told Steve Bornfeld of the *Las Vegas Review-Journal*, "It's my symbol because I'm based in reality. A rose is beautiful but it has thorns. It's like life. If people accept my artwork, they accept me because the rose is there—I'm there."

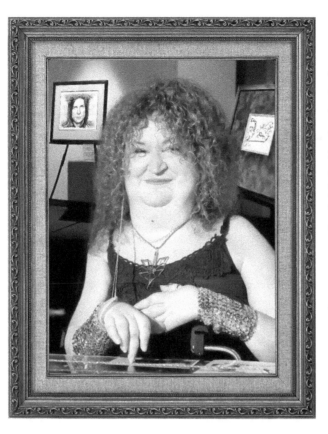

Her artwork's subject matter included animals, which she had a great affinity for, as they are not judgmental. Another favorite subject was rock 'n roll, especially her favorite rock stars such as Todd Kerns, John Lennon (her painting is owned by his son Julian), and one inspired by the band the Moody Blues. Other subject matter included whimsical play on words such as Fleye, Marsoupial Soup and Bat Masterson or the dark The Silent Scream.

In spite of her physical limitations, she had an exhibition record that most artists would envy with thirty-four solo exhibitions, ninety-eight group exhibitions, and numerous awards. She would regularly appear on the MDA Telethon, garnering national attention. Her artwork is in the permanent collection of the Daniel Freeman Memorial Hospital in Inglewood, California and her artwork has been exhibited internationally.

Karen's commitment to her community extended beyond the MDA telethon as she volunteered regularly and was on the board of directors of the Very Special Arts California from 1985 to 1992 and continued as an honorary board member. In 1990 she was awarded the Disabled Professional Woman of the Year by the Pilot Club of Southeast Los Angeles.

In Nevada, Karen was appointed by Governor Brian Sandoval to the Governor's Council on Developmental Disabilities in 2008 and received the Client Achievement Award for Southern Nevada Muscular Dystrophy Association in 2007.

Karen was always willing to help and regularly shared her knowledge of the business of art. She served two terms as president of the Las Vegas Artist Guild, was a board member from 2003, and was chair of Guild shows until 2012.

She partnered with William Schnell in 2012 and co-created GoHitYourself.com, a website dedicated to education for persons with disabilities and able-bodied people regarding their life experiences and challenges. It was later merged with Karen's website: KarenWheeler.com.

Karen may have been confined to a wheelchair and dependent on caretakers for her daily needs, but she had a spirit that defied all expectations. She was an inspiration and was always willing to put life in perspective. "That's my whole power, that they don't expect it. They think I'm sweet but they don't know me. That's my job here on Earth, to break in the weak. We're all in this together, right? And they are welcome to play with me, too."

—*Denise R. Duarte*

Ann Small-Williams

Azlee Ann Kelsay was born in Fort Worth, Texas to Royal Edward Kelsay and Carmen Azlee Isaacks Kelsay. She had one sibling, her older brother, Royal Edward Kelsay Jr. Her early childhood was spent in Corpus Christi, San Antonio, and Jacks County, Texas. After the death of her father, she moved to Denver, Colorado, residing with her mother and stepfather, Luther Vanhook Martin.

Ann attended the University of Wyoming in Laramie, Wyoming, and earned a degree in art and psychology. She remained an active and committed member of her Kappa Kappa Gamma sorority throughout her life. She married Edwin H. Small on August 22, 1953, in Denver, Colorado, and moved to his hometown of Sheridan, Wyoming. They had four children and she taught in the local school system and continued her sorority alumnae activities.

The family next moved to Laramie, Wyoming, where Ann assisted in the family pharmacy business. In the late 1960s, the family moved to Las Vegas, where she began

JANUARY 22, 1933 — DECEMBER 10, 2017

work at the Mint Hotel. Ann worked as an executive assistant for Associated Booking Corporation negotiating contracts, booking, and scheduling entertainment groups and stars into major hotels and lounges. Her training as the mother of four came in handy juggling many personalities and activities.

As the entertainment industry changed Ann decided to earn a real estate license. She worked in commercial real estate focusing on development in the Green Valley area of Henderson. She later earned a degree in nursing from the UNLV and worked as an ICU and neonatal nurse.

Looking for a new challenge after her semi-retirement at fifty-four, she pursued a law degree at Case Western School of Law in San Diego, California. After graduating in two- and one-half years, she began an internship with the City of Henderson as an assistant city attorney and was soon hired as a city prosecutor. Ann became a judge following her tenure as a prosecutor.

Ann was an ardent supporter of the pub-

Her training as the mother of four came in handy juggling many personalities and activities.

lic library system and served as chairman of the Henderson Library Board of Trustees. She was instrumental in the construction of the Henderson Library on Green Valley Parkway. Her interests included travel, cooking, and knitting, as well as a murder mystery reading fixation. Often reading a book a night, she always had a book bag ready for her next visit.

Ann married Captain Donald E. Williams, U.S. Navy (ret.), her second husband, October 2012, after meeting at a library event.

Ann helped found the S.A.F.E. House for Women in Henderson. It was established by a group of community leaders concerned about the needs of battered women and their children. With strong community support, the organization eventually opened a domestic violence shelter that houses fifty-four beds at a time and an advocacy and counseling center that serves over 4000 people a year. Today S.A.F.E. House provided a comprehensive approach to end domestic violence and abuse in the family through safe shelter, counseling, advocacy, and community education. By focusing on comprehensive services for all victims of domestic violence, along with prevention efforts, S.A.F.E. House has become one of the leading domestic violence organizations in Southern Nevada.

Thanks to Ann and other community leaders, there is currently one domestic violence and abuse shelter and one program in Henderson, Nevada, with one offering a hotline and one offering emergency shelter. Outside of this city and still nearby, there is help at six domestic violence and abuse shelters and programs in places like Las Vegas.

Ann was dearly loved by her many friends who remembered, in particular, her sense of humor, ready smile, and kindness to others.

—*Yvonne Kelly*

Betty Willis

People can be famous for many reasons. Some are born into fame. Some achieve fame such as politicians, scientists, artists, athletes etc. Nevada has a woman who achieved fame from one unique service. This woman was Betty Willis. She will always be remembered as the designer of the 'Welcome to Fabulous Las Vegas' sign.

There are actually three of the signs. One is in downtown Las Vegas. One is on Boulder Highway. The most famous is on the south end of the strip on Las Vegas Boulevard. It has moved south to its present location after the strip expanded southward.

The sign had its inspiration from a salesman named Ted Rogich. He figured that a booming Las Vegas needed a distinctive gateway greeting for visitors. He had heard about Betty Willis and offered her $4000 for her work. It took seven years to complete. Once the sign was completed, it was placed in the National Registry of historical places and the rest is history.

The Willis family arrived in Las Vegas in 1905 on a horse-drawn wagon. Her father was Stephen Whitehead, who became Clark County's first assessor. Her mother, Gertrude Meader, was a homemaker.

Betty was born in Overton, Nevada. She at-tended art school in Los Angeles but quit to work in advertising. She returned home and got a job at the courthouse assisting women find appropriate attire to wear for divorce hearings. She became a legal secretary and moonlighted as a commercial artist. Later on, a sign company, Western Neon, hired her. She was one of the first neon engineers.

Western Neon is where Ted Rogich came upon Betty and hired her. She took her inspiration for the shape of her sign from the Goodyear Tire and Rubber Company's logo. Inspired by Disney, a starburst was placed at the top of the sign to promote happiness. The silver dollars were designed to offer good luck. In addition, Betty is known for her work on the Moulin Rouge and Buxum Motel Blue Angel signs.

Betty was proud of her work. She once told daughter that she is a 'world-famous design star.' She was known to sign greetings cards and messages with, "Welcome to Fabulous Las Vegas from the infamous Betty Willis."

Betty married Leon Willis in 1951. They had one daughter, Marjorie, and divorced afterward. She worked as a neon sign designer until retirement in 1977. She lived in Las Vegas until 2008 when she moved back to Overton, where she died at the age of ninety-one.

The sign was a gift to Vegas' public domain,

MAY 20TH, 1923 — APRIL 29TH, 2015

however, is actually located in Paradise, which is an unincorporated portion of Clark County. The sign is twenty feet tall. It is a horizontally stretched diamond shape with the top and bottom angles pointed while the side angles are rounded. It is double-backed and internally lit with a border of flashing and chasing yellow incandescent bulbs. In a nod to Nevada's nickname as 'the Silver State,' the top of the sign contains white neon circles placed across the sign designed to represent silver dollars with the word 'Fabulous' in cursive font. The words 'Las Vegas' are printed in red in all capitalized letters and take up a larger space on the sign, mostly filling the width of the sign and are placed on the next line. Crowning the sign is an eight-pointed, red-painted metal star, which is outlined with yellow neon.

Betty Willis had intentions to create a sign that was unique in its shape, style and content. She wanted it to be her gift to the city. Today, Young Electric Sign Company (YESCO) currently owns the sign. They lease it to Clark County.

Prior to 2008, it was difficult and even risky to get access to the iconic sign for photo purposes. There weren't legal places for visitors to park. A small parking lot was completely packed by a high number of visitors, which steadily increased over the years. In 2012, parking lots were added. There was room for two buses.

In April 2012, the Clark County Commission authorized the expenditure of $500,000 to add twenty more spaces to accommodate visitor traffic.

On April 23, 2015, a second site enhancement project was completed at a cost of $90,000. This project added twenty-one additional parking spaces along with additional cosmetic and safety improvements, including marked crosswalks and traffic signs to allow pedestrians safe access to the sign. Anytime of the day the sign is mobbed with people trying to take pictures. Now you can take pictures, sit by the sign, and snap away.

The text of the sign was changed once when Mayor Oscar Goodman unveiled the new marketing campaign 'Camp Vegas.' The sign was adorned with a cover that read: 'Welcome to the Fabulous Camp Vegas.' Holly Madison, Oscar Goodman, and a slew of showgirls and skydivers hosted the event.

Clearly, Betty Willis left a permanent fixture that will forever be a relic in the legacy of Las Vegas and all that it embodies.

—*Donna Matulis*

Dorothy Steiwer Wright

reserving Las Vegas history was Dorothy Wright's mission. Dorothy worked tirelessly to enhance and preserve the community's historic resources for future generations.

Born Dorothy Susan Steiwer in Spokane, Washington, she graduated from Lewis and Clark High School in 1966. She moved to Las Vegas in 1969 and earned a bachelor's degree in psychology in 1971 and a master's degree in history in 1981, both from UNLV.

Serving on the Nevada Humanities Committee, Dorothy was instrumental in their Pioneer Tapes Project in which historians interviewed old-timers who had done important things in the community.

Dorothy worked with the Clark County Parks and Recreation's Cultural Division from 1988 to 2010. She helped establish and determine events and programing for many county locations, like the amphitheater and cultural centers. In 2009 she produced a series of events, exhibits, programs, and publications to celebrate Clark County's Centennial year.

Serving on the Neon Museum board for twelve years beginning in 2003, Dorothy acted as chair of the Neon Museum's Facilities committee. She oversaw the renovation of the La Concha Motel lobby and its relocation to the Neon Museum Boneyard.

Pat Marchese, Dorothy's friend, said they were sometimes the only women in museum planning meetings filled with male engineers and contractors. They would tease each other by saying, "See the mess you've gotten me into!" Pat also related that Dorothy was a brilliant woman and her death was a big loss to Nevada.

Dorothy volunteered her time for many years with the Las Vegas Historic Preservation Commission. This Commission was responsible for developing, coordinating and implementing programs for the preservation of buildings, structures, places, sites, and districts in the city. She was also an active member of The Preservation Association of Clark County and Preserve Nevada boards.

In 2007, Dorothy helped preserve the Fifth Street School in Las Vegas. She said of the school, "It really takes you back to when there were houses downtown, when all that was residential. It's just a jewel and we have so few things left."

Dorothy was also instrumental in nominating the Betty Willis designed 'Welcome to Fabulous Las Vegas' sign to be listed in the National Register of Historic Places. She filed the application with the United States Department of the Interior to start the process. She wrote, "The 'Welcome' sign is the best

FEBRUARY 5, 1948 –
JANUARY 19, 2016

preserved and indeed the most iconic expression of the remarkable ascendency of post-war Las Vegas and its famous strip. While the Strip itself has changed dramatically since the 1950s, the 'Welcome' sign remains virtually unchanged since 1959. It embodies, through its design and history, Las Vegas as it established itself as a nationally and internationally important center of gambling related tourism. While so much of that period was demolished to make way for larger developments, and the Strip itself has transformed repeatedly over the years, the 'Welcome' sign remains the unchanged symbol of one of the more dynamic stories in the history of entertainment and tourism in the nation."

Dorothy's persuasive Statement of Significance was convincing and the sign was approved for protection status and listed on the National Register of Historic Places in 2009.

Dorothy worked on many articles and newsletters to further her cause of protecting Nevada landmarks by documenting her research. In 2010 she published, *Nevada Yesterdays: Short Looks at Las Vegas History*. Dorothy completed this book after her co-writer and husband, Frank Wright, passed away.

Dorothy also co-wrote *Spectacular: A History of Las Vegas Neon*. It was published in 2012 and shows beautiful images and explains the history of the unique Las Vegas signs that were renovated and placed on display in the Neon Museum.

In 2014, Dorothy was presented with a

Historic Preservation Commission Career Achievement Award. "In recognition of your years of dedicated service and leadership in preserving Nevada's history for the education and enjoyment of all citizens."

The Board of Clark County Commissioners proclaimed April 21, 2015 Dorothy Wright Day. The proclamation honors Wright's work as a historian, preservationist, and cultural proponent acknowledging her significant contributions to the Southern Nevada community.

The proclamation also recognizes Wright's efforts to bring arts education to rural Nevada communities by partnering with the Kennedy Center for the Performing Arts. She started the Lee Canyon Arts Camp and helped produce the 'Jazz in the Park' series at the Clark County amphitheater which brought local, national, and international artists to Clark County.

The proclamation states Dorothy Wright Day was named "To honor a truly outstanding citizen who has made a huge impact and created a greater sense of community within Clark County."

The Las Vegas Historic Preservation Commission created an award they call 'The Dorothy Wright Brick and Mortar Award' in her remembrance.

Dorothy's mission of preserving Nevada history will live on through the giving of this award named after her. Also, think of her preservation work when driving by the now protected 'Welcome to Fabulous Las Vegas' sign.

—Michele Tombari

Barbara Zielinska

It's a long trip from Poland to Silver City, Nevada. Not only a long trip, but most people have never heard of either place. At least, had not heard of either place until award-winning scientist Barbara Zielinska came along.

Barbara was born in the city of Lódz, Poland and as a child was interested in anything and everything scientific, ranging in subjects from air quality to organic chemistry. On top of her cerebral talents, she was an avid skier, hiker, mountain biker, kayaker—and later on, a world traveler. Added to all the above, she was a serious practitioner of hatha yoga of bikram, something very important in her life.

Bikram is an offshoot of traditional hatha yoga. The word hatha, which means force, denotes a system of techniques supplementary to a broad conception of yoga and is suitable for weight loss whereas bikram is more of a relaxing session for the mind and body. Each technique was undoubtedly suitable for Barbara and her intense life as there was no question about her being a force.

As Barbara grew up, she continued to be interested in science and ultimately earned a master's degree from the Lódz University of Technology, followed by a doctorate from the Polish Academy of Sciences in 1979. There she continued her research into organic

AUGUST 7, 1946 —
JULY 26, 2017

measurement instruments and methods of measurement of hazardous air pollutions.

For more than thirty years Dr. Zielinska made "significant contributions to air quality research, advancing the understanding of chemical processes that effect air quality, visibility, climate, and ultimately human health."

The exact date of Dr. Zielinska's immigration to the United States is not known, but after her arrival, records show she worked as an assistant research chemist at the University of California, Riverside for six years. In 1989, she moved to the Desert Research Institute (DRI) in Reno, Nevada, as an associate research professor and was promoted to full professor in 1997. There she established the Organic Analytical Laboratory which ultimately became one of the premier global laboratories for organic chemical analyses in the country. Topics ranged from groundbreaking tunnel studies of car emissions to biomass burnings and the impacts of hydraulic fracturing. Dr. Zielinska's impact in Nevada has included fundamental air quality research at Lake Tahoe, Las Vegas, and Reno.

The need for a second analytical cornerstone, an Organic Analytical Laboratory (OAL), was identified by the scientific community and Dr. Zielinska was chosen to fill the role as OAL director with an extremely modest budget.

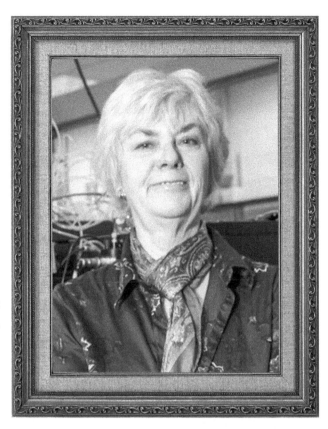

"When I was hired we didn't even have a single beaker, just an empty space for the lab," she said.

Ultimately, Dr. Zielinska turned the Nevada OAL into one of the premier global laboratories for organic chemistry analyses and utilized this capability on topics ranging from groundbreaking tunnel studies of car emissions to biomass burning and the impacts of hydraulic fracturing (DRI).

During her tenure, Dr. Zielinska authored or co-authored over 100 peer-reviewed papers and made presentations at numerous scientific conferences throughout the United States as well as internationally. Her work attracted more than $17 million in research funding, most being from competitive national programs such as the National Science Foundation.

In 1999, Dr. Zielinska was recognized with the Desert Research Institute's Women of Achievement Award and in 2002 the DRI's highest award, the Dandini Medal of Science.

For more than thirty years, Dr. Zielinska was a world expert in applying advanced organic chemistry knowledge to atmospheric air quality. She attracted funding from competitive national programs including from such agencies as the National Science Foundation, the U.S. EPA, the Renewable Energy Institute, the Health Effects Institute, the California Air Resources Board, the U.S. Department of Agriculture, the U.S. Department of Energy, and many other sponsors.

Dr. Zielinska was a national leader in service to the scientific community—including a role on the National Research Council Committee on Risk Management and Governance Issues in Shale Gas Development; three consecutive terms on the U.S. EA Clean Air Scientific Advisory committee (CASAC); an active participant in scientific societies including the American Geophysical Union, the Air & Waste Management Association, and the American Association for Aerosol Research; and a reviewer for many scientific journals.

Dr. Zielinska was truly a woman of accomplishment and possessed a unique combination of personality traits that allowed her to strike a balance between her personal, spiritual, and professional lives and perform with equal engagement and dedication.

The *Reno Gazette-Journal* published the following, stating her "spirituality brought harmony to each sphere of her life and gave her peace, equanimity, and strength that enabled her to cope with numerous tragedies she experienced: the loss of her brother, her parents, her husband, and her only child."

Barbara was a long active participant, as well as former president of Satyachetana International (SCI), a spiritual organization that meets regularly at the ashram in Silver City, Nevada. She will never be forgotten with all the lives she has touched locally, nationally, and internationally.

—Barbara Riiff Davis

Bibliography

SARI PHILLIPS AIZLEY
White, Claytee. Oral History, UNLV Special Collections, November 4, 2016.
Paul Aizley remembers, 2018.

SHIRLEY ANN BARBER
https://www.dignitymemorial.com/obituaries/las-vegas-nv/shirley-barber-7740867
http://obits.dignitymemorial.com/dignity-memorial/obituary.aspx?n=Shirley-Barber&lc=1009&pid=18
 8010409&mid=7743588
https://www.shirleybarberelementary.com/
https://www.legacy.com/obituaries/name/shirley-barber-obituary?pid=188010409

HELEN BAUCUM
Keck, Layne. Interview, 2019.
Marshall, W. D. "Interview with Helen M. Baucum, An Oral History." UNLV Special Collections,
 1975.
Obituary, *Las Vegas Review-Journal*, March 2013.

JUDY BAYLEY
"Judy Bayley dead at 56." *Las Vegas Review-Journal*, December 31, 1971.
"Judy Bayley." Women's Research Institute of Nevada, unpublished article.
Moehring, Eugene. *UNLV: A History*. University of Nevada Press, 2007.
Nevada Men and Women of Achievement, 1966.
Taylor, Richard. *Las Vegas Hacienda Hotel History*, Vol. II, 1997.

MARTA BECKET
Becket, Marta. *To Dance on Sands: Life and Art of Death Valley's Marta Becket*, 2006.
Noon and Skinner. "Stranded by a Flat Tire, Marta Made the Desert Dance," February 1, 2017.
"Marta Becket's Last Curtain Call." *The New York Times*, February 3, 2017.
Sandomir, R. "Marta Becket, Dancer who Built a Theater in the Desert, dies at 92." *The New York*
 Times. February 03, 2017.
Stringfellow, Kim. "Amargosa Opera House: Marta Becket's Death Valley Arts Oasis." KCET.org,
 January 4, 2016.

ELIZABETH GUIDO BECKWITH
Obituary, *Las Vegas Review-Journal*, 5/11/2019.

BARBARA BERNABEI
Kudialis, Chris. "Co-founder of Nevada's Easter Seals division dies," *Las Vegas Review-Journal*.
https://www.eastersealsnv.org/
https://www.eastersealsnv.org/mission
Obituary, *Las Vegas Review-Journal*, June 4, 2015

IRIS BLETSCH
https://www.dignitymemorial.com/obituaries/henderson-nv/iris-bletsch-5738484
Johnson, Jack. *Boulder City Review*, November 21, 2013.

BONNIE BRYAN

Adrian, Marlene J. and Gerdes, Denise M., Editors. *Nevada Women's Legacy–150 Years of Excellence.* Las Vegas: Women of Diversity Productions, Inc. 2014.

"Bonnie Bryan: Classy and Genuine." *Las Vegas Review-Journal,* September 3, 2016.

Obituary, *Las Vegas Review-Journal,* September 1, 2016.

Photograph source*:* Adrian, Marlene J. and Gerdes, Denise M., Editors. *Nevada Women's Legacy–150 Years of Excellence.* Las Vegas: Women of Diversity Productions, Inc. 2014.

MARY CASHMAN

Obituary, *Las Vegas Review-Journal,* July 9, 2017.

Koch, Ed. "Longtime business, civic leader headed family enterprises," *Las Vegas Sun,* December 7, 2005.

Smith, John L., "Conversations with Great Las Vegas Characters," *Vegas Voices,* Las Vegas, Nevada. NevadaSmith, c2014

MARGARET CONWAY

Obituary, *Las Vegas Review-Journal,* April 2012.

Krause, Barbara Grey. Notes from 80th birthday party address. 2006.

SHEILA CONWAY

https://www.bizapedia.com/people/nevada/henderson/sheila-conway.html

https://obits.reviewjournal.com/obituaries/lvrj/obituary.aspx?n=sheila-conway&pid=174211968

https://www.mylife.com/sheila-conway/e135974001390

Photograph source: Paul Washeba

CHARLETE CRUZ

Cruz, Charlene. Personal biography.

Obituary, *Las Vegas Review-Journal,* March 8, 2014.

JEAN D'AGOSTINO

Obituary, *Las Vegas Review-Journal,* March 1, 2015.

www.ffflv.org

www.lasvegan.net

www.nonprofitlocator.org

www.theartfactory.com

www.womenofdiversity.org

Photography source: Suz Lieburn/Brna

MARY DANN

"An Elder Passes: Mary Dann, Western Shoshone." http://www.Indian CountryTodayMediaNetwork. com/Editors report.

LeDuff, Charlie. "Range War in Nevada Pits U.S. against 2 Shoshone Sisters." (http://www.nytimes. com/2002/ 10/31/US/range-war-in-nevada-pits-US-against-2-shoshone-sisters.html. *The New York Times*, October 31, 2002.

Leigh, Laura. "In memory of Mary Dann: Mary and Carrie Dann." Western Shoshone elders, Eureka County, NV. Wild Horse Education Blog. From an article by KNPR, April 21, 2014.

"Mary and Carrie Dann of the Western Shoshone Nation (USA)." (http://www.rightlivelihood.org/ dann.html). The Right Livelihood Award, 1993.

"Mary Dann, Activist for Shoshone Tribe, Dies." *The New York Times*, April 23, 2005.

"Remembering Mary Dann – W. Shoshone Warrior." American Indian Movement of Colorado, April 25, 2005.

Vogel, Ed "Shoshones stake their claim." *Las Vegas Review-Journal*, April 5, 1998.

Photograph source: Ilka Hartmann.

HELEN DASELER

Daseler, Neil H. Helen Daseler's Eulogy

https://obits.reviewjournal.com/obituaries/lvrj/obituary.aspx?pid=160335280emory

https://www.lvds.com/history

NIKI SILVER-DEVINE

Koch, Ed. "Longtime Las Vegas socialite loses battle to Alzheimer's." *Las Vegas Review-Journal*, September 5, 2014.

DOREE DICKERSON

https://www.americanmothers.org/nominate/

https://www.jllv.org/

https://obits.reviewjournal.com/obituaries/lvrj/obituary.aspx?pid=191784513

MINNIE DOBBINS

Obituary, *Las Vegas Review-Journal*, June 27, 2018

The *Rebel Yell*, volume 5, issue 17, November 3, 1987

The *Rebel Yell*, Volume 28, Issue 5, September 30, 1982.

VERLIE GENTRY DOING

Adrian, Marlene J. and Gerdes, Denise M., Editors. *Nevada Women's Legacy-150 Years of Excellence*. Las Vegas: Women of Diversity Productions, Inc. 2014.

Obituary, *Las Vegas Review-Journal*, January 30, 2016.

"Verlie Doing had special love for Searchlight." *Las Vegas Review-Journal*, January 30, 2016.

LINNEA MILLER DOMZ

NV Garden Club 50th Anniversary Celebration Oct. 13, 2013 information booklet. History of NGCI and Presidents, Vicki Yuen, Editor

Obituary, *Las Vegas Review-Journal*, July 29, 2018

Interview with Linnea's family; Kristie Livreri, former President NV Garden Clubs and former Director of Pacific Region of National Garden Clubs;

Wikipedia: Golden Gate Hotel early years; Stories as remembered from conversations with Linnea, Judy Stebbins, LV Flower Arrangers' Guild & President NV Garden Clubs, Inc. 2019-2021; Vicki Yuen, former president of NV Garden Clubs

THALIA DONDERO

Adrian, Marlene J. and Gerdes, Denise M., Editors. *Nevada Women's Legacy–150 Years of Excellence.* Women of Diversity Productions, Inc. Las Vegas, 2014.

Photograph source:

Adrian, Marlene J. and Gerdes, Denise M., Editors. *Nevada Women's Legacy–150 Years of Excellence.* Las Vegas: Women of Diversity Productions, Inc. 2014.

JEANNE CRAWFORD DUARTE

"Jeanne Crawford Duarte," Humboldt County Library Oral History Project.

Lecumberry, Rhona. Humboldt Historian Pamphlet

Las Vegas Review-Journal, April 18, 1946; January 11, 1949; May 4,1955; February 11, 1962.

Las Vegas Sun, June 29, 1965.

Nevada State Journal, December 24, 1950; September 26, 1951; March 1, 1957.

Reno Evening Gazette, November 22, 1946; January 13, 1949; August 5, 1950; May 1, 1952; March 26, 1954; April 7, 1954; March 8, 1957; July 13, 1962; February 22, 1971.

FLORA DUNGAN

http://digital.library.unlv.edu/jewishheritage/people/flora-dungan

https://www.it.unlv.edu/classroom-technology/classrooms-buildings/

https://www.library.unlv.edu/speccol/databases/index.php?coll=photocoll&recid=63

http://www.onlinenevada.org/articles/flora-dungan

https://www.womennvhistory.com/portfolio/flora-dungan/

JESSIE MAY EMMETT

Emmett, Patricia. In person interview conducted by author Michele Tombari of Jessie Emmett's daughter. Las Vegas. March 9, 2018.

"Flying Grandmas try to set aviation records." United Press International, Las Vegas, Nevada. February 1, 1984

"Goodwill Awards." *The Rebel Yell.* 22(23). March 01, 1978.

Henle, Mike. "Jessie Emmett passed on bid for LV Mayor." *Home Scene*, April 20, 1991.

"Job Seekers now have One Stop shop." *Las Vegas Review-Journal*, January 24, 2001.

"Local Woman on Queen For a Day Show." *Redondo Reflex*, July 24, 1953

Obituary, *Las Vegas Review-Journal*, 2005.

"Passages." *RealtorMag*, February 1, 2006

"Realtor Jessie Emmett Honored." *Las Vegas Sun*, October 10, 1976

Rheinberger, Linda. "President's Message." *Southern Nevada Realtor*, February 2006

Russell, Diane. "College of Business Advisory Board Appointed." UNLV Media Relations press release, November 24, 1998

"Selma Barlett, Jessie Emmett, Angie Wallin To Receive National Jewish Humanitarian Awards." *Las Vegas Israelite*, 25(9). May 12, 1989.

Vogel, Irene. "A Tribute to Two Great Women." *Southern Nevada Realtor.* February 2006.

Photograph source: Patricia Emmett's personal collection

ANDREA ENGLEMAN

Dentzer, Bill. "Open government advocate dies at 79." www.reviewjournal.com

https://www.newsreview.com

https://www.reviewjournal.com/local/local-nevada/ande-engleman-nevada-journalist-and-press-advocate-dies-at-79-1691699/

Obituary, *Las Vegas Review-Journal*, June 21, 2019

Photograph source: Nevada Press Association

VICKI EWY

https://www.legacy.com/guestbooks/lvrj/vicki-satterfield-ewy-condolences/172270965

https://www.mylife.com/vicki-ewy/e36439972722

JANICE STEEN FAHEY

Ragan, Tom. *Las Vegas Review-Journal*, July 21, 2013

Obituary, *Las Vegas Review-Journal*, July 19, 2013.

VIRGINIA FENTON

Fenton, Virginia "Teddy." Unpublished oral history interview.

http://www.bcnv.com. Boulder City Visitors Guide.

http://www.ci.boulder-city.nv.us.

http://www.pbs.org/bouldercity. PBS documentary.

McBride, Dennis. "Remembering the Legacy of Those Dam Women." KNPR.org, August 16, 2016.

Obituary, *Las Vegas Sun*, March 31, 2005.

Wagner, Angie. "That Dam Tourist Traffic Threatens Peaceful Boulder City's Way of Life." *Los Angeles Times*, March 11, 2001.

VIVIAN FREEMAN

https://carsonnow.org/story/12/05/2013/former-nevada-assemblywoman-vivian-freeman-dies
https://www.legacy.com/obituaries/rgj/obituary.aspx?n=vivian-freeman&pid
http://nevadalabor.com/vivian/vivian.h

JESSIE BENTON FREMONT

Denton, Sally. *Passion and Principle*. (2007) Bloomsbury, USA.

TERRY GIALKETSIS

https://m.lasvegassun.com/news/2013/dec/03/philanthropist-had-long-love-affair-nevada-history/
https://obits.reviewjournal.com/obituaries/lvrj/obituary.aspx?pid=168321894
https://www.mylife.com/terry-gialketsis/e100537058232336

ELDA ANN GILCREASE

An Oral History Project of the Tule Springs Preservation Committee.
Escobar, Corrine. The Gilcrease Farmstead, PACC Newsletter, April 2009.
https://thegilcreaseorchard.org/history-orchard
Las Vegas Review-Journal, August 10, 1952, March 11, 1968, February 15, 1976, January 23, 2005, March 28, 2012.
Las Vegas Sun, December 01, 2003.
McCracken, Robert. Interview with John Theodore Gilcrease, produced by the Women's Research Institute of Nevada, UNLV (2002), funded by the Nevada State Parks Cooperative Assoc.
Nevada State Museum in Las Vegas
UNLV Special Collections

TONI HART

"A Symphony of the Heart," 1984.
Hart, Garry. Interview, 2019.
Wadler, Joyce. "A Las Vegas Mansion, Glue-Gunned to Perfection." February 24, 2010.

MARY HEALY

https://en.wikipedia.org/wiki/Mary_Healy_(entertainer)
https://www.imdb.com/name/nm0372351/bio
Weatherford, Mike. "Healy, 96, starred in Las Vegas showrooms: Singer-actress who teamed with husband onstage dies in L.A." *Las Vegas Review-Journal*, Feb 7–8.
Photograph source: Jay Florian Mitchell

SYLVIA BARCUS HEALY

Obituary, *Las Vegas Review-Journal*, October 29, 2013.

HAZEL SHEPHERD HEFNER

Stuhmer, Ellen. Oral interview of family memories.
"The Gilbert Hefners, Ranching, bootleggers and general good." *The Nevadan* magazine, September 5, 1976.

CHARLOTTE HILL

Koch, Ed. "Charlotte Hill, founder of Sun Camp Fund and pioneer of Las Vegas Volunteerism, dies at 92." *Las Vegas Sun*. April 27, 2018.

Thomas, Althea. *Las Vegas Israelite*. Vol. 9, page 6. February 23, 1973.

White, Claytee. Oral History, UNLV Special Collections. May 4, 2009.

RITA MCCLAIN ISOM

McClain, Scott. Biographical information.

Mesquite Club. Biographical information of members.

Obituary, *Las Vegas Review-Journal*, December 31, 2017.

JEAN BOWLES JENKINS

Belcher, Caitlyn. "Real Estate Pioneer Helped Draft Modern Home Design." July 11, 2014.

Houston, Susan. Oral History.

"Longtime Realtor: Jean Bowles Jenkins." Member Spotlight, *Southern Nevada Realtor*, May 2015.

"Tract Housing in California, 1945–1973: A Context for National Register Evaluation." California Dept. of Transportation, 2011.

FERN JENNINGS

Las Vegas Review-Journal, March 10, 2018.

www.dignitymemorial.com/obituaries/las-vegas-nv/fern-jennings.

www.fern-jennings.com/happy-hoofers.html.

MIRIAM KATZ

Aizley, Paul. Interview, 2018.

Obituary, Dignitymemorial.com. April 11, 2015.

Obituary, *Las Vegas Review-Journal*. April 14, 2015.

EDYTHE SPERLING YARCHEVER KATZ

Obituary, *Las Vegas Review-Journal*, August 17, 2016.

MARY KAY HEIM KEISER

Bolling, Barbara and Pepper, Marge. Oral interviews.

Keiser, Julie. Family documents, letters and memories.

Obituary, *Las Vegas Review-Journal*, September 28, 2016.

DOROTHY LAUREL KEMP

Kemp, Donald. Oral history.

Obituary, *Las Vegas Review-Journal*, 2016.

LORNA KESTERSON

Kesterson, Lorna. Interview, OH-01011. [Transcript.] Oral History Research Center, Special Collections and Archives, University Libraries, University of Nevada, Las Vegas. October 18, 1974.

Obituary, *Las Vegas Review-Journal*, January 2012.

www.ccsd.org. Profile of Lorna Kesterson.

AI JA KIM

Gerdes, Sarah. *Sue Kim of the Kim Sisters: The Authorized Biography*. Goodreads.com, 2017.

Han, Benjamin M. "Transpacific Talent: The Kim Sisters in Cold War America." Pacific Historical Review, Vol 87, No. 3, pp 473-398, 2018.

Hong, Euny. *The Birth of Korean Cool. How One Nation is Conquering the World Through Pop Culture*. Simon and Schuster, 2014.

Kwon, Myoung-ja Lee. Oral History Interview, UNLV, Feb 1996.

The Kim Sisters. Wikipedia.org.

Photograph source: nedforney.com

DORIS SHOONG LEE

Obituary, *Las Vegas Review-Journal*, August 28, 2018.

Obituary, *Mesquite Local News*, August 29, 2018.

Photograph source: Audrey Dempsey

MARY MOSS LONGLEY

Dimmitt, Joan. Personal memories.

Hartig, Laurie. Interview.

Obituary, *Las Vegas Review-Journal*, June 17, 2017.

FRANCES RUTH MACDONALD

Houston, Susan.

MacDonald, Rich. Remembrances, 2018.

Obituary, *Las Vegas Review-Journal*, 2017.

Photograph source: Audrey Dempsey

BETTY VANWINKLE MAHALIK

Mahalik, Betty. *Living a Five-Star Life*. Simple Truths, 2008.

Mahalik, Betty. www.simpletruths.com/author/betty-mahalik.html. Accessed May 3, 2018.

"National Association of Women Business Owners, Women of Distinction Dare to Dream." *Las Vegas Sun*, special supplement to "In Business Las Vegas," March 30, 2007.

Obituary, *Las Vegas Review-Journal*, October 2014

"Shelter Box Appoints Las Vegas Summerlin Rotarian as Ambassador." The Highlighter, 85(10), April 2012

Tombari, Michele. Telephone interview with Andrew Mahalik. May 20, 2018.

Tombari, Michele. Email correspondence with Andy Mahalik. June 7–11, 2018.

"Women of Distinction awards ceremony planned." *Las Vegas Sun*, February 16, 2005.

Photograph source: Andrew Mahalik's personal collection

RUTH MCGROARTY

https://learn.org/articles/Insurance_Broker_Become_an_Insurance_Broker_in_5_Steps.html
https://obits.reviewjournal.com/obituaries/lvrj/obituary.aspx?pid=174153839
https://www.neighborhoods.com/crestview-estates-las-vegas-nv
http://www.nvcontractorsboard.com/aboutus.html
http://www.saintannelasvegas.org/home/
http://www.tributes.com/obituary/show/Ruth-Palmer-McGroarty-102194593

MARIE MCMILLAN

Luchs, Kelli. Oral Histories, UNLV Special Collections, September 15, 23, October 1, November 24, 2009. OH-01272. [Transcript.] Oral History Research Center, Special Collections and Archives, University Libraries, University of Nevada, Las Vegas.
Obituary, *Las Vegas Review-Journal*, March 26, 2019.

PATRICIA STARKS MCNUTT

Grace Presbyterian Church Memorial Service Program
Obituary, *Las Vegas Review-Journal*, October 23, 2017.

MAYA MILLER

"Maya Miller Biography, 1915-2006." *Las Vegas Review-Journal*, June 2, 2006.
"Maya Miller – Nevada Activist," *Los Angeles Times*, June 6, 2006.

NAOMI MILLISOR

League of Women Voters of Las Vegas Valley Historical Documents.
Obituary, *Las Vegas Review-Journal*, March 16, 2017.

BERNICE (JENKINS) MOTEN

Obituary, *Las Vegas Review-Journal*, April 22, 2000.
www.lasvegassun.com/news/2000
Photograph source: Frederick Moten

BARBARA MULHOLLAND

Koch, Ed, "Longtime philanthropist, patron of Las Vegas community groups dies." *Las Vegas Sun*, June 23, 2016.
Morrison, Jane Ann. "Remembering a giver who gave wisely." *Las Vegas Sun*, July 6, 2016.
Obituary, *Las Vegas Review-Journal*, June 23, 2016.

LAURA MYERS

https://www.legacy.com/obituaries/name/laura-myers-obituary?pid=183060176
https://www.reviewjournal.com/local/local-las-vegas/nevada-journalist-and-humanitarian-laura-myers-has-died-at-age-53/

GEORGIA NEU

Atreides, Paul. *Las Vegas Review-Journal*, August 29, 2014.

Cling, Carol. Internet and Facebook, *Las Vegas Review-Journal*.

Gubbins, Laura. Permission to write biography of her mother, Georgia Neu.

Gubbins, Rob. Permission to access personal email.

In Memoriam-Georgia Neu. Facebook.com

Price, Norma. Personal contact with Georgia Neu.

Wasserstein, Wendy Wasserstein. Wikipedia and The *New York Times*, Jan. 1, 2006.

Wennstrom, John. Personal contact, Actors Reparatory Theater.

Photograph source: courtesy of Facebook.com, August 29, 2014.

JEAN SLUTSKY NIDETCH

McFadden, Robert D. *The New York Times*, April 29, 2015

Meltzer, Marisa. *The New York Times*, May 6, 2017

Robison, Jennifer. *Las Vegas Review-Journal*, April 30, 2015

wikipedia.org/Jean_Nidetch

www.mylifetime.com/She-did-that, Sari Rosenberg

www.pbs.org/wgbh/theymadeamerica, whomadeamerica/Innovators/JeanNidetch

Photograph source: *The New York Times*, April 30, 2015

JANET MICHAEL NITZ

https://obits.reviewjournal.com/obituaries/lvrj/obituary.aspx?pid=171505191

CAROLYN RANDALL O'CALLAGHAN

"Carolyn J. (Randall) O'Callaghan." Nevada Women's History Project.

HeadsUp, www.headsupnvada.org/legacy.

"O'Callaghan Family Matriarch Dies at 68." *Las Vegas Sun*, August 9, 2007.

O'Callaghan, Mike. "Definition of Mike O'Callaghan and Synonyms." dictionary.sensagent.com/mike o callaghan/en-en/

RENE O'REILLY

Ancestry.com

Las Vegas Review-Journal, June 21, 2012.

Las Vegas Sun, June 21, 2012.

Morales, Viridiana. *Nevada History*.

Rebel Yell.

Photography source: Sonya D. Wasson

TRUDY PARKS

Jackson, Nicholas. Biography.

Obituary, *Las Vegas Review-Journal*, August 23, 2010.

WANDA LAMB PECCOLE

Obituary, *Las Vegas Review-Journal*, June 17, 2011.

www/peccolenevada.com/about-us/

SANDY COLON PELTYN

Huffey, Dorothy. "Society news," *Las Vegas Review-Journal.*

Latin Chamber of Commerce, Las Vegas, Nevada.

Minutes, Dignity Health, St. Rose Dominican Hospital Foundation

PRLOG.com, December 31, 2010.

Saintpetersbergblog, 2017.

United States Congressional Record, v 153, PT3 February, 2017.

VegasInc.com

Vegasnews.com

Photography source: Maggie Arias-Petrel

MARY MARKESON PERRY

Obituary, *Las Vegas Review-Journal*, March 30-31, 2019.

FRANCES PETERSON

Minnesota State Public School History, supra note 92. Catholic Charities Volunteer Corps, History of Catholic Charities St. Paul/Minneapolis, http://www.ccvolunteercorps.org/history.aspx

MARGARET PIERCE

Assembly members address and phone list

"Legislator dies of cancer," *Las Vegas Review-Journal* October 11, 2013

Legislative biography, 73rd (2005) session

Margaret Pierce sources/ documents December 18, 2018

Obituary, Legacy *Las Vegas* (ap).

Tweets & replies.

Photograph source: Helen Mortenson private collection

WENDY PLASTER

Kester, Jillian and Plaster, Maggie. "Philanthropist and Lover of the arts Remembered for a life well lived." *LUXURYLV* magazine, May 5, 2017.

Obituary, *Las Vegas Review-Journal*, August 5, 2016.

Wargo, Buck. Richard Plaster interview, July 30, 2010.

SARANN KNIGHT PREDDY

Ciciero, Cynthia, editor. *72 Years in Las Vegas, Dr. Sarann Knight-Preddy.* Las Vegas, NV: PDQ Printing, 2015.

NORMA JEAN PRICE

Family members, interviews.

Gafford, Mary. Interview.

Hayes, Eileen. Interview.

Las Vegas Review-Journal. June 21, 2018.

DEBBIE REYNOLDS

Bright Lights: Starring Carrie Fisher and Debbie Reynolds. Co-producer Todd Fisher. HBO 2017.

Fisher, Todd. My Girls: A Lifetime with Carrie and Debbie, 2018.

IMDB

Official Debbie Reynolds website: www.debbiereynolds.com

Reynolds, Debbie. *Unsinkable: A Memoir.* 2013.

Wikipedia

Photograph source: Todd Fisher, Debbie Reynolds' son.

CLARINE RODMAN

Hayes, Chanelle. "UNLV receives $12.9 million gift to support special education interests." *Las Vegas Review-Journal*, October 27, 2014.

Juhl, Wesley. "Businesswoman, philanthropist Kitty Rodman dies." *Las Vegas Review-Journal*, February 28, 2014.

Levy, Ana. "Kitty Rodman: Pioneer businesswoman succeeded in 'a man's world,' left lasting legacy at UNLV." *Las Vegas Sun*, February 27, 2014.

Lyle, Michael. "Kitty Rodman Center namesake known for 'smashing through glass ceiling.'" *Las Vegas Review-Journal*, April 3, 2014.

Nordli, Brian. "Philanthropist's $12M gift to boost special education programs at UNLV." *Las Vegas Sun*, October 12, 2014.

LUCILLE SAVAGE ROGERS

Obituary, *Las Vegas Review-Journal*, August 28, 2012.

Perdue, Cheryl Rogers. Interview.

www.ccsd.net, 2015.

CECILE ROUSSEAU

Graduates. *The San Bernardino County Sun*, July 10, 1975, p. 38.

"New French Alliance Active." *Las Vegas Sun*, June 22, 1969, p. 42.

Obituary, *Las Vegas Review-Journal*, August 8, 2014.

"Paying Tribute to Grace Community Church. Congressional Record." V. 152, Pt. 9, June 16, 2006 to June 27, 2006, pp. 11656-11657.

Polk's Directory of City and County of Honolulu. 1981-1984.

"United Methodist Ministers to Move." *Honolulu Star-Bulletin*, June 22, 1974, p. 4.

SUSAN SCANN

Ferrara, David. "District Judge Scann, 70, mourned by colleagues." *Las Vegas Review-Journal*, July 17, 2016

https://www.reviewjournal.com/local/local-las-vegas/clark-county-district-judge-susan-scann-dies-after-battling-cancer/

https://www.ournevadajudges.com/judges/susan-w-scann/overview#!

https://ballotpedia.org/Susan_Scann

https://www.clarkcountybar.org/in-memoriam-the-honorable-susan-scann/

Obituary, *Las Vegas Review-Journal*, July 21, 2016

GENE SEGERBLOM

Haraway, Fran. Interview with Gene Segerblom. Boulder City, March 19, 2001.

Hopkins, A.D. "Personalities: Gene Wines Segerblom." *Las Vegas Review-Journal*, October 31, 1989. 15L.

Morrison, Jane Ann. "Segerblom Fills Family's Shoes." *Las Vegas Review-Journal*, January 3, 1993. 1B.

Segerblom, Gene. "Our Magazine Assignments Were Family Affairs." *Nevada* Magazine. July/August, 1996, p. 65-66.

Segerblom, Gene. "Nevada in Her Heart." Political Pamphlet, 2000.

ELINOR SHATTUCK

"Action Elects Chairman." *Reno Gazette-Journal*, April 4, 1967, p. 6.

"Frank Shattuck Resigns Post to Attend Law School." *Mason Valley News*. Yerington, Nevada, January 4, 1963, p. 7.

"Frank Shattuck Announces Candidacy for Assembly." *Reno Gazette-Journal*, July 7, 1970.

"Happiness is Finger Painting." *Reno Gazette-Journal*, July 8, 1969, p. 8.

LaPlante, Mimi. "Items about People You Know." *Reno Gazette-Journal*, October 31, 1969.

Las Vegas High School, Class of 1956. http://www.lvhs56.com/class_profile.cfm?member_id=7367633

Miller, Bob. *Son of a Gambling Man*. Macmillan, 2013, p. 34.

"Shattuck to represent Hilton Hotels." *Reno Gazette-Journal*, October 27, 1972.

US Census, 1940.

U.S. City Directories, 1821-1989; Salt Lake City, 1941; Reno, 1971.

Yearbooks: Granite High School (Salt Lake City, Utah); Las Vegas High School.

MARY SHAW

Churchill, Sue. Interview.

Joy, Patricia. Obituary, *Las Vegas Review-Journal*, May 7, 2019.

Shaw, Nancy, daughter. Interview.

AMY RUYKO SIMPSON

https://obits.reviewjournal.com/obituaries/lvrj/obituary.aspx?pid=171784910

Galloway, Ryk. Interview. July 3, 2019.

BETTINA SMITH

Obituary, *Las Vegas Review-Journal*, January 20, 2019.

Southern Nevada Museum Guild Biographies

Winlow, Christy. Personal collection.

DEBBIE SMITH

Las Vegas Review-Journal, February 22, 2016.

Las Vegas Sun, February 21, 2016

Reno Gazette-Journal, February 21, 2016

Votesmart.org

www.leg.state.nv.us/73rd/Legislators/Assembly/Smith.cf

www.nvsenatedems.com/the-blog/214-senator-spotlight

Photograph source: Claire J. Clift, Secretary of the Senate, State of Nevada

MURIEL STEVENS

Biography of Muriel Stevens. Southern Nevada Jewish Heritage Project. Circa 1975.

Katsilometes, John. "A Sad Time to Close the Chapter of my Friend Muriel Stevens." *Las Vegas Review-Journal*, December 16, 2016.

Koch, Ed and Clifford-Cruz, Rebecca. "Muriel Stevens 1925-2016." *Las Vegas Sun*, December 14, 2016.

Obituary, *Las Vegas Review-Journal*, December 18, 2016.

HELEN JANE WISER STEWART

https://www.roadsideamerica.com/story/37851

SANDRA THOMPSON

Lopez, Nancy. "Namesake." 6 Nov. 2014, www.thompson-ccsd.net/namesake-1.

Lopez, Sandy. "Educator's Life May Have Been Cut Short, but Her Legacy Lives On." *Las Vegas Review-Journal*.

"Remembering Sandy Thompson: 1948-2002." *Las Vegas Sun*, August 16, 2002.

DOROTHY TINKER

Nevada Men and Women of Achievement, 1966, p. 138.

www.familysearch.org

www.findagrave.com

JEAN TOBMAN

digital.library.unlv.edu/.../people/jean-tobman

https://lasvegassun.com/news/2016/apr/23/longtime-las-vegas-businesswoman-philanthroper-jea/

https://obits.reviewjournal.com/obituaries/lvrj/obituary.aspx?pid=179744136

hhttps://www.legacy.com/obituaries/lvrj/obituary.aspx?pid=179744136ttps:

https//www.rehab.com/westcare-community-triage-center/5534227-r

Southern Nevada Jewish Heritage Project, UNLV University Libraries

White, Claytee. Transcript excerpts of interview with Jean Tobman, Marilyn Moran, and Janie Moore. November 5, 2013.

DOROTHY TOMLIN

Obituary, *Las Vegas Review-Journal*, May 11, 2014.

Peterson, Kristen. "Mama was a Showgirl," *Las Vegas Sun*, September 16, 2014.

HARRIET TRUDELL

Smith, John L. *The Nevada Independent*, January 5, 2020

Obituary, *Las Vegas Review-Journal*, January 5, 2019.

Wooten-Greener, Julie. "Longtime activist, Democratic stalwart Harriet Trudell die." *Las Vegas Review-Journal*, December 20, 2019.

www.library.unlv.edu/speccol/finding-aids/MS-00540.pdf

www.womennvhistory.com/portfolio/harriet-trudell/

CAROLYN HAYES UBER

Campbell, Suzanne. Personal emails.

Little, Annalise. "Book publisher known for adventures." *Las Vegas Review-Journal*, September 20, 2014.

PAMELA VAN PELT

Obituary, *Las Vegas Review-Journal*, June 20, 2012

BARBARA VUCANOVICH

Biographical Dictionary of the US Congress.

History, Art and Archives, US House of Representatives

Vucanovich, Barbara and Cafferate, Patty. From *Nevada to Congress and Back*. University of Nevada Press, Reno and Las Vegas. 2005.

SISTER ANGELITA WASCO

Bower, Carol. "Sister Angelita's Bread," Booklet; St. Rose Dominican Hospital Women's Committee.

Celebration of Life (draft) letter Sister Angelita (Anne) Wasco, OP 3/7/1998 born 3/5/22.

Delesandro, Victoria, O.P. Women's Committee, *Las Vegas Review-Journal*. May 18, 1998.

Freeman, Al. Marketing of cellophane covering for Angel Bread.

Freeman, Al. UNLV Special Collections.

Henderson Historical Society – various presentations

Hopkins, A.D. and Evans, K.J. *The First 100: Portraits of the Men and Women Who Shaped Las Vegas*, Huntington Press. 1999.

McSweeney, Joan. "1997 Report Angel Bread Celebration." Interview with Sister Robert Joseph, May 1997.

McSweeney, Joan. "1998 Report Angel Bread Celebration." Interviews: June 9, June 24, and July 21, 1997.

McSweeney, Joan. Personal collection.

50 Years: Henderson – an American Journey

www.tpgolinedaily.com/the-story-of-dominican-hospital

St. Rose Dominican Hospitals: Celebrating 60 Years Of Caring, Shauna Walch, St. Rose Dominican Hospitals' Communications Department.

MARY WESLEY

Jackson, Raven. "Las Vegas community activist Mary Wesley dies at age 79." *Las Vegas Review-Journal*, September 18, 2016.

"Las Vegas community activist Mary Wesley dies at age 79 ..." https://www.reviewjournal.com/local/local-las-vegas/las-vegas.

Torres-Cortez, Ricardo. "Mary Wesley, whose social activism brought hope to impoverished Las Vegans, dies at 79." *Las Vegas Sun*, September 16, 2016.

KAREN WHEELER

Bornfeld, Steve. *Las Vegas Review-Journal*, March 31, 2011
Perez, P.J. *Las Vegas Weekly*, July 20, 2006.
Wikipedia
www.karenwheeler.com

ANN SMALL WILLIAMS

https://obits.reviewjournal.com/obituaries/lvrj/obituary.aspx?n=ann-small-williams&pid=187751716
http://safehousenv.org/history/
www.domesticshelters.org

BETTY WILLIS

Las Vegas Review-Journal, April 21, 2015.
Las Vegas Sun, September 18, 2001.
Las Vegas Sun, March 9, 2007.
Las Vegas Sun, April 17, 2008.
www.lasvegasadventurer.com, April 9, 2008.
www.moulinrougemuseum.org, April 1, 2010.
www.vegas.com/attractions/onthestrip/welcome, April 1, 2010.

SARAH WINNEMUCCA

https://www.aoc.gov/art/national-statuary-hall-collection/sarah-winnemucca

DOROTHY STEIWER WRIGHT

Avila, Richard. Phone interview. Las Vegas, May 15, 2018.
Bertolaccini, Christian. "Historian Wright dies at 67." *Las Vegas Review-Journal*, January 22, 2016.
Day, Dorothy Wright. "Clark County Parks and Recreation." Posted April 21, 2015. https://www.facebook.com/clarkcountyparks/posts/902486783143168.
Kelly, Danielle. "In memoriam: Dorothy Wright was an unsung hero of Las Vegas history." *Las Vegas Weekly*, January 25, 2016.
"Lewis and Clark High School." In Memory – Class of 1966. http://www.lctiger66.com/class_profile.cfm?member_id=7184675. Accessed June 20, 2019.
Marchese, Patricia. Phone interview, June 3, 2019.
Obituary, "Dorothy Wright." *Las Vegas Review-Journal*, January 22, 2016.
Peterson, Kristen. "Lessons in history." *Las Vegas Sun*, May 26, 2007
United States Department of the Interior, National Register of Historic Places. https://www.nps.gov/nr/feature/weekly_features/LasVegasSign.pdf. Accessed June 20, 2019.
Photograph source: Avila, Richard. Personal collection.
Photograph source: UNLV Special Collections #0062 0335

BARBARA ZIELINSKA

Desert Research Institute. Colleagues, Newsroom.
SilverCityReads.blogspot.com/2018/02scientist-babrbara-zielinska-abd-silver.html;
International Communities. http://www.satyachitana.org

Printed in the USA
CPSIA information can be obtained
at www.ICGtesting.com
LVHW011912031123
762986LV00007B/126

9 780578 699349